SCULPTING THE
FIGURE
IN CLAY

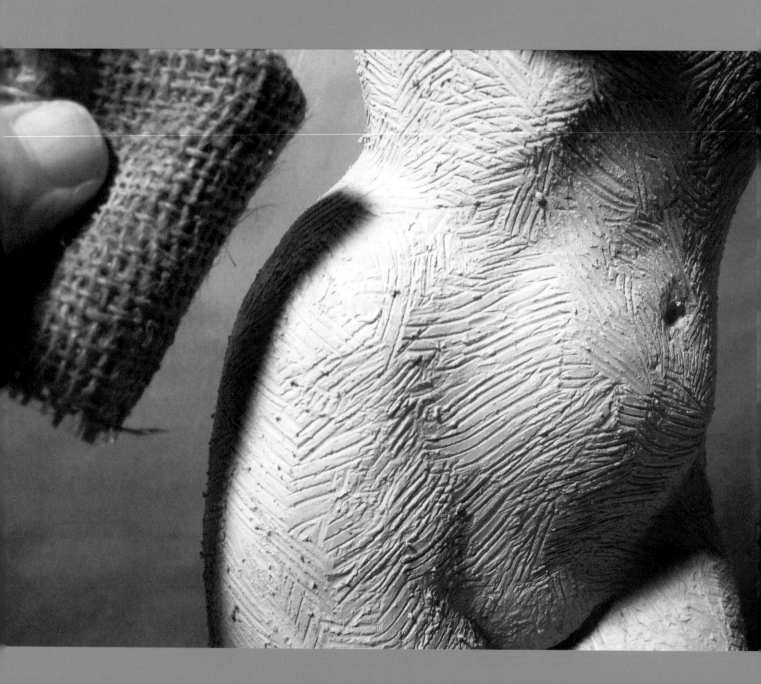

PETER RUBINO

SCULPTING THE FIGURE IN CLAY

AN ARTISTIC AND TECHNICAL JOURNEY TO UNDERSTANDING
THE CREATIVE AND DYNAMIC FORCES IN FIGURATIVE SCULPTURE

WATSON–GUPTILL PUBLICATIONS
NEW YORK

In memory of my father, Bernard—Ben—friend and mentor. His creative spirit, brilliant palette, mastery of medium, and artistic vision was without compromise. He continues to inspire the best in me. I will miss his council. And in memory of my mother, Ruth, my greatest fan and believer in small miracles. I will miss her energy, encouragement, and love.

ACKNOWLEDGMENTS

First and foremost, I want to extend my deepest appreciation and sincere gratitude to my anchor and very patient wife, Michael, for her understanding, for her encouragement, and for inspiring all that is good in my life.

To my sons, Dean, Lukas, and Jesse, and their beautiful families, for keeping my dream alive.

To my mother-in-law, Lillian, and in memory of my father-in-law, Michael, for their kind, caring support and for always believing in me.

To my "fratello" and master mold maker, Dominic Ranieri, for his dedication and commitment to excellence.

To Dave Brubeck, for his generosity, genius, and illuminating foreword.

To Dale Shaw, for his encouragement and support.

To my dear friends David and Maureen Canary, for being there and championing my cause.

To my paesano Joe Pantoliano, for his courage, for his hope, and for trusting in me.

To all of my students, at home and attending my workshops, for your talents, high expectations, and willingness to receive.

And in memory of my best buddy, Tom Mortellaro, who left us much too early, for being there at the beginning and supporting me in ways only a best friend can.

SPECIAL THANKS

Photographer: Sierra Dobson, for her creativity and expertise in photographing the reclining pose and all reference poses.

Photographer: Andrew Zygart, for his intuitive eye and commitment to the pose in photographing the standing torso.

Photographer and digital assistant: Romanus Dolor, for his photo of the Brubeck bust.

Models: Mary Ellen (torso), Laurie (reclining and reference poses), and Sue (reference poses), for making this book come to life.

And to the dedicated staff at Watson Guptill Publications/ Random House:

Executive Editor: Candace Raney, for believing.
Senior Development Editor: Alisa Palazzo, for honing my manuscript and getting it.
Editorial Assistant: Autumn Kindelspire, for creating my art log.
Publicity Director: Kimberly Small, for getting the word out.

Library of Congress Cataloging-in-Publication Data
Rubino, Peter.
 Sculpting the figure in clay : an artistic and technical journey to understanding the creative and dynamic forces in figurative sculpture / Peter Rubino. -- 1st ed.
 p. cm.
 Sequel to the author's The portrait in clay.
 Includes index.
 ISBN 978-0-8230-9924-5 (pbk.)
 1. Modeling--Technique. 2. Figure sculpture--Technique. I. Rubino, Peter. Portrait in clay. II. Title. III. Title: Artistic and technical journey to understanding the creative and dynamic forces in figurative sculpture.
 NB1180.R83 2010
 731'.82--dc22
 2009029130

ISBN 978-0-8230-9924-5

Printed in China

Design by Vera Thamsir Fong

10 9 8 7 6

First Edition

FOREWORD

Ever since Goethe called architecture "frozen music" there has been an attempt to link various forms of the visual arts to the auditory art of music. It is an abstract connection that is difficult to explain because the mediums appear to be so different. And yet, I think one instinctively intuits a relationship. I know that I did. When I was somewhere between four and five years old, my greatest desire was to be either a sculptor or a musician. Knowing my interest, my mother sent me a book on sculpture from Italy when she was studying abroad, and in my lonely hours, I spent many a rainy afternoon looking at these photos of classic statues.

In the end, of course, music won. But I do believe a similarity exists between the art of creating music and that of sculpture. It all begins with an idea—an image or a musical theme. The sculptor begins by taking a slab of marble or gobs of clay, and through chiseling or molding and working with the materials, a form begins to take shape that is pleasing to the eye. Composing music follows a similar path from a blank piece of paper to written notes and imagined sounds and an eventual piece of music with a recognizable form.

Craftsmanship, learned through years of doing, supplies the tools that serve the inner vision. There is an emotion and a unique life created in the arts, and no matter how abstract the creation may be in visual or musical terms, the artist's individual touch or voice is perceptible. This is especially evident, I think, in Rubino's more abstract pieces, where he has broken the mold, so to speak, of classical tradition to make a more personal statement, in much the same way as the jazz musician adapts a standard form to invent a new piece of music out of the feeling of the moment.

Rhythm is the core, the heartbeat of it all—the visual rhythm of the eye viewing the forms of a sculpture, the pulse in music and in poetry, that gives life to sound.

I've known Peter Rubino for many years, and from viewing his works and seeing the master in action as he dances around his work in progress, I have a feeling that he feels these relationships in much the same way as I do.

Dave Brubeck

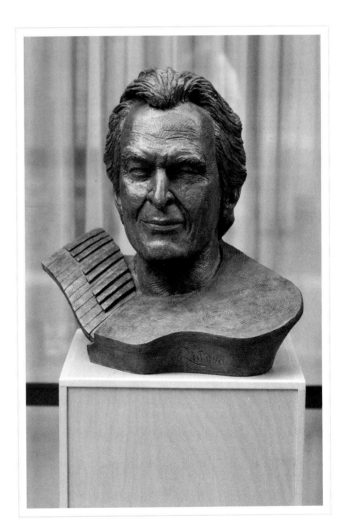

Bust of Dave Brubeck by the author.

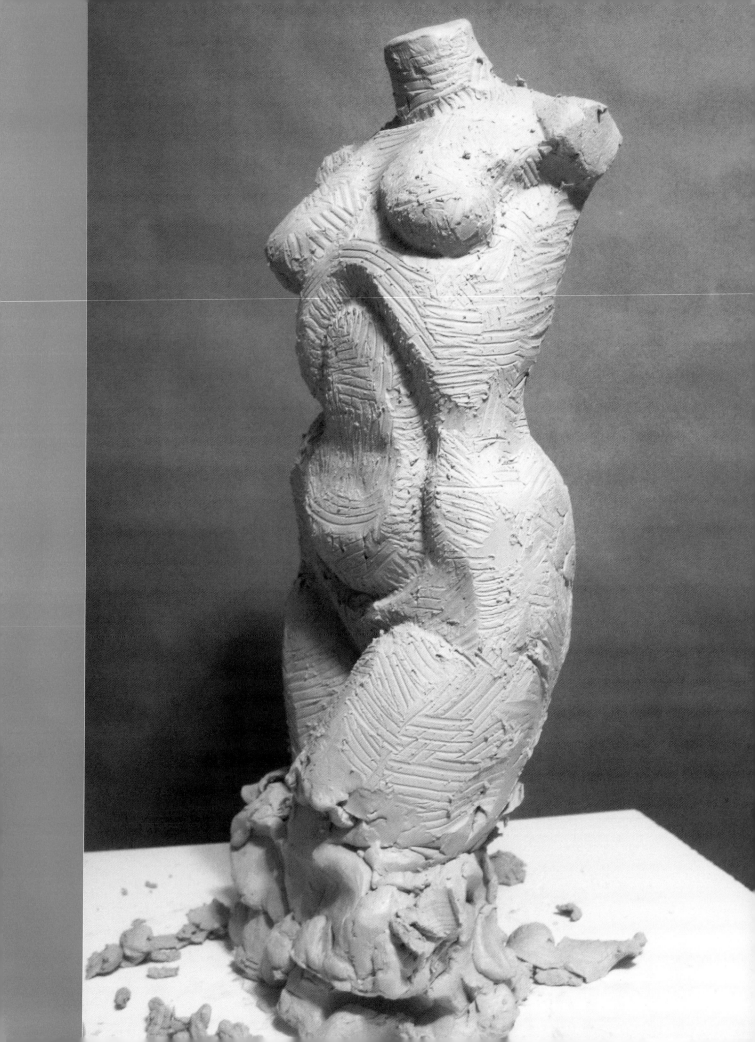

CONTENTS

FOREWORD 5

INTRODUCTION 8

PART ONE THE BASICS

 1 Fundamentals of the Clay Torso 12

 2 Observing the Model 20

PART TWO THE SCULPTING PROCESS

 3 The Torso 26

 4 The Full Figure 60

PART THREE AN INTRODUCTION TO FIGURE ABSTRACTION

 5 The Clay Sketch 120

 6 The Finished Sculpture 126

PART FOUR INDIVIDUAL PARTS

 7 The Hand 134

 8 The Foot 152

PART FIVE REFERENCE POSES 170

RESOURCES 191

INDEX 192

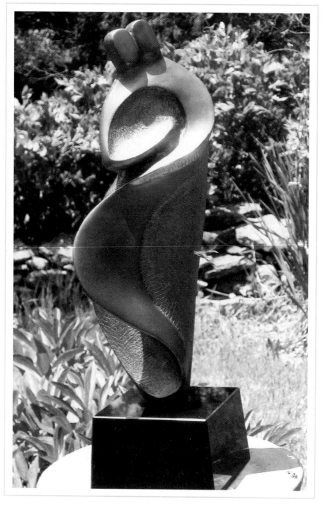

Hope, commission for actor Joe Pantoliano's charity organization, No Kidding Me Too.

Angel, commission for Disney Corporation.

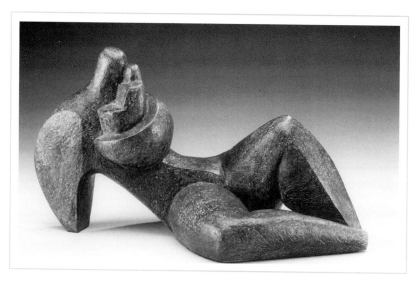

Nurture

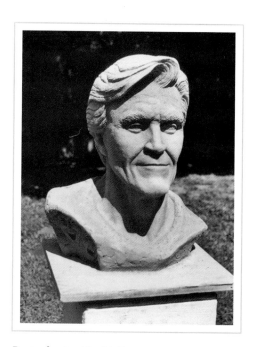

Bust of actor David Canary.

INTRODUCTION

Why the human figure? The figure has been the inspiration of both heroic and sublime artistic creations for thousands of years. The figure continues to inspire and is the subject of choice for many contemporary sculptors worldwide. It is a most fascinating form: available in a variety of shapes and sizes, and in two genders. Perfectly constructed, possessing power and grace, it offers dramatic movements and an endless array of pose possibilities. Ideally suited, the figure features an abundance of volumes and contours, presenting the sculptor with infinite design and compositional options while boasting an unlimited range of emotional expressions. Studying and sculpting the figure can be the gateway to self-awareness, discovery, and expression. Besides, it's a great way to celebrate the human experience.

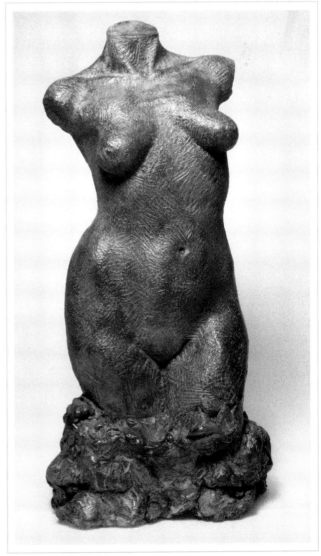

This is not another anatomy book for artists. The lessons introduced in this book are designed to help sculptors see and think in the round, by providing a fresh and functional sculptural language. These concepts are suitable for the development of both the male and female figures in clay. The focus of this comprehensive instructional guide is on the female figure, covering a standing torso and a full-figure reclining pose, with additional references for seated poses. My step-by-step method of arranging simple block shapes of clay, according to the position proportion and planes of the model, is a quick and easy-to-follow sculpting technique that establishes the foundation of a pose without requiring the use of an armature (although you may use one if you like, as I do on page 30). Once the foundation is in place, the sculpture will begin to take on its final figurative form.

My intension here is to provide a complementary and alternative approach to the figure. My hope is that you will learn how to see and expand your vision of the figure. My goal is to simplify the complexities of the figure. My mission is to encourage students to develop an individual artistic style. My declaration is "We don't make mistakes, we make adjustments." My mantra is "Pursue it with *passion.*" Sculpt!

Fired finished torso demo piece with bronze patina application.

THE BASICS

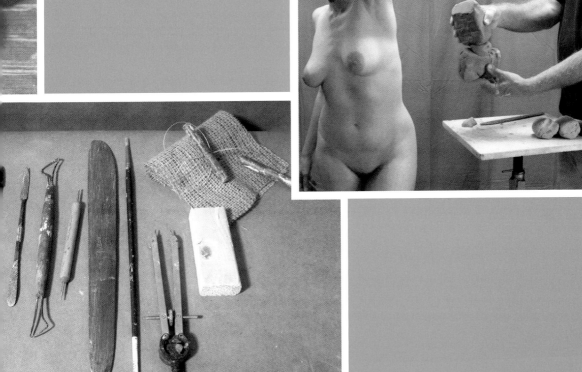

1

FUNDAMENTALS OF THE CLAY TORSO

There are certain characteristics that are common to the torso of every figure, regardless of body type or gender: a finite number of sections and similar movement abilities. These elements become the foundation of your sculpture. If you keep them in mind, they can function as landmarks that help you get things in place on every project. The following demonstration shows how you can translate complex anatomy into simple shapes and capture the movement of the pose.

THE CLAY BLOCK SYSTEM

Think of the body as having two large masses: a rib cage and a pelvis. These masses are positioned one above the other and attached to a spinal column with a core group of muscles centrally located between them. The human body can move in three different directions simultaneously by bending the rib cage forward and back, leaning the pelvis from side to side, and turning the pelvis and rib cage in opposite directions.

When looking at a model "in pose," it's critical to be aware of this bend, lean, and turn—or BLT—as well as the three Ps: the *position*, *proportion*, and *planes* of the pelvis and rib cage. Position is the placement and arrangement of rib cage and pelvis relative to each other. Proportion is the relative size of the individual masses. And planes are the surfaces of the form.

So whenever you approach the figure, visualize the pelvis and rib cage masses as two individual, three-dimensional rectangular blocks and the central core muscle group as a ball. Observe the model and determine the BLT and the three Ps of the pose; then begin to sculpt. The following lesson demonstrates how to utilize this *clay block system* and employ the BLT and three Ps *before* working with a live model in pose, which is something I recommend doing. Note that we'll consider the actual sculpting tools needed a bit further on; this exercise will first introduce the fundamentals of observing and analyzing the figure before you get to work.

1. To become familiar with using blocks of clay to establish the figure, make two simple rectangular blocks that are similar in size to represent the two body masses of the torso (the rib cage in the upper section and pelvis in the lower), and use a ball of clay to represent the muscle core between them. Mapping out some landmarks helps orient things further: The arched line on the upper block indicates the shape of the lower edge of the rib cage, and the horizontal line with a small vertical indent in the center marks the chest. The curved line that arcs down to the middle of the bottom block surrounds the stomach, and the V at the bottom center locates the pubic form. Upward-curving lines on each side of the V indicate the tops of the thighs.

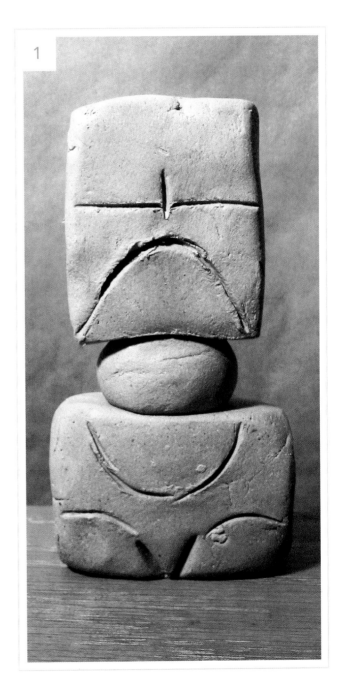

1

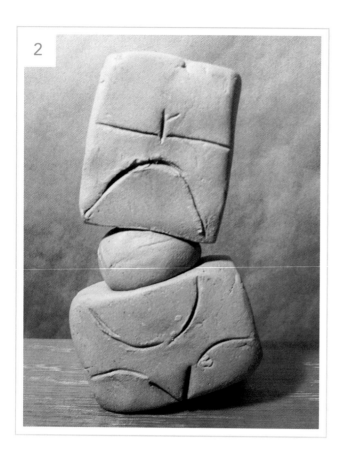

2. Not every pose is head-on and straight up and down, of course, so depending on your particular pose, you can then begin to adjust the placement of the blocks relative to each another. Here, the pelvis block leans up on the right side (our right) toward rib cage. The rib cage block leans down and almost touches the pelvis on the same side. The clay ball in between the blocks stretches on the left side and compresses on the right to accommodate the new position of the two blocks.

3 & 4. Continuing the adjustments, the right side of the pelvis block turns to the back, in addition to leaning up. The right side of the rib cage block leans down, and the block turns to the left overall. The clay ball changes shape further, twisting to accommodate the new position of the two blocks. The line drawn down through the center of the front planes of the blocks and the ball highlights the twisting movement of the forms. A side view of this stage (4), reveals how the front planes of the blocks are facing in different directions, away from each other, whereas in photo 1 both front planes face in the same direction.

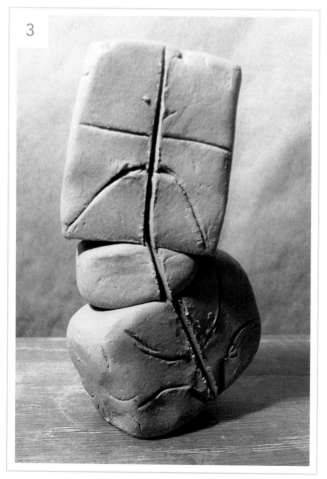

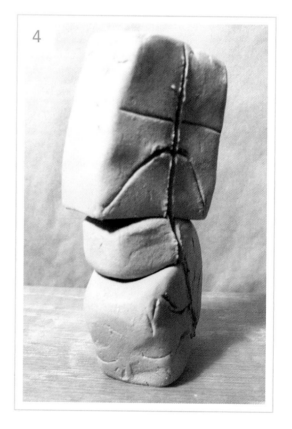

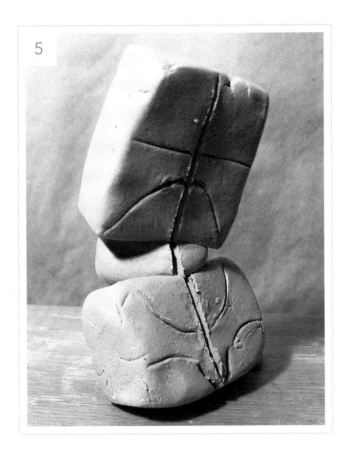

5. The pelvis block can also be made to bend back, causing its front plane to face upward. Note that the pubic V lifts up off the underlying base, and the weight shifts to the lower back edge of the block. This is a "stomach crunch" movement. The top of the rib cage block bends forward, with its front plane facing downward. The clay ball is pinched in front and stretches in the back. Back is convex and front is concave.

6 & 7. Here, the pelvis block bends forward, in contrast to the previous adjustment, and its front plane faces downward. The rib cage block bends back, more so on the left than on the right, and the front plane faces upward. The side view (7) confirms that the back is arched and the central ball stretches in front and compresses in back. The line drawn through the center of the side planes of the blocks and ball highlights the curving movement of the forms.

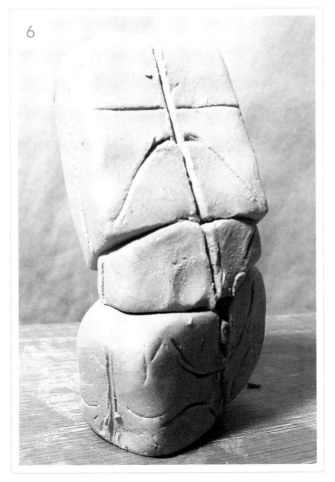

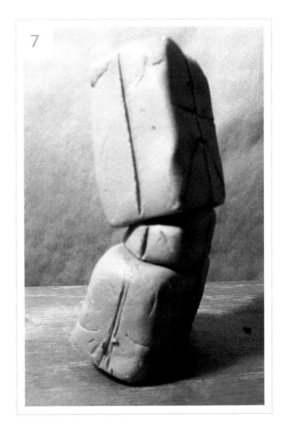

8. For the tops of the thighs, form two clay cylinders, rolling up both so that they are slightly bigger in diameter on the top end. For a standing pose, place the cylinders on the bottom plane of the pelvis block. They should be centered at the pubic V and be round enough to reach the outer sides of the block so that each leg fits under half the pelvis.

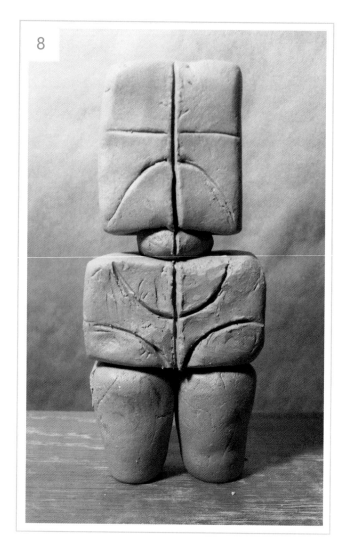

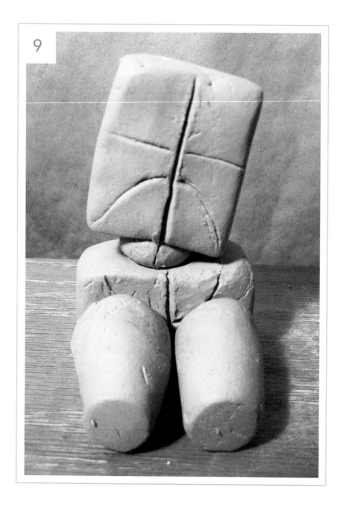

9 & 10. For a seated pose, take the cylinders out from under the pelvis block, place the block down with its bottom plane resting on the base, and place the cylinders on the front plane of the block. Make sure the cylinders are still centered at the V.

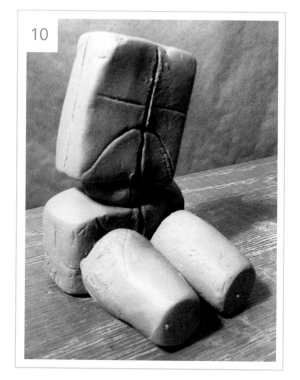

11, 12, 13 & 14. For a reclining pose like this one, place the basic standing pose (8) on a side plane (11). When the legs bend forward in the pose, temporarily remove the leg cylinders and cut a plane on a 45-degree angle across the bottom front edge of the pelvis block (12).

Then, replace the legs, first positioning the lower cylinder on the new plane at the base of the block (13) and following with the top leg at their proper angles. Again, make sure that you keep both of the legs centered on the form (14).

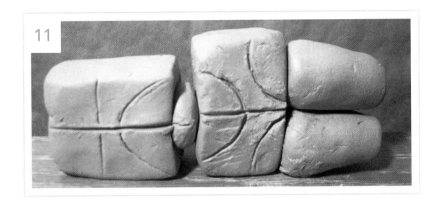

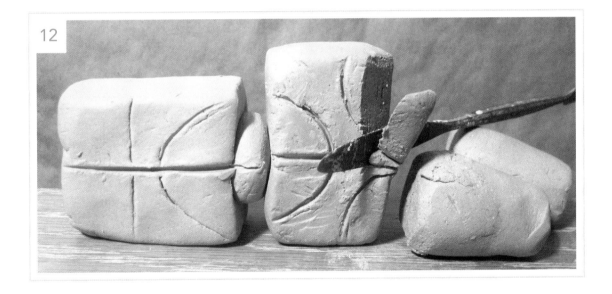

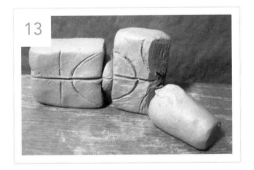

MATERIALS AND TOOLS

Water-based clay comes in 25-pound bags, ready to use. It is available in a variety of clay body types, with or without grog. Grog is pulverized fired clay that is added to the fresh clay to give it strength. Grog is gritty and comes in fine, medium, and heavy grade. The heavier grog is great for larger projects, which don't call for modeling fine details. The grog is always present on the surface and is labor intensive to smooth out. If you want a smoother finish to your work, it's better to use clay without any grog added to the mix.

A water-misting bottle is perfect for spraying your piece every twenty to thirty minutes during a sculpting session. You don't have to drench your piece; just give it a quick spray to keep it moist. Then spray it before wrapping in plastic, at the end of the session.

Regarding tools, the use of various implements, in combination with your hands, often yields the most successful results. Tools help you create hard edges, precise planes, and round forms. They also increase your ability to model details and apply surface textures.

To start, a *plaster tool* is a specially shaped, thin, metal spatula that comes in many sizes. I use it to smooth out the surface and to make sharp lines or cuts in the clay.

The *Milani riffler* is a handcrafted rasp specifically designed to smooth out rough edges left by carving chisels. It gets into hard-to-reach places on stone. The surfaces at both ends of the tool have tiny spurs that grip clay. This gripping action lets you press the clay into shape, which comes in handy when modeling details, whereas wood, metal, or plastic tools tend to slide across the clay surface.

The *wire loop tool* is perfect for scratching the clay surface in a technique I call raking. I prefer that the loop has a serrated texture or be wrapped with a thin wire. This helps to evenly grade the clay when you crosshatch.

The *embossing and stylus tool* is a wooden dowel that has a metal rod with a ball at the tip on each end. Held like a pencil, it's great for cleaning up hard-to-reach areas, such as nostrils, eyes, teeth, toes, and so on.

The *flat modeling stick* is used to apply pieces of clay to build up the mass and shape of the sculpture. It also slices away unwanted clay and creates planes by cutting across the surface of the piece.

Calipers help you check proportions. For example, place one arm of the caliper on a knee and the other on the ankle. Tighten the arms in place, and compare that measured distance to the same area on the other leg. Decide which distance you want, and adjust the other leg accordingly.

The *wood block* is for tapping the clay sculpture into its basic shape. It's great for creating flat surfaces, planes, hard edges, and round forms, and for absorbing moisture and tightening the clay mass—all by simply tapping the rough edge of the block against the clay.

The *cutting wire* is handy for cutting large chunks of clay from a new clay block or performing painless surgery on your sculpture.

A *painter's brush* with medium-firm bristles is good for cleaning up hard-to-reach areas of a piece. Use very little water and brush the clay. This will act like a fine wire loop tool and help model a smooth surface. I only use the brush in small areas when I'm finished sculpting the piece. Don't use this technique in the way potters flush their pieces with water and a sponge. That would only wash out all of your fine modeling and any nuances you were able to achieve on the surface.

A piece of *burlap* acts as a finishing tool. Bunch it up in your hand, spray it with water mist, and use a gentle pouncing technique over the sculpture. This will blend the existing tool marks with the texture of the burlap to produce a uniformly finished surface.

For cleanup, the *wire brush* that plumbers use for cleaning threaded metal pipes is ideal for cleaning dried clay off tools. I don't wash my tools with water. I first wipe the clay off with paper towel and then scrape and brush off the remaining clay once it dries.

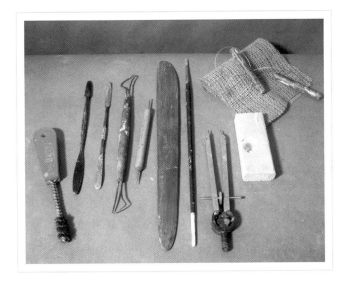

A selection of tools. From left to right: wire brush; plaster tool; Milani riffler; wire loop modeling tool; embossing and stylus tool; flat modeling stick with cutting edge; brush for cleaning small detail areas; caliper; wood block tool; cutting wire; square foot of burlap.

An armature can be made with a ½-inch thick board cut to any size you need. Use a smooth pipe threaded on one end and a flange to screw the pipe into for support. (Also see description on page 30.)

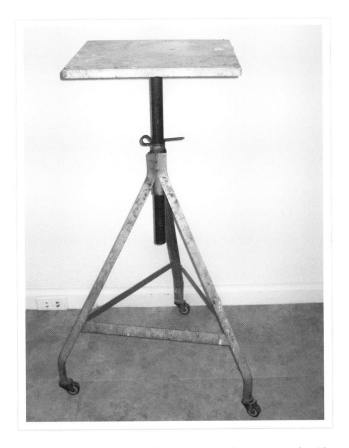

The tripod sculpture stand is versatile and easy to work with. It comes with wheels and an adjustable tabletop that allows you to change the overall height of the stand to suit your needs. Make sure the stand can safely hold the amount of clay with which you wish to work.

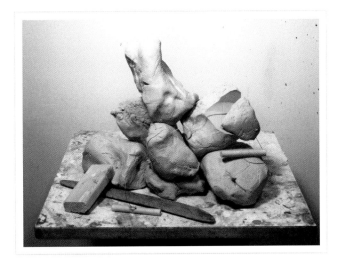

Clays fire at different temperatures. A low firing is suitable for sculpture. You don't have to hollow smaller pieces before firing them; just make sure they're dry, and begin the firing process at 200 degrees (that's below the boiling point). Bring the temperature in the kiln up slowly, over a two- or three-day period, until the cone temperature 06 to 08 is reached. Check with your clay supplier and kiln operator for best firing results. It's the moisture trapped in air pockets (within the clay) turning to steam that causes a piece to blow in the kiln, not the air pocket itself. So, fire low and slow.

OBSERVING
THE MODEL

Learning to see and think in the round is the cornerstone to sculpting

the figure. It begins by observing the model from all views. Each view

reveals both the subtle and dramatic rhythms of the form. The more

visual data you collect (scan and store) from observing the model from

every angle, the greater your capacity to re-create (download) the sub-

ject you wish to sculpt. Learning a fundamental and simple sculptural

language will help you understand the architectural elements that are

inherent in figure sculpture.

THE FIGURE IN THE ROUND

The lesson in this brief chapter will introduce you to the process of translating complex anatomical forms and movement into the simple geometric shapes/ blocks seen in the previous exercise. Observing the "bend, lean, and turn" of the model in pose and being able to interpret the position, proportion, and planes of the rib cage and pelvis into simple block shapes will help you develop the clay foundation for any pose.

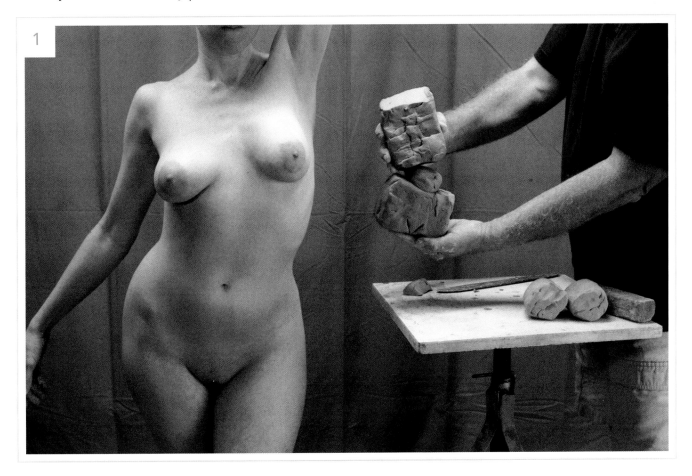

1. The model needs to be observed from all sides before you can truly *see* and understand the pose. The front, back, and two sides are just the starting points, or the four basic views. Remembering that all sides of the body are planes, continue to observe the model from views *between* the front and sides of the body, then the sides and back; those are four more different views. Continue viewing the model in this way, from positions between the previous views, until you have viewed it from every position along an imaginary circular line drawn on the floor around the model. This will help you realize that what happens in the front affects, and is related to, what

happens in the back or any opposite side or surface you are working.

This is a basic standing pose with one leaning movement. On the left side of the form, the pelvis leans upward, and the rib cage leans downward. On the right side of the form, individual ribs spread apart slightly, and the core muscles stretch. On the left, both individual ribs and the core muscles compress. This body movement creates a contrast between the elongated, almost vertical right side and the more compact and angular left side of the body. Note that the positioning of my blocks of clay reflects this.

2. When you observe the position of the pelvis and rib cage masses from the left profile, you see that the top of the rib cage tips backward and the top of the pelvis tips forward. This movement creates an arch in the back and a convex curve along the front planes of the chest and core.

The rib cage and pelvis are attached to a curved spinal column, making it impossible for the body stand perfectly straight. Therefore it's crucial to observe the model from the side. This curve is not apparent from either the front or back views. Your clay blocks should exhibit the same curve when viewed from the side.

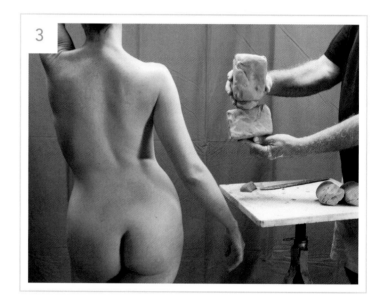

3. In the back view, the pelvic area and hip lean upward as they travel toward the right and are higher on the right side than on the left. The rib cage area and right shoulder lean downward toward the right and are lower on the right side than on the left.

4. The right side view (of the model) shows the curve created by the position of the rib cage and pelvis. You should always observe the front, back, and two side views of the model before making decisions about the movement of the pose.

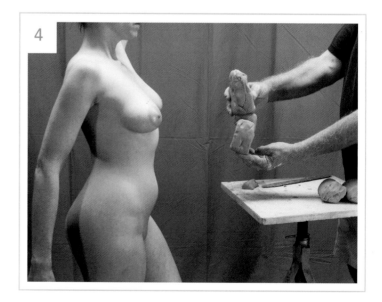

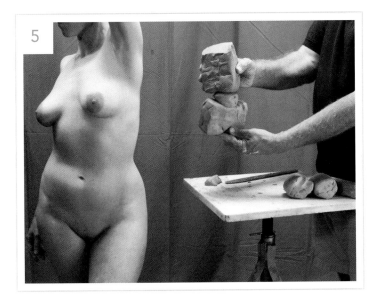

5. From this angle, a second movement in the pose becomes evident: The rib cage turns to the left (our left, the model's right). Keep the clay blocks leaning as they were, and turn the rib cage block slightly to the left.

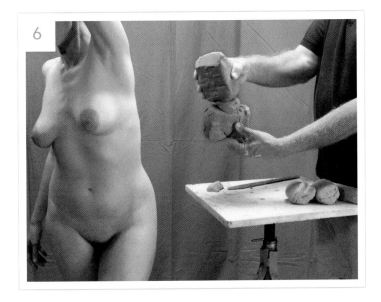

6. While similar to the previous step, you can see that a third movement has been added to the pose as the model bends her rib cage forward.

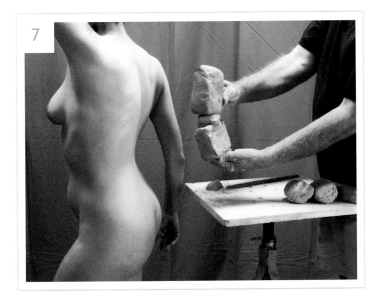

7. This view reveals that the right arm is behind the back and out to the side. The right shoulder blade projects from the rib cage in the back, and the left arm and shoulder pull forward. Position the clay accordingly, and you have a simple sculptural foundation of the pose.

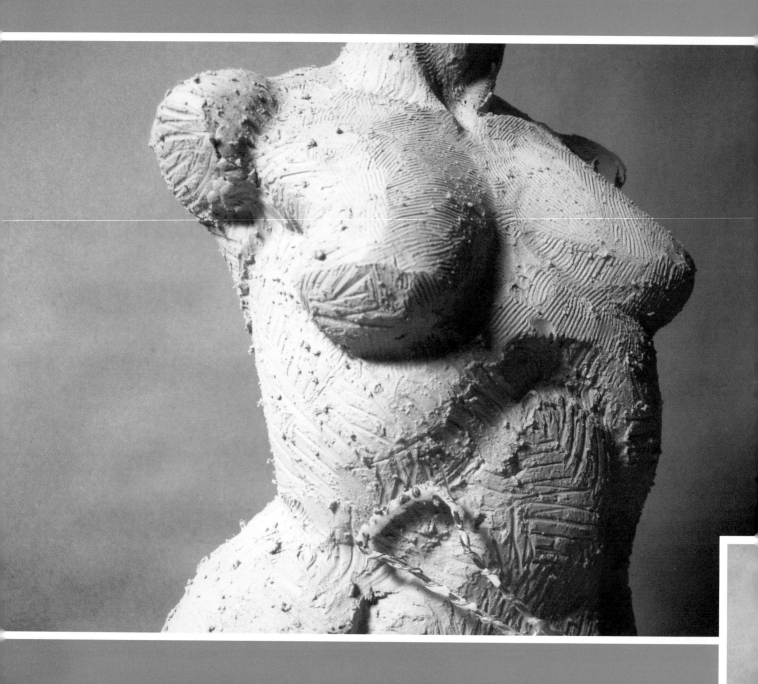

THE SCULPTING

PROCESS

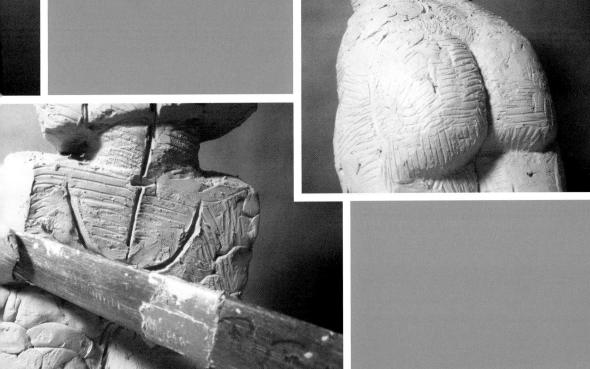

3

THE TORSO

Sculpture develops in three stages: foundation, form, and finish—the three Fs. In many ways it's like a movie having a beginning, middle, and end. A movie weaves the main characters, supporting players, bit parts, and extras together, bringing the story to life. Similarly, a sculpture has main large forms and minor smaller forms, each playing an integral role in bringing the whole sculpture to life. To illustrate how the three Fs come together, I'll use a basic standing pose, focusing on the torso.

ASSESSING THE POSE

Perhaps one of the most important lessons of this book is to teach sculpture students how to truly see and observe the nude model in pose. This requires looking at the model from every angle in order to fully understand the form in the round. In class, I walk my students around the model and point out the relationships of the parts to the whole, *before* the sculpting process begins. If students don't do this, their perception of the figure is two-dimensional. Since this book cannot provide live access to the model, study the following reference images, illustrating the pose in the round in sequential order, before the clay lesson begins. The 360-degree sequence starting below and continuing onto the next two pages will get you seeing and thinking in the round, three-dimensionally, which is what differentiates sculpture from drawing and painting.

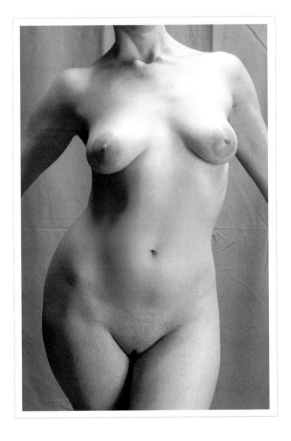 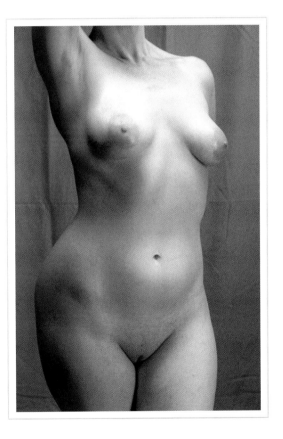

Students have a tendency to only look at the details of the figure when they first observe it, so they will immediately notice the smaller bones, muscles, and shadows instead of focusing on the larger masses. So it's a good idea to squint when first observing the model; this will block out the details so that you can concentrate on those large forms and foundation elements. Pay attention to the proportions of the model, the height versus the width, and the movement of the pose.

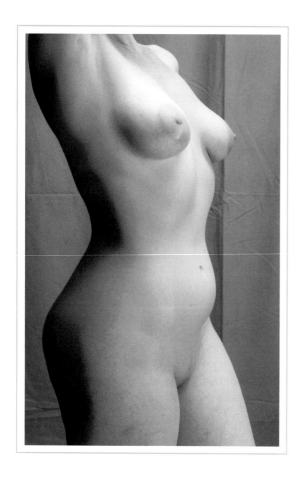

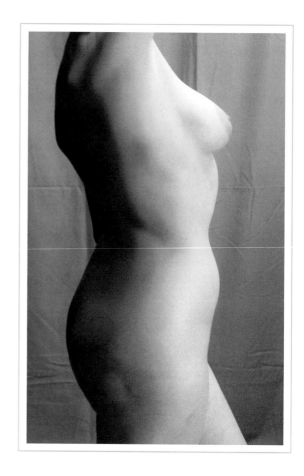

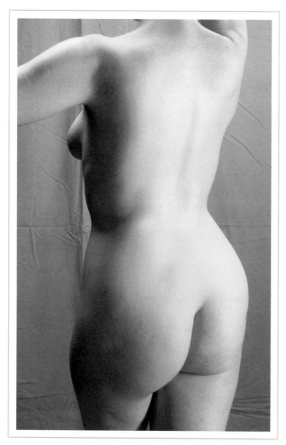

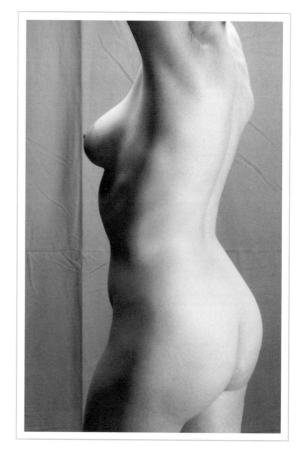

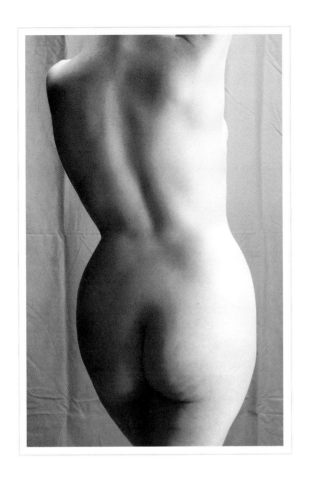

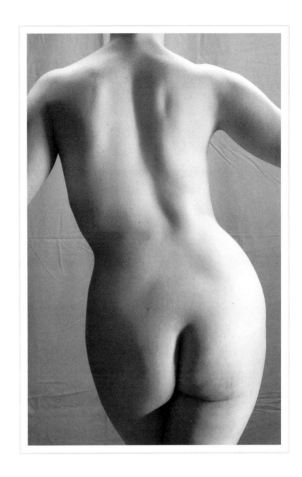

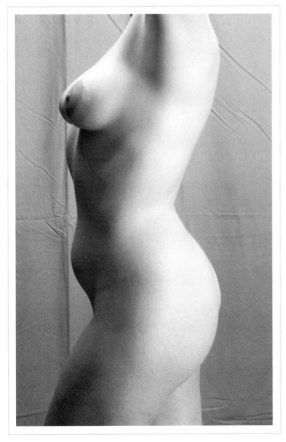

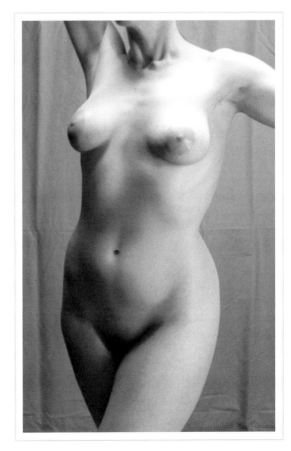

THE STANDING TORSO

As with any pose, the sculpting process for the standing torso begins with stage one: *foundation*. This involves setting up the composition of the sculpture with simple clay blocks utilizing the principles of 3Ps (position, proportion, and planes). It is also during this stage that the BLT (bend, lean, and turn) of the model in pose is determined. This information is gathered by observing the model from every view. Stage two, *forms*, sees the modeling and building of the larger anatomical shapes by adding and subtracting small pieces of clay to the planes, and then modeling the surfaces with a wire loop tool and tapping with a wood block to enhance and give shape to the form. Stage three, *finish*, entails modeling the smaller anatomical shapes and pulling the forms together (blending) by tooling the surface to create the final surface texture.

For an exercise like this, you can use an armature pipe that's 12 inches high and ½ inch in diameter, and a board that's 10 x 10 x ½ inches. Attach a flange that's also ½ inch in diameter to the board with screws, and screw the armature pipe into the secured flange.

1. Begin by attaching cylinders of clay to the pipe. Stack the clay cylinders upright, and press the pieces together around the pipe. Go about 4 inches high. This will be the foundation mass for the thighs.

2. Begin building a clay block for the pelvic mass, and attach it horizontally to the pipe on top of the thigh mass. Position the block according to the BLT (bend, lean, and turn) of the pose.

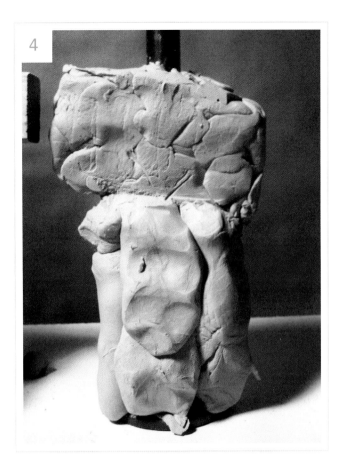

3 & 4. To create corners on the pelvis block, place a small piece of clay on the tip of the wood modeling stick and press it to the top surface of the block. Do the same to the front of the block. Do not smear clay in place; just use a little pressure so that the clay pieces stick to the block and to each other. Continue adding small pieces of clay with the modeling stick to the top and front of the block. This is the building process I use to develop the shape and form of the blocks. Build up the surfaces so that they meet at the end of the blocks to create an edge. Most students like to put clay on with their fingers and then smooth out a clay shape also with their fingers. However, try to get comfortable using tools to build hard edges, flat surfaces, and round forms. Once the surfaces are built up, tap them with a wooden block to create flat surfaces and sharp edges and corners.

5. Once the clay block is shaped and all the surface planes are flat, add a ball of clay—for the core muscles—to the pipe on top of the pelvis block.

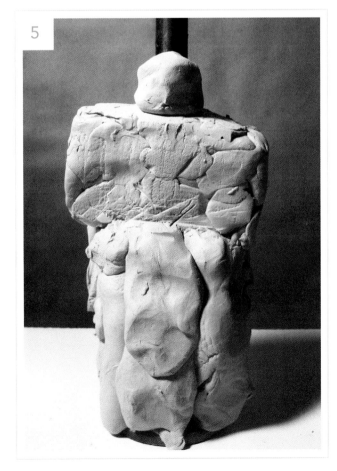

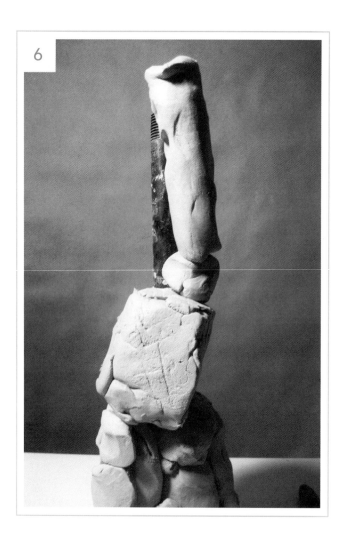

6

6. As you begin adding clay to the pipe on top of the ball for the rib cage mass, position the sections to reflect the angles and gesture of the pose, even at this early stage. When viewed from the side, the convex bend of the front of the rib cage is evident.

6a. Note that it's okay to have the clay extend above the pipe.

7. To fill out and shape the rib cage block, continue to add pieces of clay to the back of it. As in step 6, the beginnings of the gesture of the pose can be seen here in the left side view, as evidenced by the convex line created by the front of the torso.

8. When you've finished building the block foundation, draw a guideline by scoring the clay with the edge of the wooden tool, moving down the center of the two blocks in the front. The line travels from the top of the rib cage to the bottom of the pelvis. Draw a V shape at the end of the line for the pubic form.

9 & 10. Check the three Ps (position, proportion, and planes) and the BLT (bend, lean, and turn) of the blocks from the front, three-quarter (opposite, bottom left), side (opposite, bottom right), and back views.

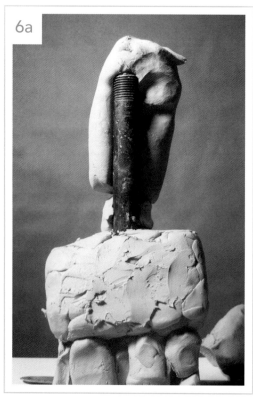

6a

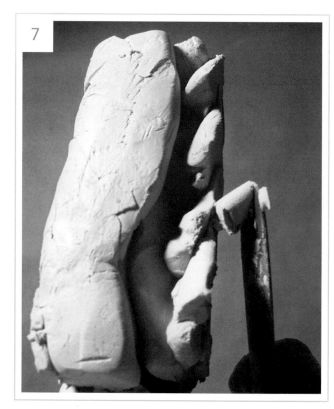

7

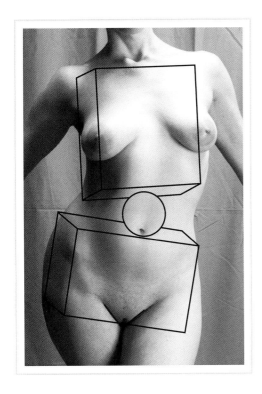

Before progressing to the next step, take a moment to analyze and check your foundation in relation to the actual figure. For example, the rectangular pelvis and rib cage blocks are similar in size. The horizontal pelvis block bends forward as it travels upward (contributing to the arch of the back).

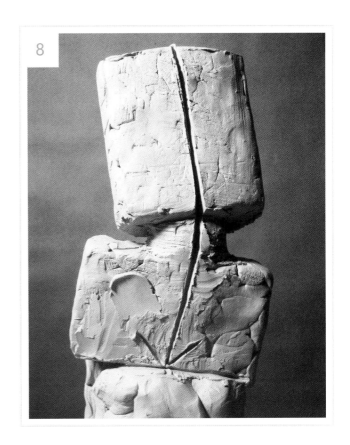

8

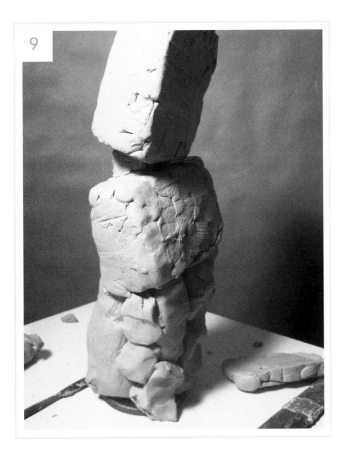

9

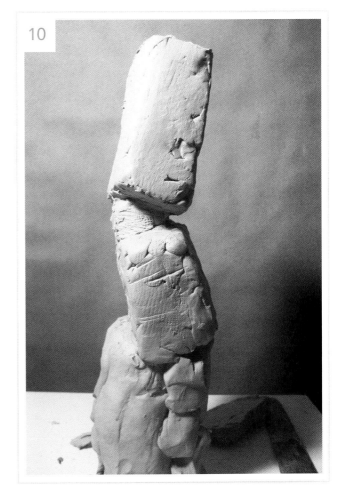

10

11. Again in the side view, you can see that the top of the rib cage slopes downward from the upper back (where the trapezius muscles are) to the front of the upper chest (where the clavicle bones are). Cut this sloping plane with the wooden tool across the top of the rib cage. Use the long edge of the tool, and cut the clay in the same way you would use a knife to slice cheese. The neck will eventually sit on this sloping plane.

12. Cut a second, smaller sloping plane in front for the top of the chest. Model the clay blocks by pulling and raking the wire loop tool across the clay surface. Use a cross-hatching pattern to "delump" and evenly grade (level off) the clay surfaces. The scratching of the clay, using this technique, is similar to raking the front lawn before seeding. Tap all sides of the clay mass with the wood block to get sharp edges and flat planes.

13. Draw arched guidelines for the shape of the rib cage on the top block and additional guidelines to indicate the lower abdominal muscles, stomach, and tops of the thighs on the bottom block. Score a vertical line in the center of the leg mass from the V at the tops of the thighs to the base to define the individual legs. Then, slice a small plane on the inside of each thigh.

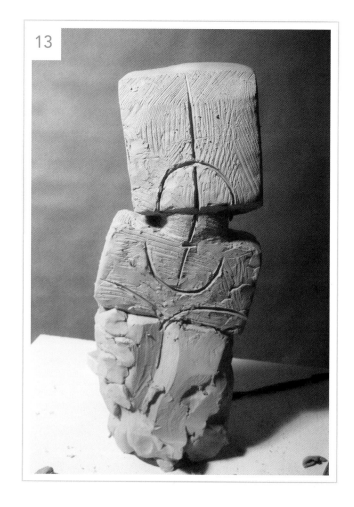

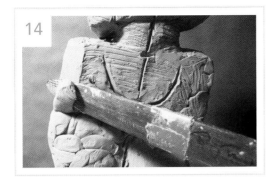

14 & 15. Cut a plane on the left edge of the pelvic block at a 45-degree angle from the front plane to the side plane of the block. Then, cut an identical plane on the right side, keeping the block symmetrical. Start to build the roundness of the upper thighs by adding pellet-shaped pieces of clay with the wooden stick tool.

16. Cut planes on the left and right front edges of the rib cage block. The thighs are shaped like a wedge; cut planes on the inside and outside of each one. The *plane breaks* (the edge created where two planes meet) of the thighs line up with the side plane breaks of the pelvis. The plane break represents a directional change between the two planes. The high points of each thigh are at the plane breaks, while the low points are where the inner thigh planes of both legs meet, just below the pubic V. The outer thigh planes travel back toward the side of the pelvis block. The diagram below left further maps out these relationships.

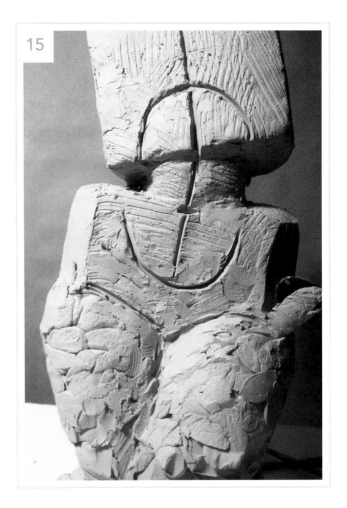

Note how the dotted line at the top of each thigh starts at the bottom of the V, travels up the inside plane of thigh, then changes direction at the high point of the thigh. The line continues from there down along the outside plane of the thigh to the back of the leg. The vertical dotted lines on the legs indicate the plane breaks of the inner and outer thighs. The curved dotted line is drawn to indicate the transitional area between the pubic arch and the form of the lower abdominal muscles (stomach). The stomach is positioned in between the hips, which are indicated with solid lines.

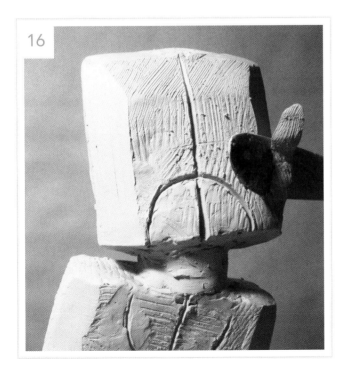

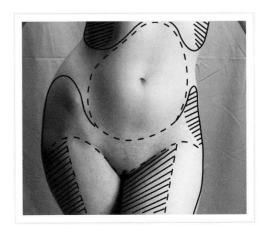

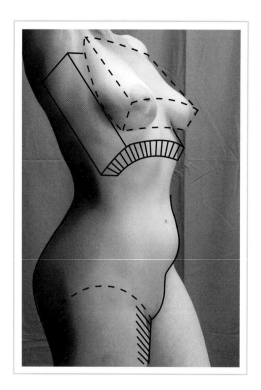

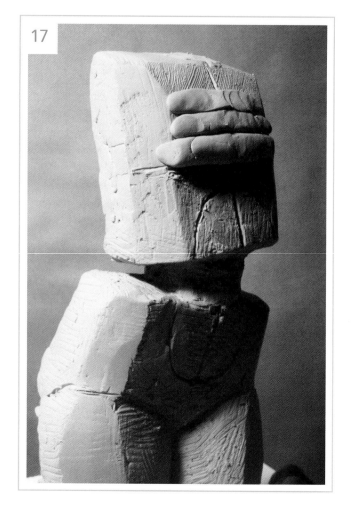

Note that the breast section rests on top of the curved block shape of the underlying rib cage. The breast section has a top, front, and side planes all indicated by dotted lines. The plane of the curved bottom section of the rib cage is outlined by parallel solid lines and shaded with a series of short vertical lines.

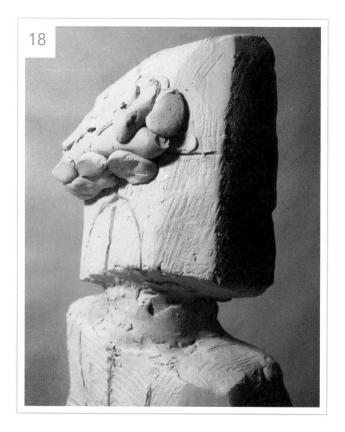

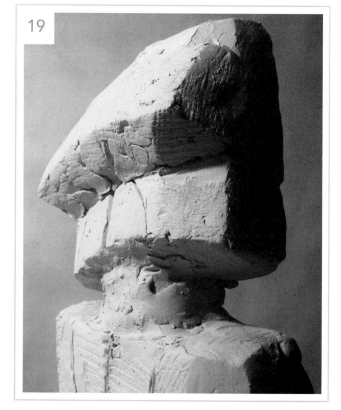

17. To begin building the foundation of the chest and breast section, draw a horizontal line across the center of the rib cage block. Begin to add cylinders of clay from this horizontal line continuing up to the chest plane that was cut earlier in step 11. Extend these cylinders across the front plane of the rib cage.

18 & 19. Continue building up this area using small pellets of clay. Basically you are adding a triangular block of clay to the rib cage for the foundation of the chest and breast section. The chest and breast area is arched and rests on the convex contour of the rib cage. The plane across the top of the chest is curved. Planes are developed under and on the sides of the breasts.

20. At this point, also add clay to the central muscle core on the right side. (For reference, see diagram on page 35.)

21 & 22. Add pellets of clay to the outlined area of the lower abdominal muscles and to the left side of the central core. Cut a plane across the top edge of the right side of the pelvis. Repeat this on the left side, as well, and then tap planes into the tops of the hips with the wood block. Then cut a plane on the right side of the lower rib cage. The edges on both upper and lower clay blocks need to become distinct planes.

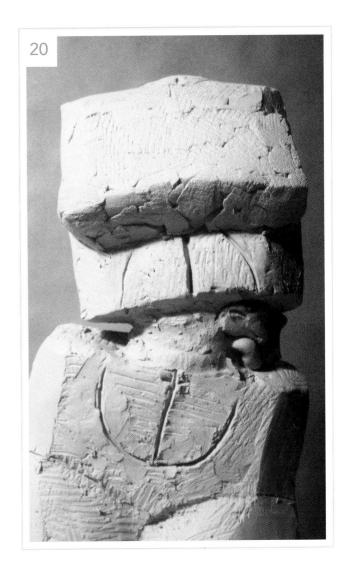

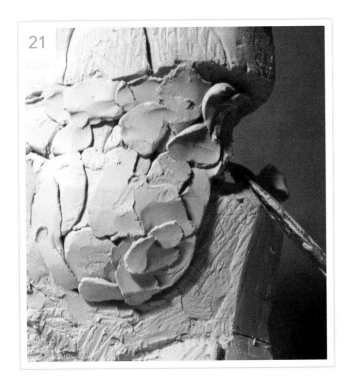

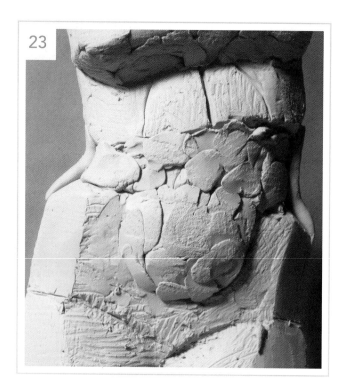

23 & 24. Add small, thin clay cylinders for the external oblique muscles located on both sides of the abdominal muscles. This clay links the rib cage to the pelvis, making a rhythmic transition from one block to the other. The muscles on the front of the body form a T shape, with chest muscles traveling across the top of the T and the abdominal muscles traveling down the center of the T.

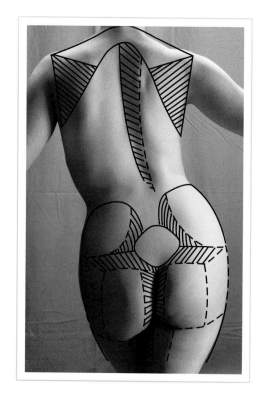

As reference for steps 25–28, I've mapped out the buttocks, gluteus maximus muscles, and the gluteus medius muscles with solid and dotted lines. Note the volume of these forms as indicated by the short solid lines used for shading along some of their side and top planes. Solid lines drawn for the shoulder blades and trapezius muscles show how they are connected. The lines on the top plane of the blades indicate their position, and triangular and wedgelike shape.

27. The shoulder blades follow the contour of the rib cage and roll toward the front of the body. They project from the surface of the back and have two planes: one rising up from the spine to the edge of the blade and the other from the edge of the blade toward the front of the body. Rake the clay with the wire loop tool to blend the surface together and create distinct triangular shoulder blades.

28. Add clay pellets to build volume in the lower back and the block shape of the gluteus maximus muscles (For reference, see diagram opposite).

25. Draw a guideline down the center of the back, from top to bottom, following the curved position of the clay blocks. Draw a horizontal line across the pelvic block approximately one-third of the way down from the top of the pelvis. This line divides the pelvic block into two parts: the lower back and the buttocks, the gluteus maximus muscles. Cut a sloped plane across the top of the rib cage for the trapezius muscles. Draw two guidelines traveling down from this plane at 45-degree angles for the shoulder blades.

26. Add clay to the shoulder blades, following the diagonal lines you've just scored.

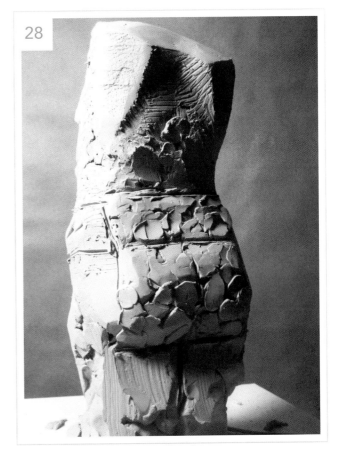

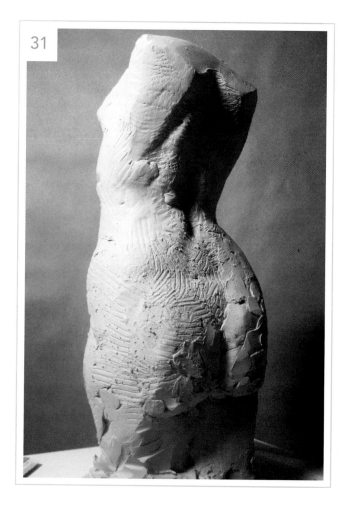

29. Place the wire loop tool into the spinal area about one-quarter of an inch deep. To capture the gesture of this pose, lean the tool to the right side, pull up, and rake the clay to the right. Continue to model the triangular shapes of the shoulder blade with the wire tool. The blade has a similar wedged shape and plane structure to the thigh. Continue to model the lower back with a raking motion of the wire tool.

30. To begin to establish the buttock area, draw a triangle in the center of the lower back section for the top of the sacrum. (Use the diagram on page 38 as reference if needed.) Draw a box on each side of the sacrum for the gluteus medius muscles. Use a raking technique to give both dimension and narrow side planes to the gluteus medius and sacrum. Draw triangular guidelines for the base of the sacrum and continue to develop the narrow side planes of the sacrum and gluteus maximus muscles.

31. Continue to add, rake, and blend clay to create fuller forms and contours.

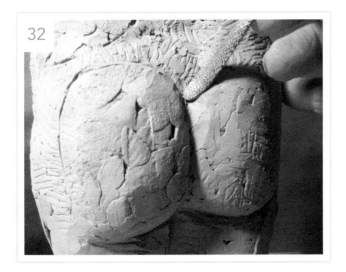

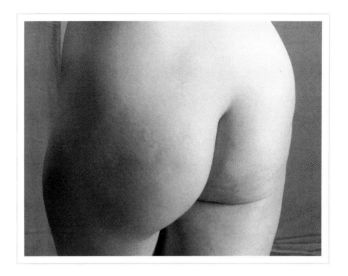

Reference the photos of the model whenever necessary, as they function in place of a live model.

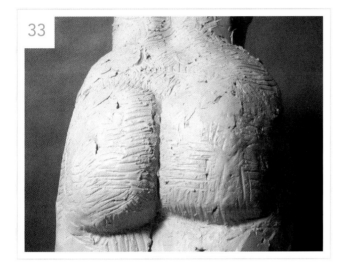

32 & 33. Using a riffler, press the clay at the top of the gluteal form to create a small plane and the shape of the sacrum. Also develop planes underneath the gluteus muscles, as this makes them more dimensional, creates more volume, and helps project the form from the leg mass.

▶ Maintaining & Storing a Work in Progress

It's a good idea to spray your clay with a water mist at least once every hour. This will keep the clay from drying out. The piece should be covered with a plastic bag and made airtight each time you take a break. For breaks of extended periods of time—more than three days—you'll want to cover your sculpture with a damp cloth or paper toweling before wrapping it in plastic. If a clay piece has dried out a bit overnight, just place a damp cloth over the dry areas for an hour or so, and the piece will come back to life.

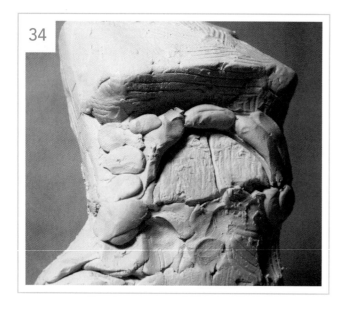

34. Add small pieces of clay under the breast, following the guideline made earlier, to build the form of the rib cage.

35. Tap the clay with the wood block to shape the top surface and contour of the rib cage. The front edge of the rib cage is curved and arches up from side to side, framing the upper abdominal muscles. There is a narrow plane under this curved edge. Rake and tap this plane in place. (See the diagram below for reference.)

36 & 37. Define the narrow, curved plane and plane break of the arched rib cage, which frames the upper abdominal muscles. In the side view, note the projection of the rib cage, the lower and upper abdominal muscles, the oblique muscles between the rib cage and the pelvis, and the direction of the hip plane.

38 & 39. Add clay to the upper and lower abdominal muscle areas. Also add clay to build up the V form of the pubic arch and inguinal ligament, the form along each side of the arch, which widens the V shape under the stomach.

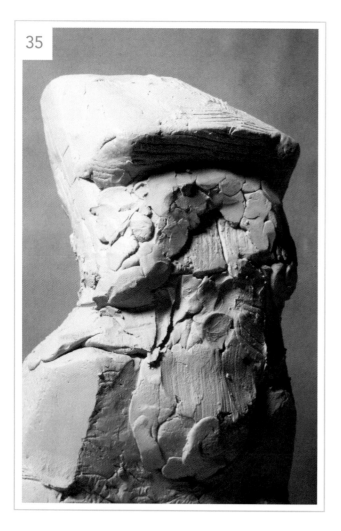

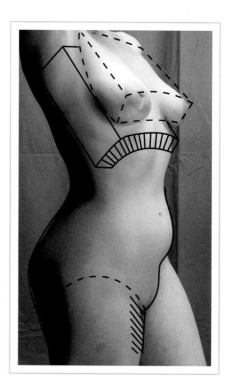

The narrow plane under the curved edge of the rib cage is indicated here with solid stripes.

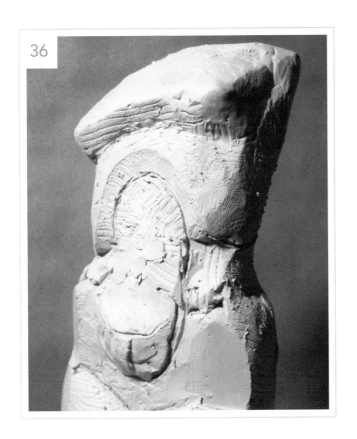

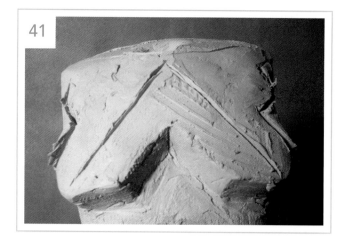

40 & 41. To form individual breasts, draw guidelines from the center of the top of the chest, where the clavicle bones meet, out to where the nipples of each breast are located. The edge across the bottom of the clay breast foundation, the baseline, completes the triangle. This area, marked by the triangle or upside-down V shape, should be proportionate in width and height to the same section of the model. Draw a smaller triangle centered just below the large triangle, starting where the model's breasts begin to take shape; this represents the space between the breasts. This space and the dis-

tance between the top points of each triangle should also be proportionate to the same area of the model. The breasts move in the same direction as the rib cage. If you were to draw a horizontal line going from nipple to nipple, on the baseline, it would be parallel to the top of the shoulders in any side-to-side, leaning position of the rib cage. (For reference, use the right-hand diagram on page 58 and photographs on pages 27 and 29.)

Then cut and remove the clay from the small triangle to create the foundation and basic plane structure of the two breasts (41).

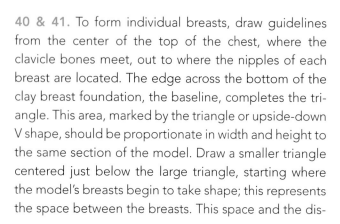

42. When you view the area from below, looking up at the breasts and chest, the inside and bottom planes of the breasts are quite distinct. The rib cage is barrel shaped and the top planes of the chest and breasts curve to conform to the rib cage.

43. To finish shaping the breast, cut clay off on the outer side of each breast parallel to the plane of the inner side of that breast. Continue cutting clay off, as if you were carving parentheses, between each shoulder and breast to create the curved shape of the pectoral muscles.

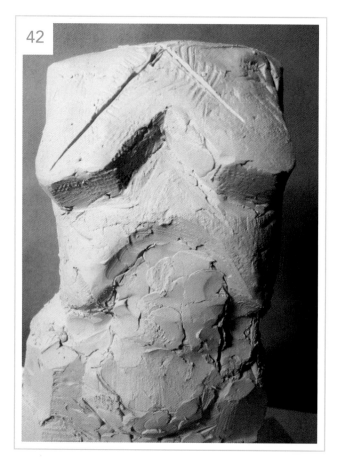

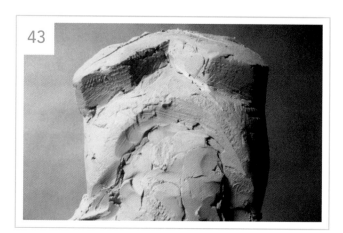

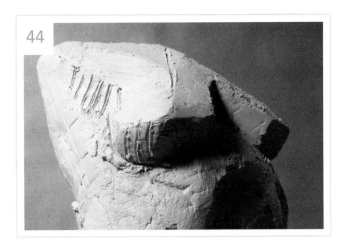

44

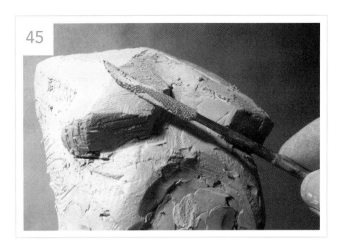

45

44. Beginning at the line of the large triangle, cut a plane on the left chest and breast downward and back toward the shoulder. The short vertical lines drawn here on the side of the breast indicate where the side plane of the pectoral muscle and the bottom plane of the breast are located.

45. Cut a plane on the top surface of the left breast from the line of the outer triangle downward toward the center of the rib cage. The line of the outer triangle has become the plane break and high point of the two top planes of the breast.

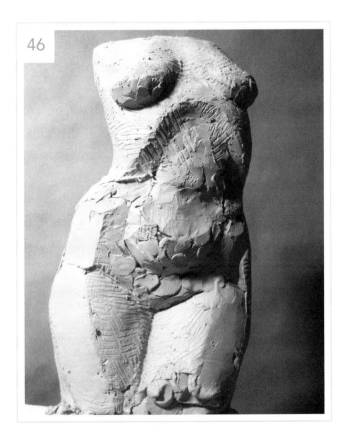

46

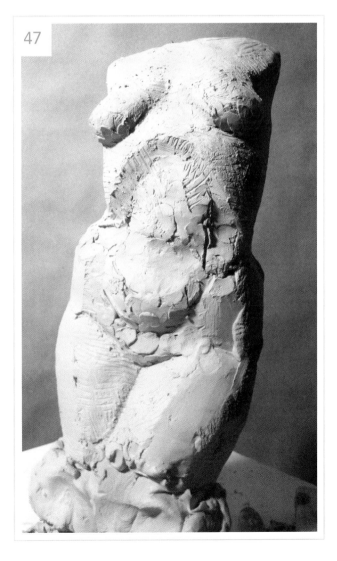

47

46 & 47. At this stage, the torso from both the right and left shows development of the breast, the barrel shape of the rib cage, the upper and lower abdominal muscle areas, and the form of the pubic arch.

48. Cut a plane on the top of the shoulders, going from back to front.

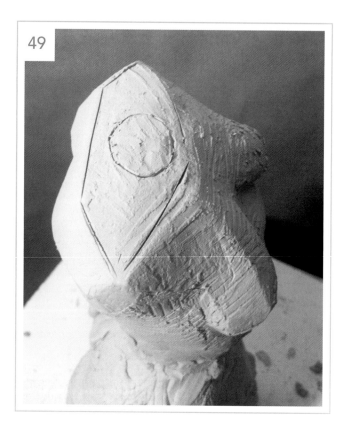

49. The triangular-shaped shoulder blades are located at the top and back of the rib cage. The blades rest on the side contour of the ribs, giving them a natural angle toward the front of the body. The planes of the clavicles, starting at the center of the chest, angle back toward the shoulder. When viewed from above, the shoulder blades and clavicles form the elliptical shape of the shoulder girdle at the top of the rib cage. Draw a circle for the neck in the center of the sloping plane of the shoulder girdle.

50. The neck is a simple cylinder shape that sits on the sloped plane of the shoulder girdle on top of the rib cage block. It leans forward because of the natural curvature of the cervical section of the spine.

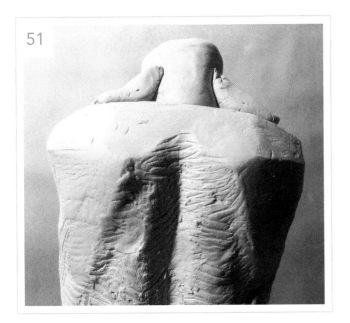

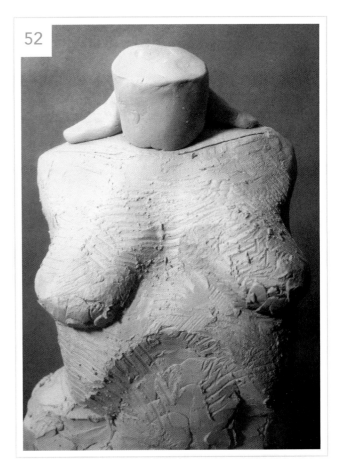

51 & 52. To create the trapezius muscles of the neck, place small cylinders of clay running from the shoulders to the neck. The clay should be higher at the neck than at the shoulder—it should slope from the neck to the shoulders. This is a triangular form. (See the top right diagram on page 59 for reference.)

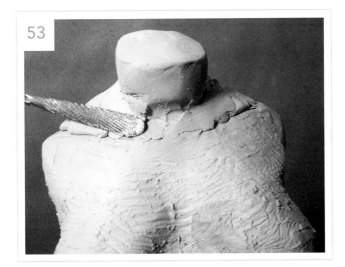

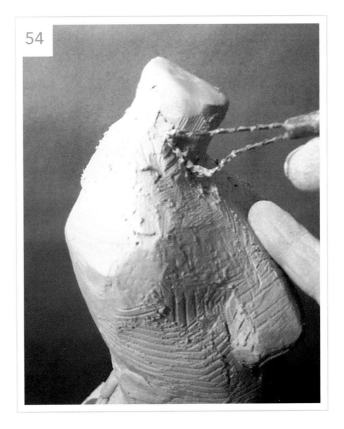

53 & 54. Add clay with the riffler from the clavicle to the trapezius to create more of a sloping plane on the sides of the neck. Then use the wire tool to rake and blend clay around the neck and neck area.

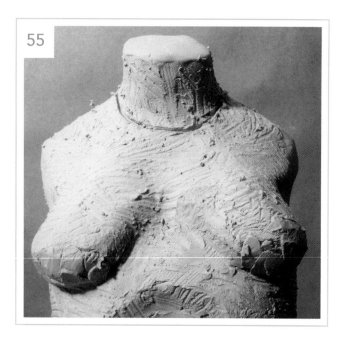

55. Using the tip of the riffler, draw a line around the base of the neck where it touches the clavicles. This is in preparation for defining the spot where the neck meets the clavicle and transitions into the chest.

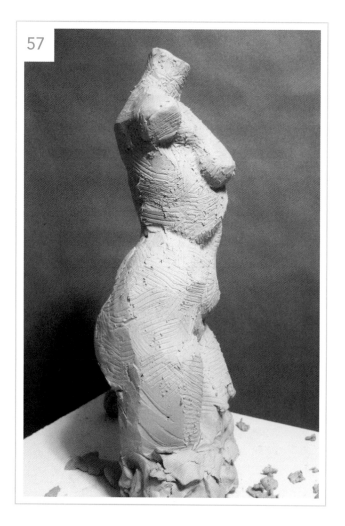

56. Push the wire tool against this line, press down, and rake the clay to the shoulder. Rake all around the neck and neck area.

57. At this point, stage one (the foundation) is complete. in the side view, note the angle of the neck. The front and back planes of the rib cage and pelvis blocks are parallel. Note, also, that the front plane of the chest and breast faces upward, while the plane across the back faces downward. The front plane of the lower abdominals and pubic arch face downward, while the plane of the lower back faces upward. You could draw an S curve through the center of the sculpture from the top of the neck to the bottom of the thigh.

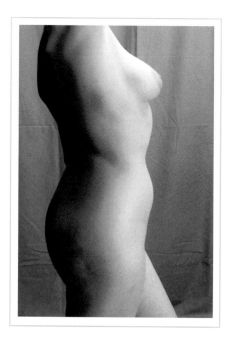

If you stop at this point to compare the piece to the model, you see that all the main angles, forms, and gestures are captured.

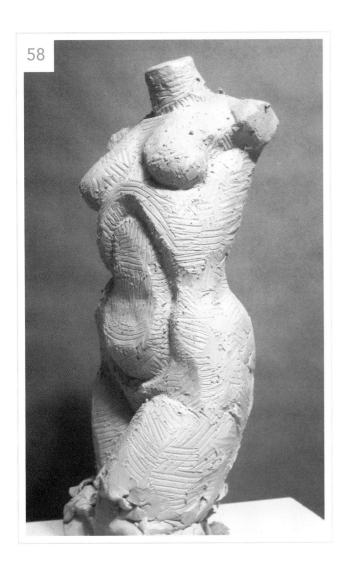

58

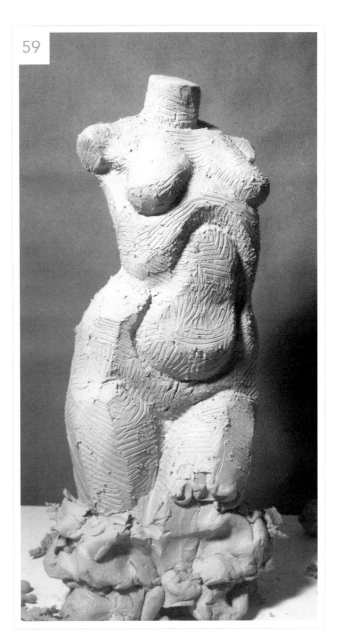

59

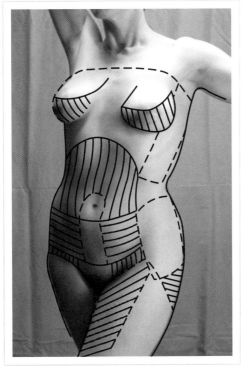

58 & 59. Moving around the foundation at this point reveals the plane structure of the large frontal forms. The foundation represents about 80 percent of the total amount of work to be done on your sculpture.

The wavy lines indicate the curve of the abdominal muscles, which can be seen on the actual sculpture, as well.

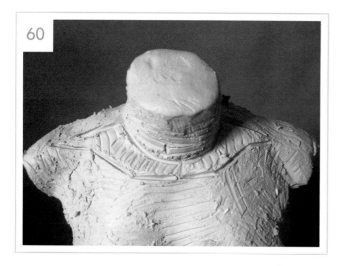

60. At the beginning of stage two (*forms*, see page 30), draw guidelines for the clavicles (collar bones). These are shaped like bicycle handlebars.

61. Create a channel between the clavicle and trapezius by removing clay between them with the wire loop. This will give definition to both forms. The channel or trench is really a low transitional area that exists between two high forms. Add a strip of clay for the sternocleidomastoideus muscle along the side of the neck, traveling from the inner end of the clavicle to the top of the side of the neck. Repeat this on the other side, and blend these strips into the neck by raking the clay with the wire loop tool.

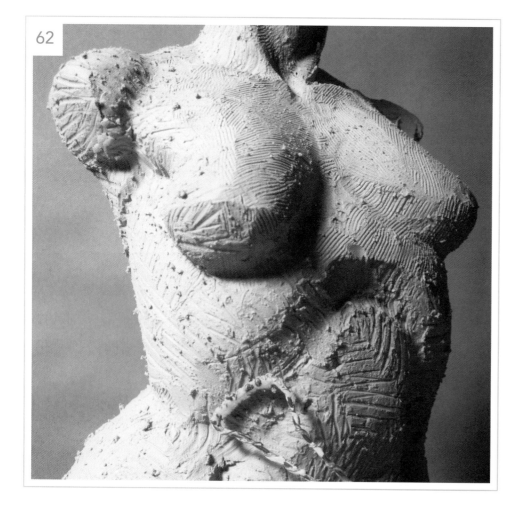

62. Pull the forms together and soften the edges of planes (plane breaks) by raking them with the wire loop. Blend the clay of the rib cage to the upper abdominal muscles. This will begin the process of creating a flowing rhythmic movement across the surface of the sculpture.

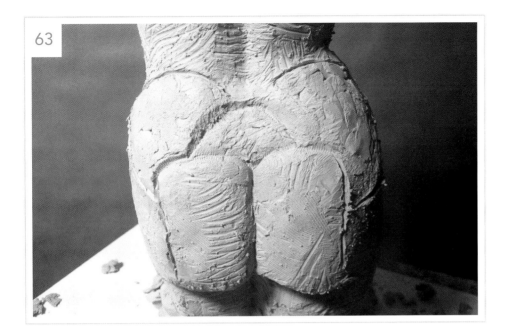

63. Continue to develop the outlined areas of the gluteus maximus, gluteus medius, and sacrum. The gluteus maximus muscles are blocky shapes. (See the top right diagram on page 59.)

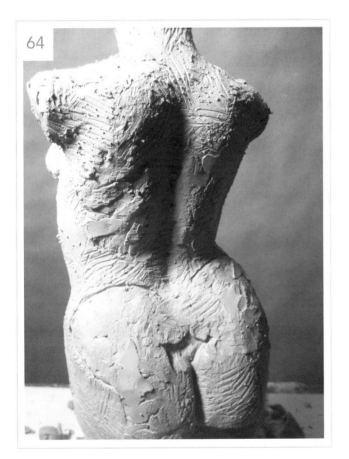

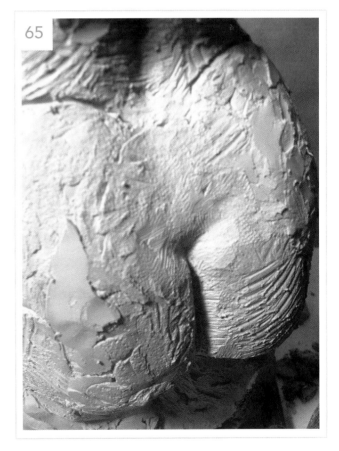

64 & 65. Start raking the forms together as you add more clay and volume to them, making sure to add clay to the V shape of the sacrum and area at the top of gluteus maximus muscles just below the sacrum. Then, tap the clay with the wood block, and rake and blend the clay of the sacrum. Push the wire tool about one-quarter of an inch into the vertical guideline between the gluteus muscles, and rake up toward the surface. This will create a narrow plane on the sides of the gluteus muscles and give them dimension. Continue to add clay to the gluteus medius to create a fuller contour. (Refer to the photos on pages 28–29 if needed.)

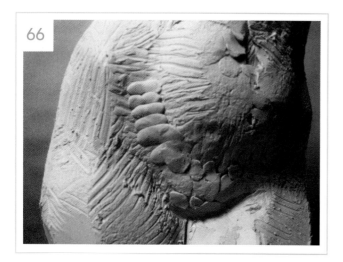

66. Add small strips of clay to fill space and link the side plane of the abdominals to the front plane of the hip. Continue adding clay strips along the entire side plane of the stomach to the hip, and then blend them with the wire loop.

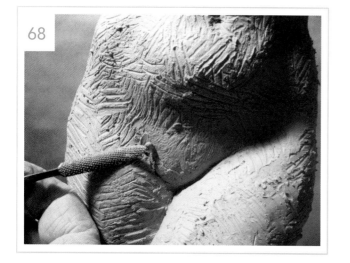

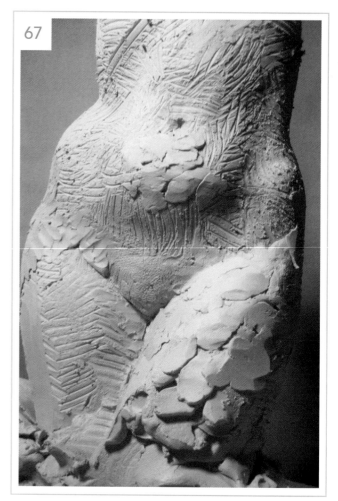

67. Add pieces of clay to build up the volume of the thigh and lower abdominals.

68. Add small pellets of clay to build up the pubic form below the lower abdominals.

69. Add strips of clay to build up the contour of the hips from the waist down to the top of the thigh.

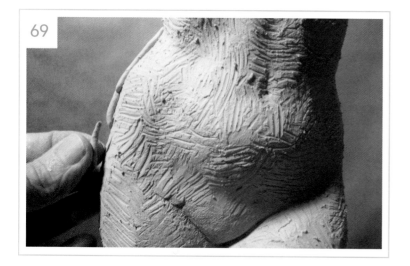

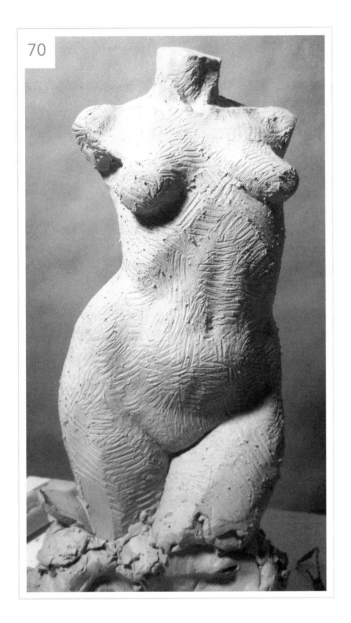

70

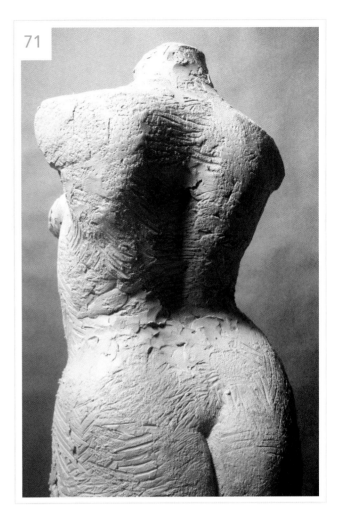

71

70 & 71. This completes stage two. The forms have been modeled, raked, and pulled together to create the rhythmic flow of the surface.

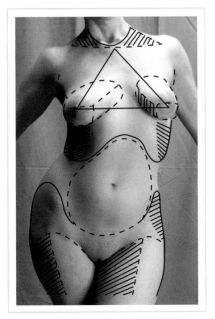

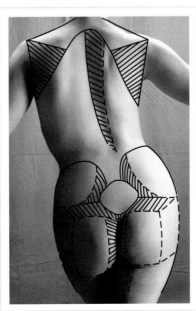

In the front view, the dotted lines mark the top of the four larger planes (two inner and two outer) of the thighs. Note the outward position of the curved rib cage mass and the volume of each breast. In the back view, note the large triangular form created by the shoulder blade on the side of the rib cage, which has three planes (top, side, and front).

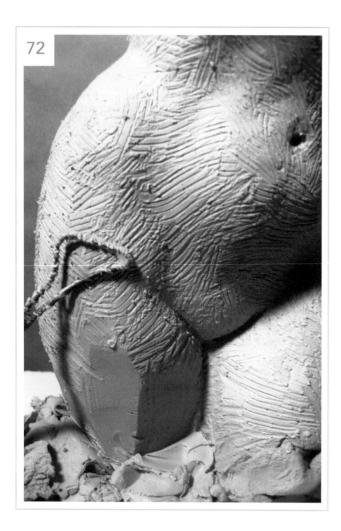

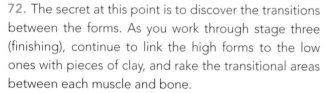

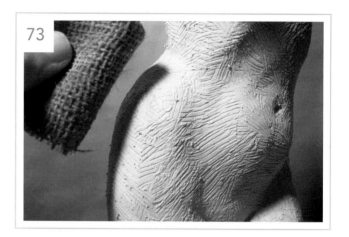

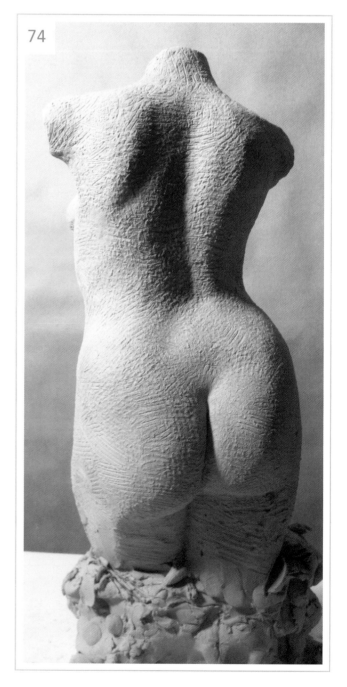

72. The secret at this point is to discover the transitions between the forms. As you work through stage three (finishing), continue to link the high forms to the low ones with pieces of clay, and rake the transitional areas between each muscle and bone.

73. Bunch up a square foot of burlap, and tap the clay with it to blend the tool marks with the weave of the fabric to create a soft, skinlike texture. Dampen the burlap to get more texture. You can also use a flat piece of burlap by pressing it in hard, to reach areas with your thumb.

74. Having the texture cover the entire form (seen here in the back view after completing the burlap technique) unifies the entire piece.

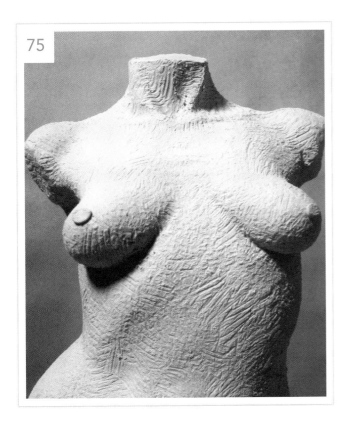

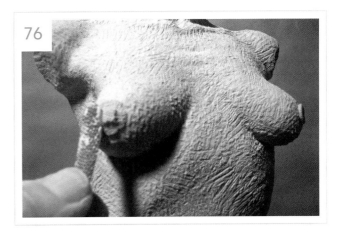

75. Place a disk-shaped piece of clay at the end of the breast, large enough to create both the nipple and the areola.

76. Press the disk against the breast with the riffler and create a small block shape for the nipple. Press and spread the rest of the disk to create the areola. Leave a slightly raised edge around the disk.

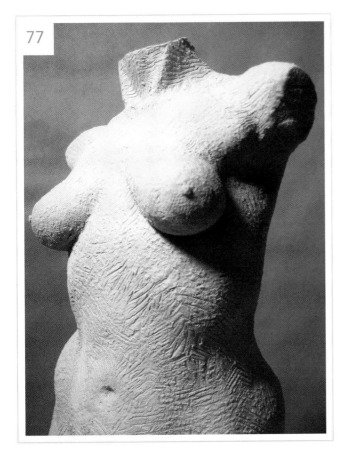

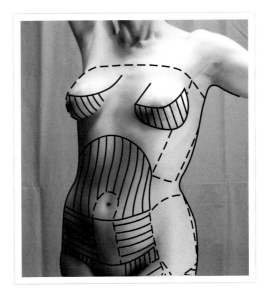

Note that the breasts have planes on the top, side, and front and sit on the top plane of the chest.

77. Just as with the rest of the form, use the burlap-texture technique on the nipples and breasts.

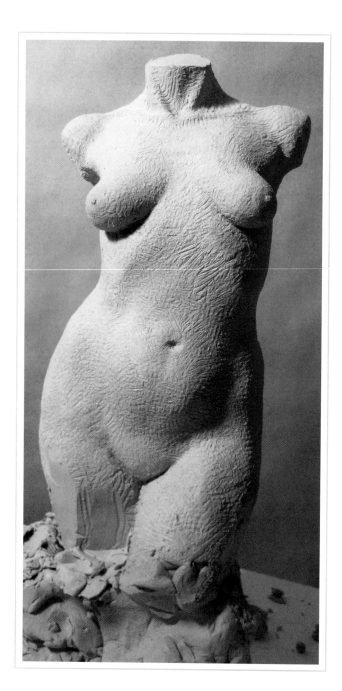

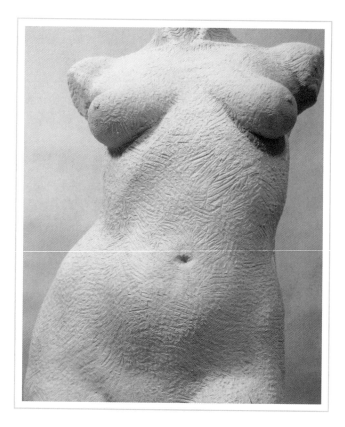

The finished clay sculpture from three different views. I enjoy the sculptural process of translating the figure into simple shapes and then transforming those shapes into a close resemblance of the model in pose. Starting with the large masses and finishing with the smallest forms works every time. In this case, the blending of the forms and development of a fine surface texture gives life to the sculpture.

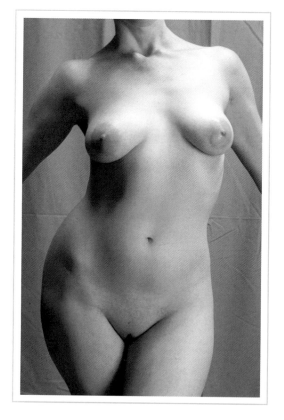

A final look at the pose allows for a comparison of the source and finished work.

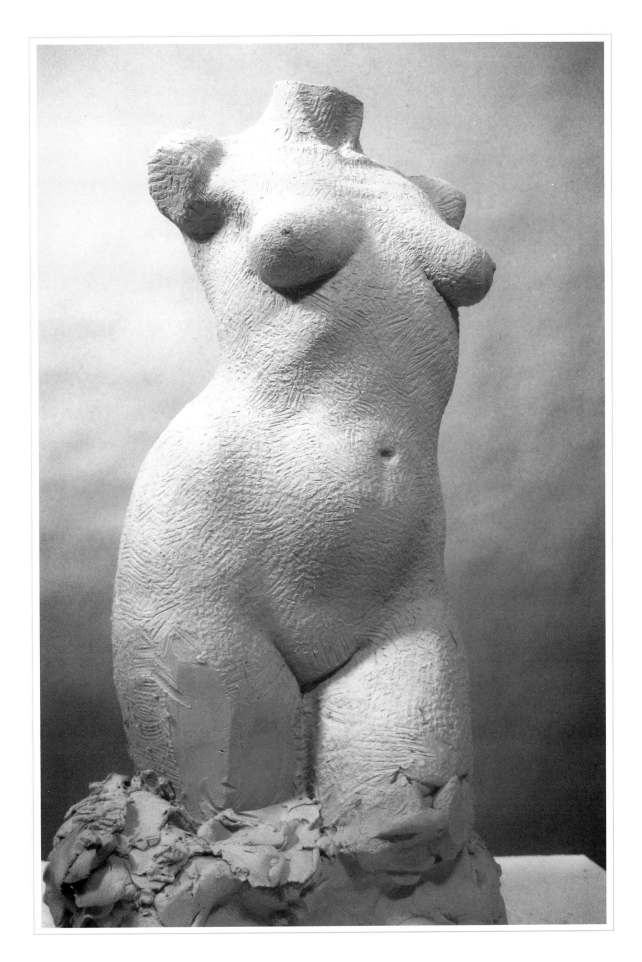

CONSIDERATION OF THE MAJOR PLANES AND DESIGN ELEMENTS OF THE FORM

I've included these diagrams as a tool to help you visualize the sculptural aspects, movement, and design features of the figure in pose. Learning how to see the blocked, simple shapes and flat planes of the figure while looking for the rhythms, patterns, and contours of the forms can be challenging at first. These diagrams represent a few of the infinite ways in which one can map out the inherent curved and angular elements of the figure. They can broaden your vision of the figure by introducing an alternative or complementary vision to bones and muscles.

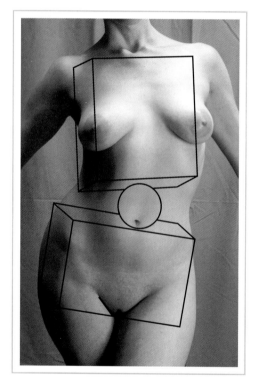

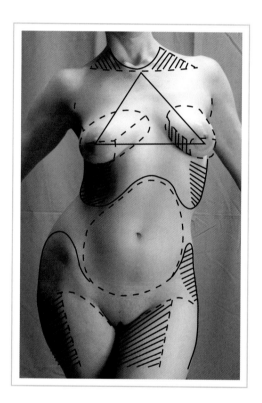

The rectangular pelvis and rib cage blocks are similar in size. The pelvis block is positioned horizontally, arching in the back and leaning up on the left side; as a result, the front plane of the block faces down slightly. The block also is higher on the left side than on the right. The vertical rib cage block leans backward as it travels upward (also contributing to the arch of the back), and as a result, its front plane faces up. The block is lower on the left side than on the right. The core muscle group, the ball, is centrally positioned in between the rib cage and the pelvis, holding them together and enabling the two block masses to bend, lean, and turn.

The solid line in the pelvis area surrounds the contour of the hips and thighs, connecting under the stomach to make a continuous loop. The solid line in the upper torso surrounds the lower form of the rib cage, starting under the breast on the left side, flowing downward toward the hip, curving up in the center of the chest, and flowing down again around to the other side of the rib cage. The dotted line in the center of the body encircles the abdominal muscle group located in between the central curvature of the rib and hip bones. This pear-shaped abdominal form will change as the abdominal muscles stretch to accommodate the many different body movements.

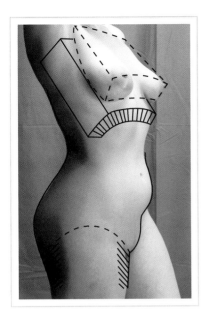

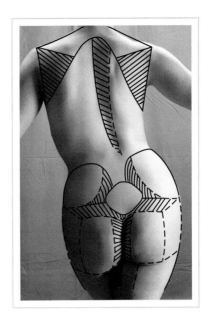

The blocky foundation of the chest and breast has a top plane across the chest, a side plane of the breast, and a bottom plane of the breast from the nipple to the rib cage. This section sits on the curved, barrel-shaped foundation of the rib cage, which has some depth to it, as indicated by the lines on its lower edge. The solid line on the right follows the transitions between the stomach, abdomen, and pubic contours on the front plane of the pelvis. The solid line on the left follows the contours of the back, hip, gluteal muscles, and back of the thigh—and complement the contours of the front forms. The thigh has a cone shape, and the diagonal lines there indicate the front and back planes of the form. A dotted line at the top of the thigh represents the transitional area between the hip and thigh.

The shoulder blades slant forward and sit on the curvature at the top and to the sides of the rib cage. The trapezius muscles arch around the back of the neck, connect to the shoulders, and create a plane from the spine of the scapula (the top edge of the shaded triangles) and top of the shoulder blades to the base of the neck. The narrow shaded plane to the right of the spine indicates the side of the section of the trapezius that travels down the back (from the top of the spine to the bottom of the rib cage) and also the sacrospinalis muscles of the lower back along the side of the spine. Planes on the side of each gluteus medius (at the upper hips areas) roll down to the sacrum (the central oval). The gluteus maximus muscles have planes on all sides, like a box. Narrow vertical planes on the inside surface of these muscles give them dimension.

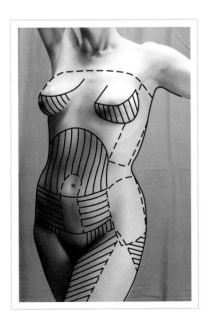

The blocks drawn with dotted lines are the foundation blocks of the rib cage and pelvis in the position of the pose. Individual breast foundation blocks have planes on the top, side, and front. The breast sits on the top plane of the chest. The upper abdominal muscles stretch with the rib cage and drape down and in, off the edge of the ribs to the bottom of the rib cage. Wavy lines show the movement of the stretched abdominals, as lines continue flowing over the umbilicus and belly button, and around and down toward the pubic area. The plane of the inner thigh drops down toward the pubis. The side planes of the lower abdominals help "pop" the front plane of the abs.

4

THE FULL FIGURE

This chapter explores again the step-by-step method of building the foundation using simple, solid rectangular and triangular shapes, only this time in a full-figure reclining pose and in even more depth than the previous chapter. Here, each shape represents the various *larger* masses and sections of the body. The focus will again be on the three Ps (position, proportion, and planes) of these shapes as well as on the BLT (bend, lean, and turn) of the body masses in pose. And, as always, the sculptor must first assess the pose. Learning to observe the model will help you see the existing anatomical shapes and the elusive transitions that link the forms together. The poetry lives *between* the forms. Connecting the hills and valleys with a rhythmic flow of the surface produces a less fragmented and more harmonious sculptural expression.

ASSESSING THE POSE

The classic reclining pose is poetry in motion and has all the elements necessary to inspire great works of art. The form flows from end to end, traveling across many hills and valleys along the way, in a continuous rhythmic motion. It reminds me of a landscape. The design created by the position of the arms at one end and the legs at the other is connected by the length of the body as it stretches in between them, and this connection creates a unified composition.

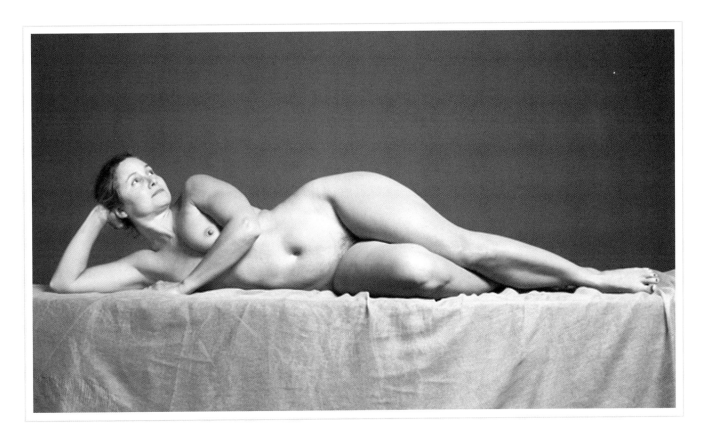

Once the pose is determined, start viewing it from the front at eye level. View it from the center front, kneeling on one knee. This eye-level view is the best for determining the highest point of the pose (here, the hip). Determine the farthest and lowest points of the pose (the elbow on the left and the big toe on the extended foot). Connecting imaginary lines from the high point to the low points of the figure determines that the pose has a long, triangular composition.

Look for more large shapes using this technique to get a feel for the geometric design of the arms and legs. Don't worry about details at this time. The following pages have the pose presented in sequence simulating the way you would walk around and observe a model in class or the studio before beginning to sculpt. Spend some time studying the pose, and refer to the overlays on pages 114–117.

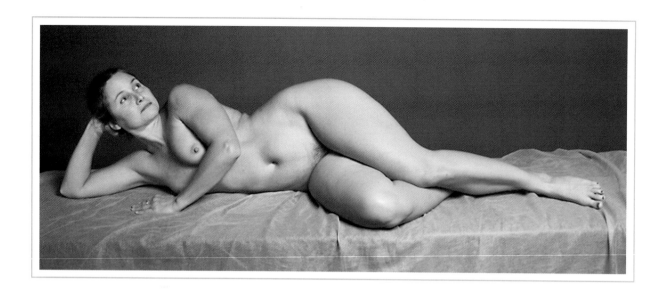

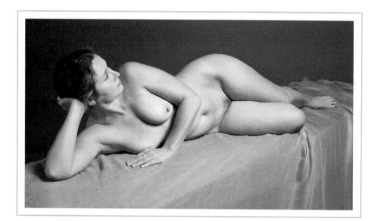 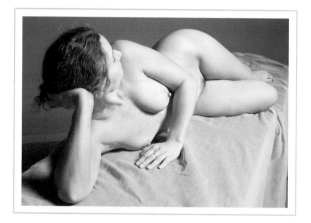

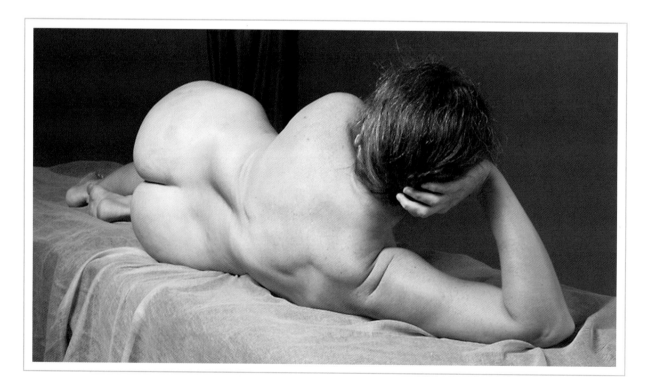

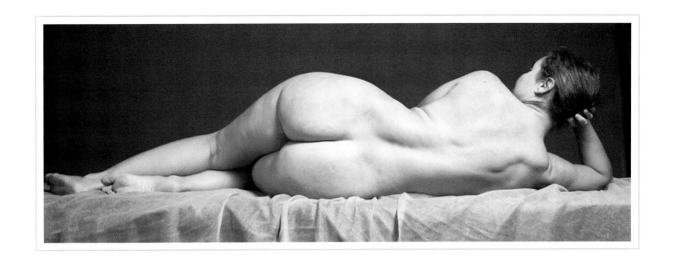

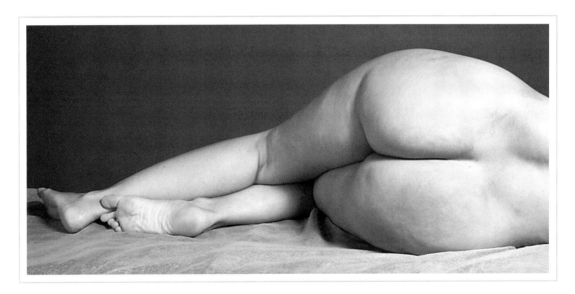

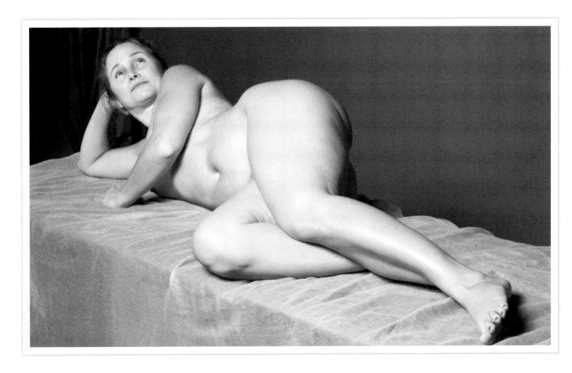

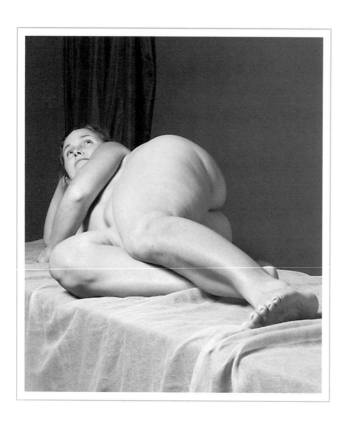
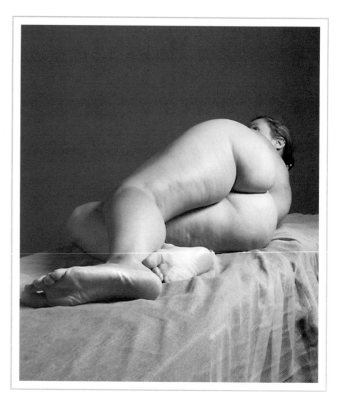
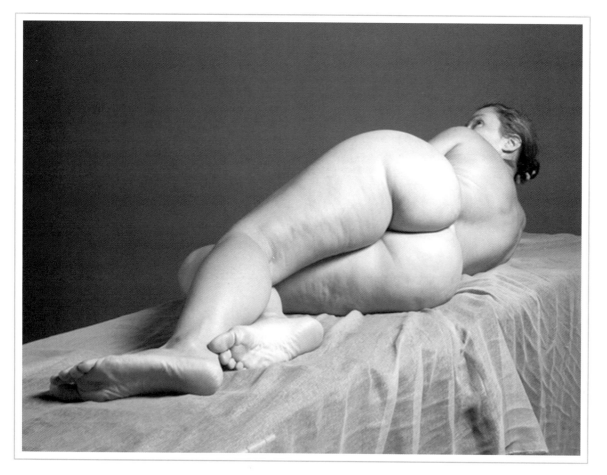

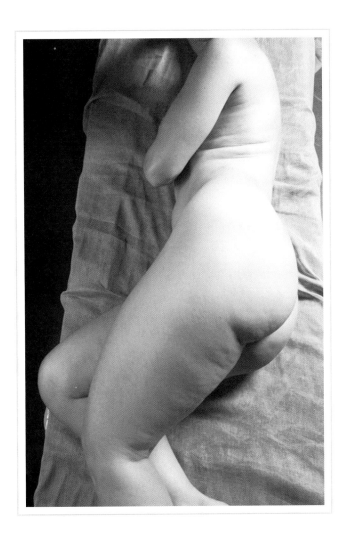

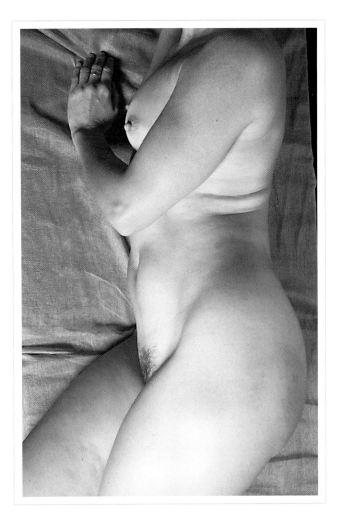

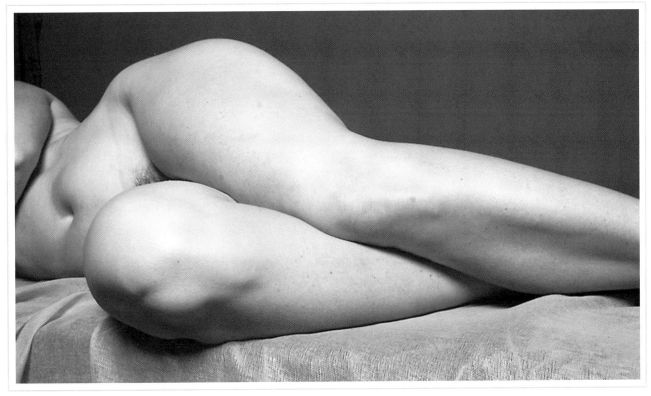

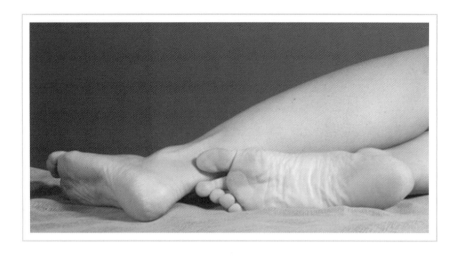

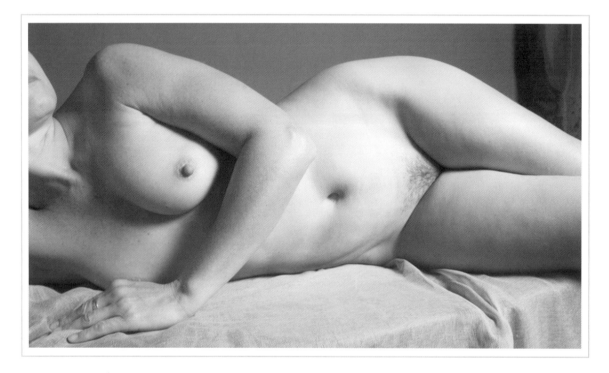

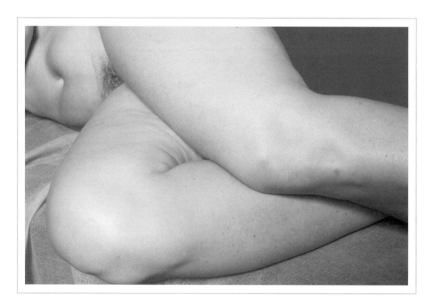

▶ Alternative Visualization

Using simple clay blocks to represent the main masses of the body is a good way to build the foundation of the sculpture and begin to understand the position, proportion, and planes of the figure; however, to see more than the figure itself—and to think outside the *block*—try to visualize the pose as an architectural design. Use a straight stick and hold it across various spots of the body to determine high points, angles, and the direction of forms.

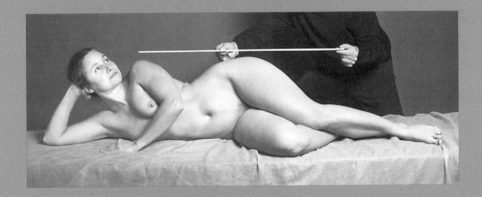

Usually the model is posing on a fairly low model stand or table, so you're looking down at the pose. Lower your viewing position. With this pose, for example, kneel either in front or in back of the model so that you're at eye level with the hip, before making a decision about which point is higher between the great trochanter (at the hip) and the shoulder.

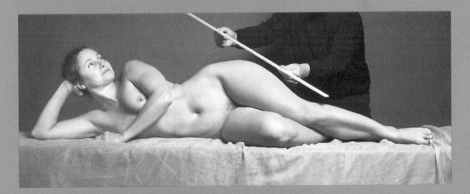

Follow the direction of the top leg from the hip to the knee to determine the angle, or pitch, of the leg.

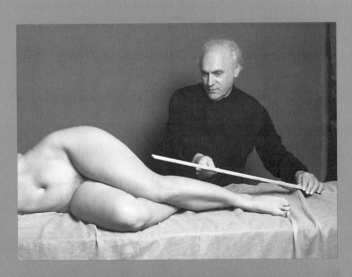

Follow the direction of the leg from the knee to the ankle. Take in many views of the pose from below, above, and at eye level before beginning to sculpt.

THE RECLINING FIGURE

I talked about tools earlier on (see page 18), but just to refresh, use the wire loop tool to rake, model, blend, and evenly grade the surface. Use the wood block to shape, define planes, and create edges on the forms by tapping the clay surfaces. Use the stick tool to add pieces of clay, draw guidelines, and cut planes. Planes give direction to the forms, help shape and position the parts, and provide the surface upon which to model the volumes of the sculpture. The planes also help to project forms from the surface.

To keep the piece evolving as a whole, I don't finish any one section at a time. I prefer to jump from front to back and top to bottom, adding clay here and taking away there. Most of the photographs in this chapter are close-ups. But when you work, you're able to see the entire sculpture. So when working on one small detail, you can immediately see the relationship of that detail to the whole. It's a constant game of checking and re-checking your sculpture from every angle. For example, when working on the shoulder, you may discover that the back of the hip needs more clay; so, jump to that spot next. This is how you can get around your piece and make modifications and check for symmetry as you go, and I speak a little more about this on page 70.

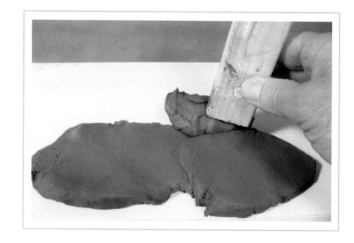

Rather than using an armature, make a clay base, or plinth, ¼ to ½ inch thick on a laminated board. The clay plinth can be any shape and should be large enough to accommodate your sculpture. The plinth helps prevent the clay sculpture from drying out, keeps the clay pieces of the sculpture attached to one another, and can be fired with the sculpture to become part of the final design of your expression in clay. Spray the plinth and sculpture occasionally with a water mist. Wrap your piece with a plastic covering each time you finish working. (See page 41 for more on this.)

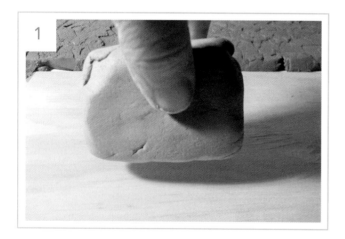

1. To begin, tap a piece of clay on the board (not the plinth) to create a block shape that will represent the pelvis mass.

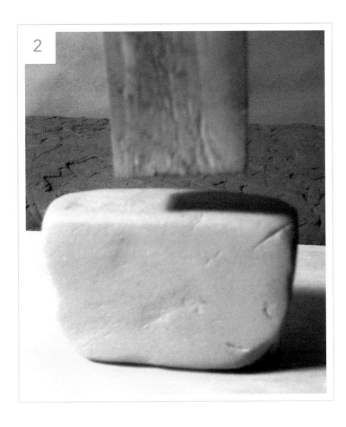

2. Then tap all sides of the clay block with the wood block tool. The sides of the block are the planes, and the edges where the sides meet are the plane breaks.

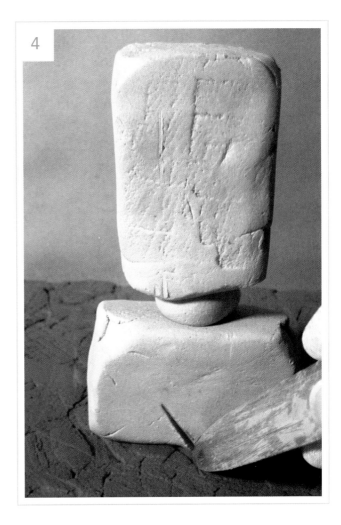

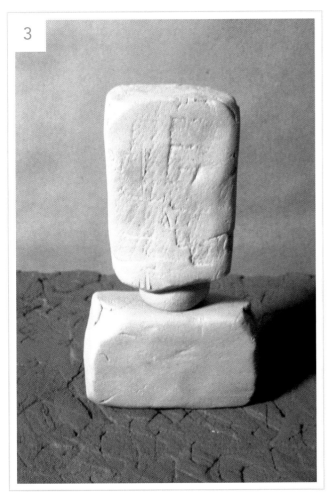

3 & 4. Make a second block for the rib cage mass and a ball of clay for the central core muscles, the abdominals. The rib cage clay block is slightly longer then the pelvis block and is positioned vertically on top of the pelvis section with the clay ball centered in between them. The pelvis is also slightly wider than the rib cage; on women, hips are wider in relation to the rib cage than on men.

When all three elements are assembled, draw a V at the base and center of the pelvis block to indicate the pubic form.

▶ Working Method: Identify and Modify

When sculpting the figure, we never make mistakes; we make *adjustments*. There are only two ways to manage the development of a clay sculpture: add and take away clay. When you notice that your clay arm or leg is too small, simply add some clay. When it's too long, take some clay away. Keep adding and subtracting clay until the desired form is realized. Take a positive approach and enjoy the process of discovery. It's not about getting it right or being wrong. I call it *identify and modify*. It's about gathering visual information from the model in order to identify the differences between your sculpture and the model. Then go ahead and make the modifications by adding and/or taking away some clay.

Every piece of clay that you put on or take away has a purpose and a specific location on your sculpture. This is particularly important when you're starting out and why learning some basic relationships of the planes of the body masses is so essential. Eventually your sculptural expressions will be more spontaneous. All the technical stuff is necessary, but it's the *passion* (the fourth P) that keeps you going. I'll leave you with a quote from Michelangelo that he made at the *end* of his life that says it all: "I've just begun to learn my craft."

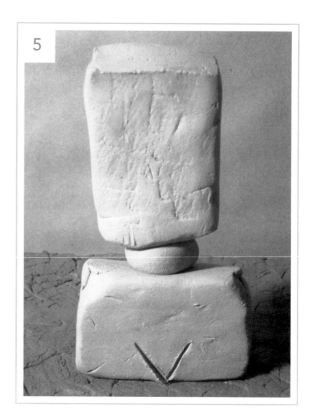

5. Note that the top of the rib cage block and the bottom of the pelvis block are parallel. Cut a forward-sloping plane across the front top edge of the rib cage block at a 45-degree angle. The neck will eventually be positioned on this sloped plane.

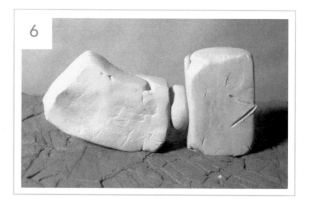

6. Place the blocks down on the plinth so that the sides of them are resting on the plinth. Stretch the top portion of the rib cage block (the shoulder area) so that the lower shoulder is longer to the left than the top one. Note that the top of the rib cage block, from shoulder to shoulder, slopes to the right at a 45-degree angle and is no longer parallel to the base of the pelvis block.

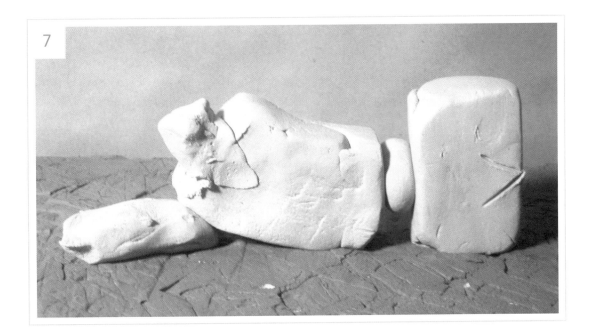

7. Place a cylindrical piece of clay under the lower shoulder for the upper arm. Place a smaller clay cylinder in the center of the sloped plane at the top of the rib cage to start the neck. Note where the pubic V is positioned.

8. Make a small clay rectangular block for the head mass. Add it to the neck, and build the lower arm that supports the head in this pose from the elbow to the head mass by adding pieces of clay that form a solid triangle supporting the head. Then, cut a sloped plane into the base of the pelvis block where you will add the legs. Replace the V on the new plane. The legs will be placed at the V.

9 & 10. Roll out clay cylinders for the thighs, tapering them both on one end to indicate the narrowing of the thighs toward the knees. Attach the bottom thigh first to the sloped plane of the pelvis at the pubic V. Attach the upper thigh next. These cylinders should move in the same direction as the model's legs. For the lower legs, roll out two more clay cylinders that taper to the ankle. Cut the knee-joint end of the lower cylinder on a 45-degree angle and position it behind the end of the bottom upper leg. The legs only bend at the joints.

11. Attach the top lower-leg section, but at a shallower angle to the thigh section than on the bottom leg. The clay legs are *both* angled at the knees. The clay legs should be solid, not too pinched or lumpy, and should not bend or curve between the hip and knee or between the knee and ankle.

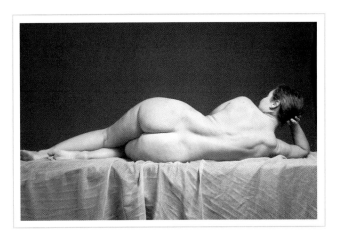

12. At this stage, stop to view the sculpture from the back to check the three Ps and the BLT (bend, lean, and turn). You're now ready to add the next level of planes and to sculpt the forms of the figure.

The foundation, arranged with simple shapes, should have the movement and feel of the model.

13 & 14. Cut two planes on the upper leg. One plane slopes toward the front of the leg, the other toward the back. The *plane break* is where the planes meet at the high point of the thigh. (See last diagram on page 116.) Also cut a plane on the top surface of the leg from the hip to the knee. Note how much lower the knee is in relation to the hip.

15. Add a rectangular piece of clay that's narrow on one end for the near foot. The front of the foot is wider and curves from the tip of the big toe back to the tip of the little toe. Attach the narrow end of the foot piece (the heel) to the end of the clay leg.

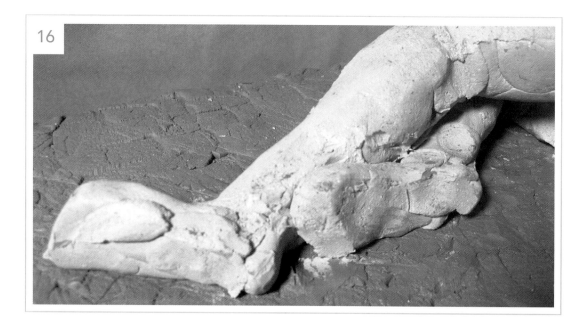

16. To create the heel of the more extended foot, add a strip of clay on the back end of that leg and foot; then add a second piece of clay to the bottom of the foot. Blend both pieces of clay and create a triangular shape for the heel.

Build up the mass of the other foot, which is partially pressing against the more extended leg. Make both feet the same size.

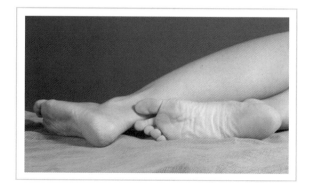

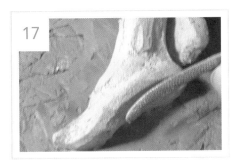

17. Shape the soles of the feet by pressing against the bottom of the foot forms with the riffler; then press the sides of the feet with the riffler. The pressing technique will help create planes and plane breaks where needed.

18. Add clay for the planes on the top of the foot (produced by the underlying tarsus and metatarsus high bone structures). Draw a guideline around the end of the high bones, and cut a narrow plane, a step, between the high and low bones. Cut a plane starting at the metatarsal of the big toe, and gradually trim clay as you cut to the outside of the foot. Make one plane for the four toes and another on top of the big toe for the toenail.

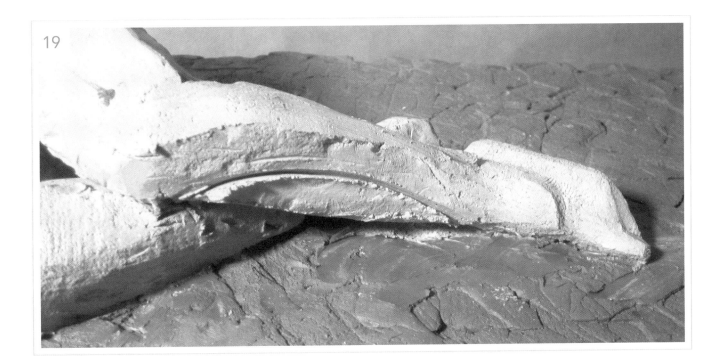

19. The lower leg is a wedge shape. Draw a guideline, slightly curved, from the knee to the ankle in the center of the top lower leg to indicate the tibia (shin bone). Then place the cutting side of the stick tool on the guideline, and slice away clay on a 45-degree angle, starting at the knee and ending at the ankle. The plane angles in toward the back of the leg and will become the side of the gastrocnemius (the calf muscle located in the back of the leg). Use the last image on page 65 for reference.

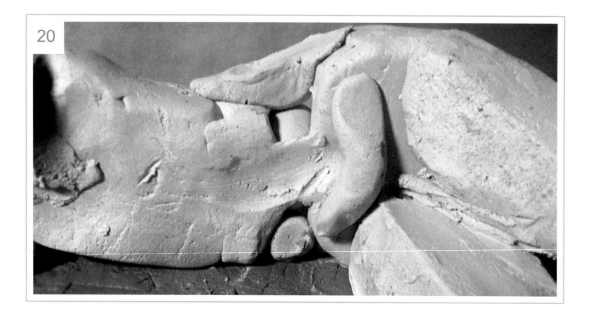

20. Link the rib cage to the pelvis block by adding a triangular piece of clay on the top side planes of the blocks just above the central clay ball and between the rib cage and pelvis. Also add a piece of clay underneath the center ball to link the opposite side of the hip and rib cage. Add a strip of clay to build up the lower abdominals.

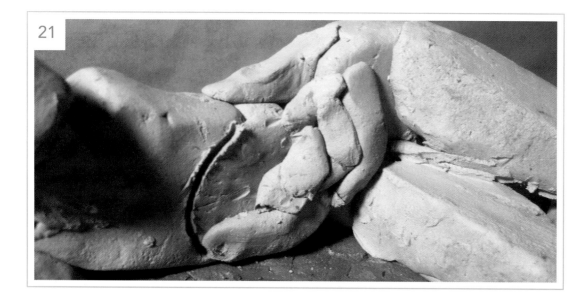

21. In this pose, gravity pulls the abdominal muscles to the surface on which the model rests, while the side of the lower side of the rib cage is stretching them toward the shoulder. To indicate this, make the stomach mass drape downward to the plinth and also stretch toward the lower shoulder. The fullness of the stomach is at the lower hip. Continue to build volume on the lower side of the stomach mass from the abdomen to the rib cage. Note that I've also incised a curved line in the torso to indicate the bottom of the rib cage.

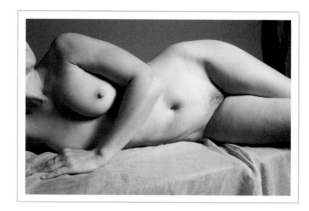

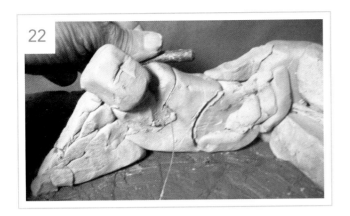

22 & 23. At this point, I decide to make and adjustment to lengthen the rib cage block. (See box on page 70.) Using a wire, I perform some painless surgery, cutting the rib cage from side to side across the middle of the chest and sliding the top portion of the cut rib cage about ½ inch from the rest of the rib cage to make it longer.

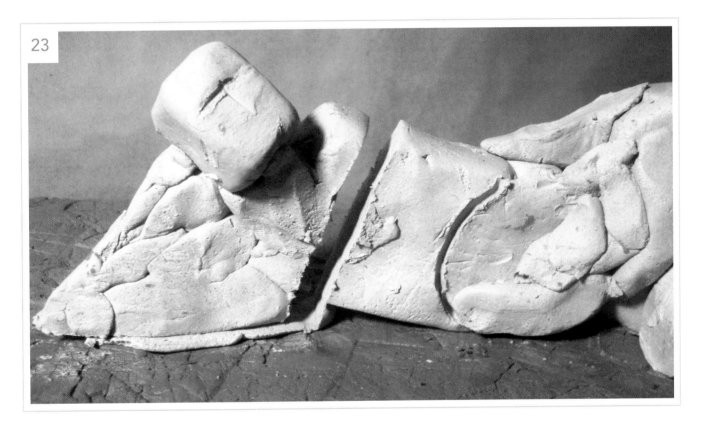

24. Now I just have to put clay between the two pieces, blend, and continue to sculpt.

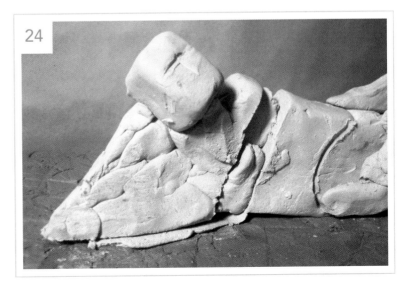

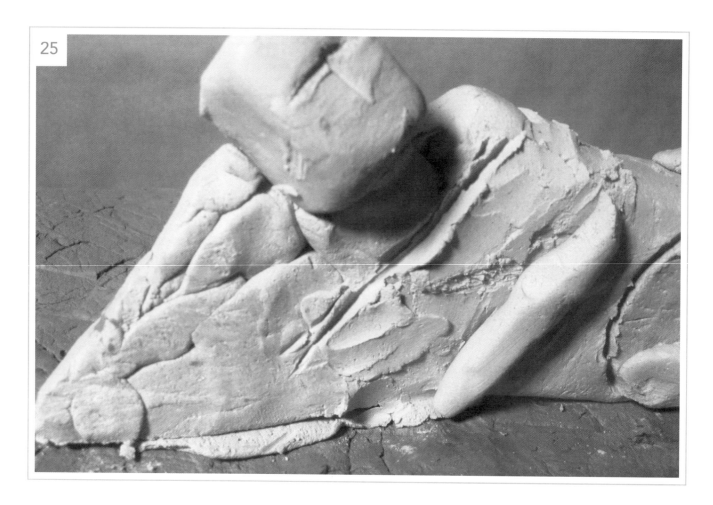

25. Draw a guideline parallel to the shoulders for the clavicle bones (collar bones). Put a strip of clay where the nipples would be for the baseline of the breasts. The baseline is parallel to the collar bones.

26. Begin to build the chest and breast mass with more strips of clay between the baseline of the breasts and the clavicles.

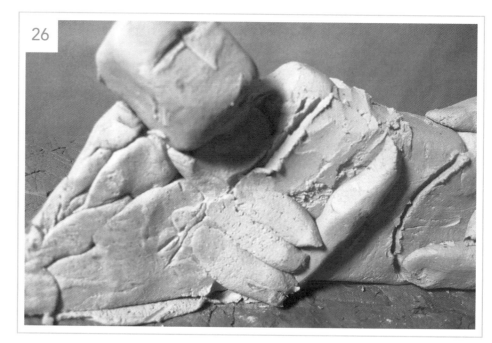

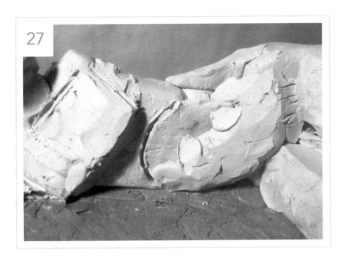

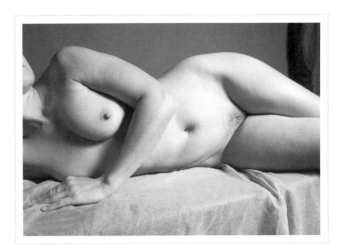

27. Complete the triangular box of the chest and breast foundation. Note the narrow plane underneath the stomach adjacent to the plane of the top thigh. This plane will project the stomach form from the pelvis block.

28. Develop the top side plane of the abdominal muscles and the plane break where the side and front planes of those muscles meet.

29. Then develop a narrow, curved plane under the rib cage and on the side of the hip down toward the stomach. Note the planes at the bottom, side, and top of the breast and chest foundation as well as the planes at the bottom and front of the stomach.

30. Start building the arm that crosses the body with clay cylinders. As with the legs, the arms only bend at the joints.

31. Cut or tap a plane on the side of the arm. Build up the shoulder with small pieces of clay.

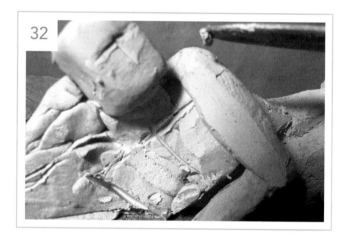

32. Add small pieces of clay to build and shape the elbow area. Cut or tap a plane in front and back as well as inside and outside of the wrist. The lower half of the forearm is rectangular in shape with broad, parallel flat planes in front and back and narrow planes on the sides. The top half of the forearm is wider and rounder than the lower half.

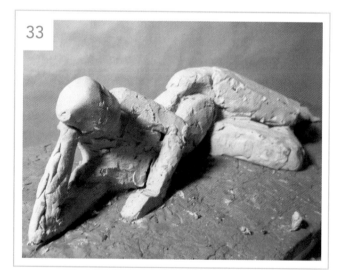

The top plane of the hand is the same plane as the top of the wrist; however; the plane changes direction when the hand bends at the wrist.

33. Build a blocky mitten shape for the hand that rests on the plinth.

▶ Planes of the Arms & Legs

At this point, you should be tapping planes on the thighs and arms. It is also helpful to consider the relationships of the planes to one another: The upper arm is like a rectangle, having four planes, or sides. When the arm hangs at the side of the body in a standing pose, the outside plane surface is the broad one and is parallel to the opposite side of the arm, which rests against the rib cage. The front plane, the biceps muscle, is narrower than the side planes and is parallel to, and paired with, the triceps muscle in the back of the arm.

Find the position of the biceps, and make a plane. In this pose the biceps of the upper arm is rolled to the side and is facing the side plane of the breast. The broader outside surface of the arm is facing the same direction as the top plane of the chest and breast. Tap this side of the arm with the wood block to create the side plane of the arm. The deltoid (shoulder muscle) will be developed at the top of this plane of the arm.

The upper legs are also a blocky, rectangular shape that has four basic planes. The top, front narrow plane, between the top of the knee and the hip joint, is made up of the rectus femoris, vastus externus, and vastus internus muscles. The narrow parallel plane in back of leg is made up of the semitendinosus,

biceps femoris, and semimembranosus and is parallel to the front plane. The outside plane is broader than the front plane. The inside plane is not parallel to the outside plane, due to a group of muscles that begins to stretch from the mid-thigh toward the ischium (the center of the pelvis). Find the direction of the knee of the top leg in this pose. That will tell you where the top narrow plane of the thigh is facing. In this case, the outside plane of the thigh is facing up to the ceiling, and the narrower front plane of the thigh is facing to the left side toward the arm.

The lower leg has a wedge shape from the front view. The center of this wedge is the tibia (shin bone). One flat plane the length of the bone flares out to the inside, and the other plane flares out to the outside of the bone. The tibia becomes the plane break and is what I'm defining in the image above.

34. Place the riffler between the arm and shoulder, and push the tool into the clay to establish the pectoral muscle at the side of the chest and the side of the deltoid (shoulder muscle).

35. Rake the planes of the wrist with the wire loop tool.

36. Draw a line around the neck, and make a narrow, curved plane between the neck and the front of the chest for the clavicle (collar bones).

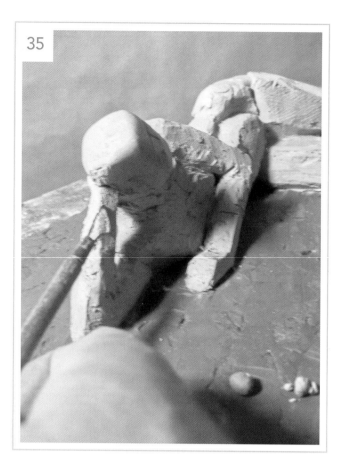

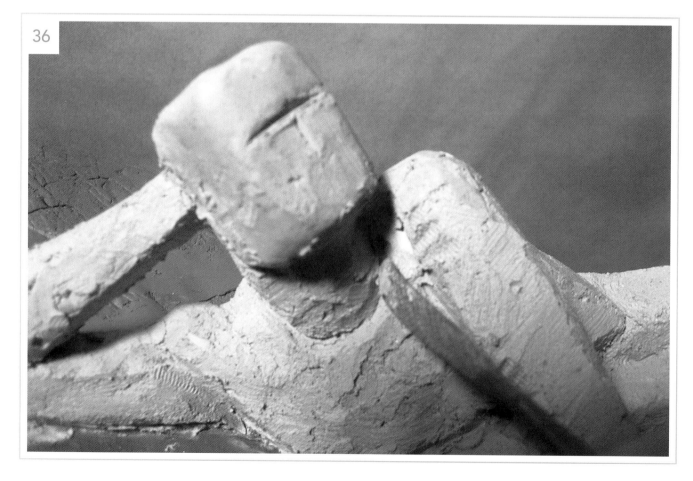

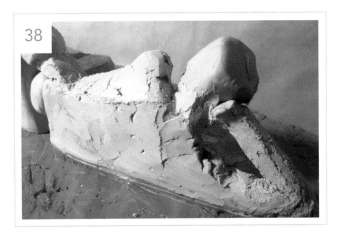

37. Moving to the back of the figure, cut a flat plane on top of the shoulder blade, and add more pieces of clay to increase volume of the upper back.

38. Cut a plane from the shoulder blade to the hip, alongside of the rib cage, and tap the back with the wood block.

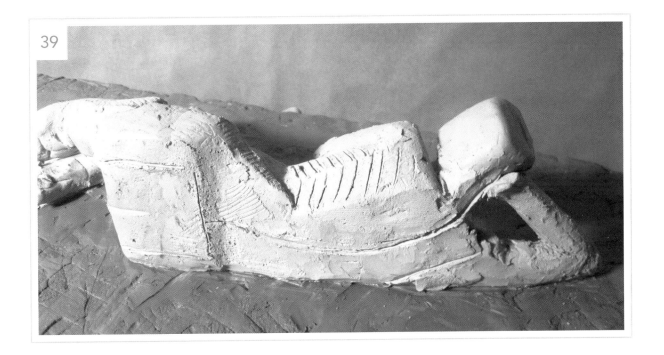

39. Draw a line to indicate the direction of the spine. Start at the center of the head block and continue through the center of the rib cage and pelvis block. Bump out the block shape of the gluteus maximus muscles by making a narrow plane across the top of those muscles. Add a section of clay as a link from the top of the hip to the bottom of the rib cage for the lower back and side muscles (the sacrospinalis and external oblique muscle). The side of the rib cage is curved from back to front. Cut a plane on the front and back on the side of the rib cage, and create a plane break where they meet.

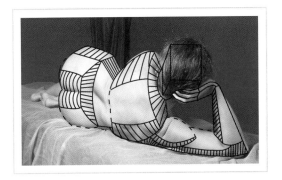

The planes of the rib cage are marked with angled lines that meet at the plane break.

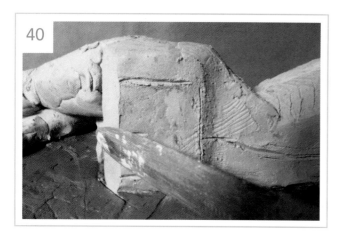

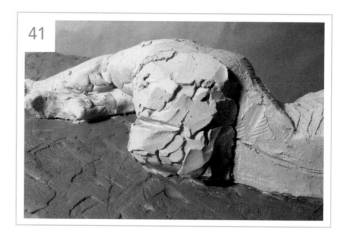

40. Cut a plane, angled 45 degrees, at the bottom of the pelvis block to the base of the gluteal muscles.

41. Continue to build more volume to the gluteal mass. Draw a horizontal line in the center of the buttocks mass. (See the second image on page 63.)

42. Increase the volume of the bottom of the gluteal mass by adding pieces of clay to the bottom of the pelvis block. (See the second image on page 64.)

43. Place the wire loop tool ¼ inch into the spinal area in the lower back. Rake and shape the two sides of the lower back section.

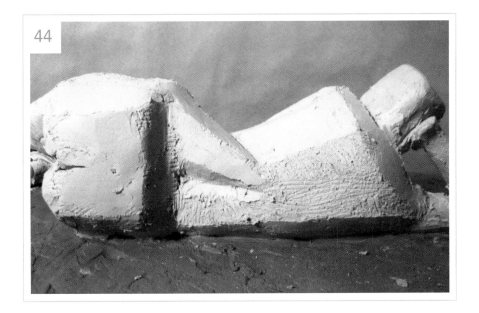

44. The basic geometric foundation and arrangement of the body shapes and masses for the pose are just about set at this point. Stop to briefly assess the structural relationships for accuracy before progressing. Refer to the third diagram on page 115 and the first image on page 63 as you do this.

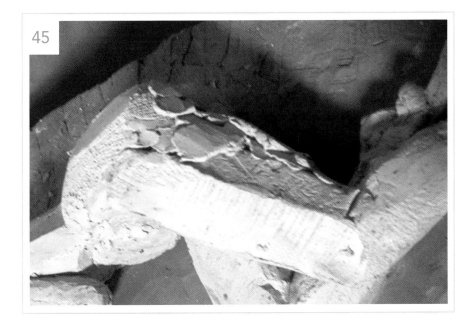

45. Add clay pellets to the back and top planes of the thigh to create the shape, volume, and contour of the leg mass.

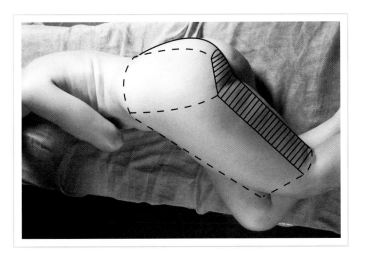

The rear plane of the leg is indicated by the lined area.

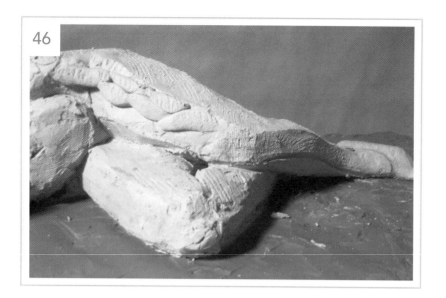

46

46, 47 & 48. The calf muscle on the lower leg is too big and is preventing the top leg and knee from resting against the lower leg in the same position as the model's leg. I make the adjustment by cutting and removing some clay from the calf muscle and am then able to press the knee down and get it lower to the plinth. I tap it in place with a wood block. Now the leg from the hip to the knee has the same pitch as the model's leg.

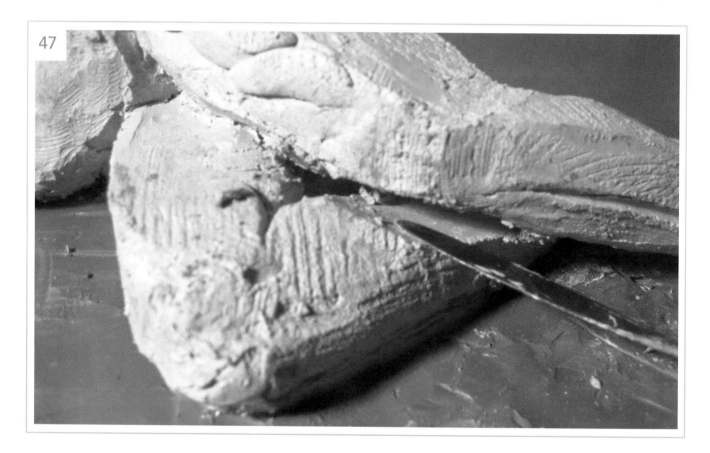

47

48

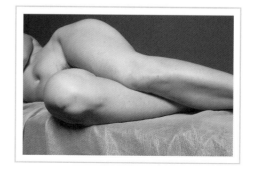

49 & 50. Shape and form the planes in the bottom of the right foot. The ball of the big toe projects from the instep and has planes on all sides. The bottom plane of the heel blends with the rest of the sole going toward the toes. The instep is arched and has planes in it. The four toes curve and are a section separate from the big toe.

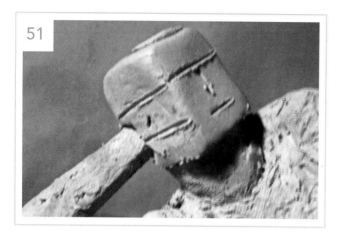

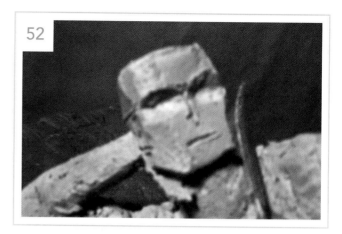

51 & 52. Once the body is in place, define the facial features. The head mass is rectangular, not square. The height and depth are the same, while the width is narrower—approximately 65 percent of the height and depth. Draw guidelines to indicate the position of the features. On the front, make a line for the brow one-third of the way down from, and parallel to, the top. Indicate the nose by a vertical line in the center third, starting below the brow. A short horizontal line in the middle of the remaining third represents the mouth. Then remove

clay to create eye sockets, cheek planes from the cheekbones to the chin on both sides.

53. On both sides of the head, cut a plane on the side of the forehead from the top corner of the eye socket to the top of the forehead. And model the area where the jawline meets the neck.

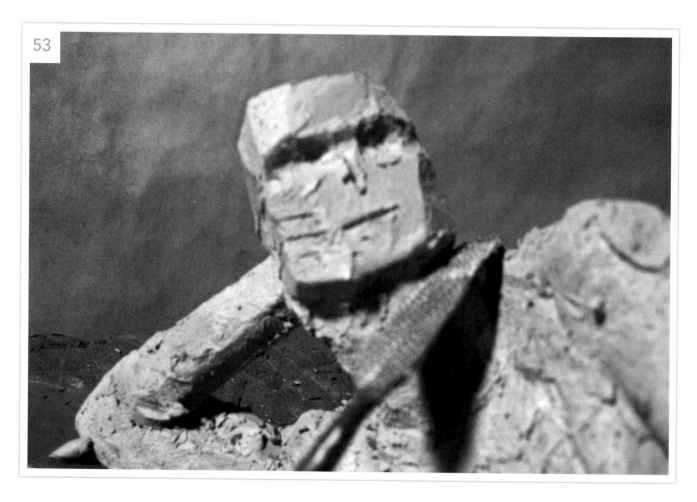

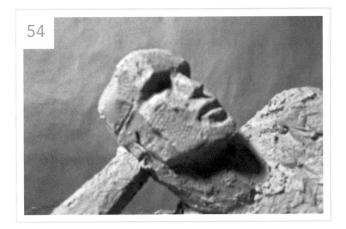

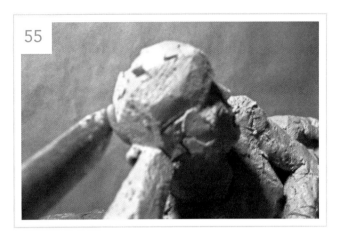

54. Place an X in the center of the side plane of the head for the ear hole. Draw a line down and forward from the ear hole to the chin for the jawline. Build a triangular block shape for the foundation of the nose. Build the foundation for the lips and chin.

55. Add small pellets of clay with the stick tool to build the rounded shape of the back of the head.

56. The top plane of the trapezius muscles in the back continues up the back of the neck to the base of skull. Make sure the flat plane of the back of the neck, between the ears, is parallel to the front face plane. It moves in the same direction as the face plane when the head turns from side to side as indicated by the curving lines drawn here on the trapezius and neck. Hold the head block with your fingers and twist it to the left to mimic the gesture of the pose.

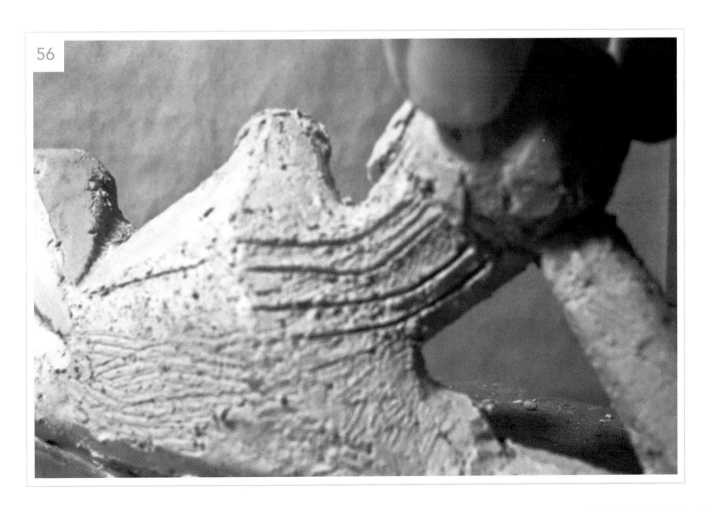

57. Add small strips of clay for the eyelids, and press them into place with the riffler.

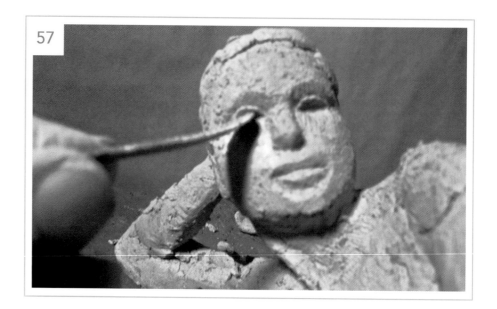

58. Add clay to build up more shoulder mass in the top shoulder.

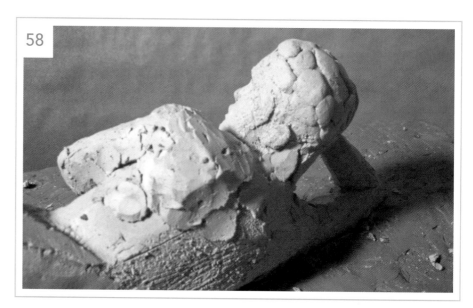

59. Draw guidelines for the lower shoulder muscle (deltoid) at the top of the arm, and indicate some of the muscles on the side of the shoulder blade (teres major, teres minor, and infraspinatus).

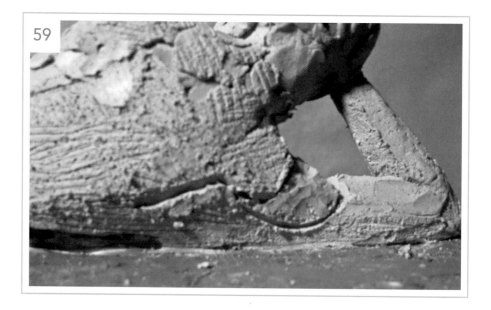

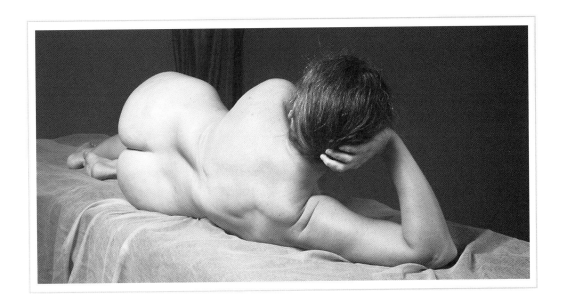

60. Make planes for each muscle fold in the lower shoulder area.

61. Model the form of the deltoid, which is located at the top outside plane of the arm. It's wide at the top and tapers to a point as it moves down the upper arm.

62. As you continue working, always check the relationships of the form. As I work on the shoulder in the back, I notice that the hip needs some more height. So, I add clay with the stick tool to the top plane of the hip.

Also note the narrow plane running along the bottom side surface of the rib cage and pelvis where the body touches the plinth. This plane helps lift the form and create a contour on this side of the rib cage. (See the last image on page 62 for reference.)

63. Add clay to the head of the femur (great trochanter) where the femur bone attaches to the hip. (See the last image on page 65 for reference.)

64. Check the arm length with the caliper. Compare both upper arms and adjust where needed. Do the same for the lower arms.

Note the foundation plane structure of the upper and lower arms, wrists, deltoids, pectoral muscles, and breasts. The ear is shaped like a wedge of an orange. A clay cylinder for the sternocleidomastoideus muscle is attached to the neck from the clavicle to the skull behind the ear.

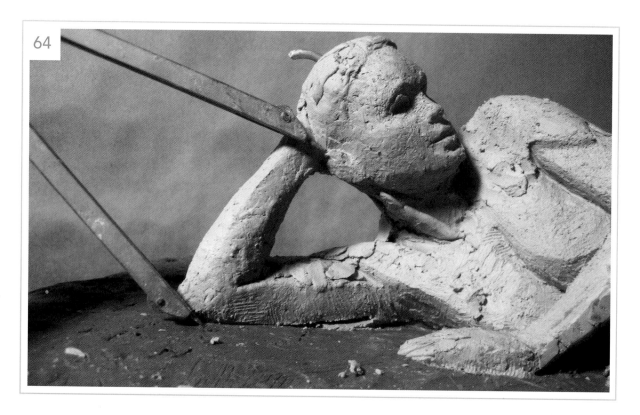

65. Continue to build the shelflike plane on the top of the gluteal form just above the sacrum. This plane will project the gluteal muscles from the surface of the lower back. Add clay to build the volume of the lower back muscles (sacrospinalis and gluteus medius), which sit above the gluteus maximus around the ilium (the outside crest of the hips).

66. The dark shadow on the plane above the gluteal muscles shows the depth of the curve of the lower back.

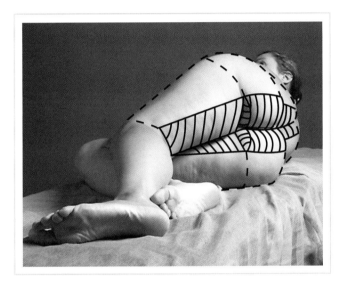

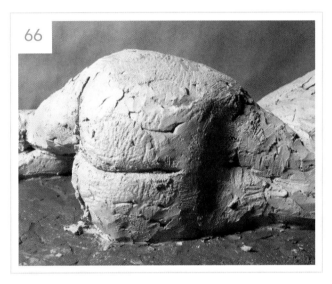

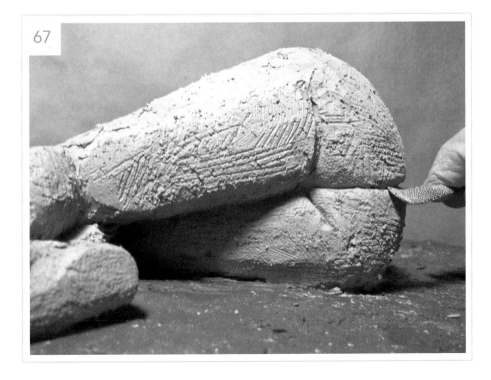

67. Press the riffler into the seam between the two gluteal muscles, and press around the edge of the form to create a narrow plane and a little separation between the muscles.

68. Using the wire loop tool, create some depth and a plane on the inside surface of the hip. Start at the top of the hip, and drag the tool down to the top of the stomach mass.

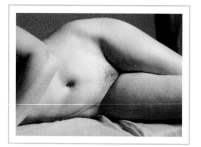

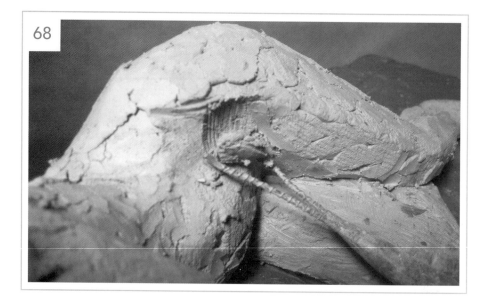

69. Continue to move the tool over the stomach to create a flow from one form to the next. The deep area below the hip and above the stomach is the transition between these two distinct forms. Note the pitch of the top leg and the planes of both legs. Also note that the knee of the bottom leg is a block shape that is smaller than the upper leg mass and projects from the end of the upper leg. (See the second image on page 62 for reference.)

70. Make a block shape for the kneecap (patella). Draw a V from the sides of the kneecap to the head of the shin bone (tibia), and wedge the clay back on each side of the V to define the lower portion of the knee. (See the last image on page 65 for reference.)

71. Square off and project the kneecap by pressing the clay on each side of the knee with the riffler.

72 & 73. Place the wire tool on the inside plane of the lower leg ¼ inch from the edge of the shin bone. Rake a trench the length of the bone to create the transition between the side of the calf muscle and the bone. (See the last image on page 65 for reference.)

74

74. On the top leg, add clay to the front plane of the leg above the knee to create the volume, shape, and contour of the thigh. (See the last image on page 66 for reference.)

75. Add pellets of clay with the wood stick to the top and side planes of the thigh of the bottom leg to create the shape, volume, and contour of the thigh. Note the definition of the hip and great trochanter. This definition and shape are achieved when you tap, rake, and blend the clay that's added or removed from the sculpture. (See the last image on page 65 for reference.)

75

76. Add pellets of clay with the wood stick and begin to fill out the volume of the hip and shoulder area. Add clay to the lower, narrow plane of the rib cage and pelvis, where the body meets the plinth, to create the roundness of the bottom side of the rib cage.

76

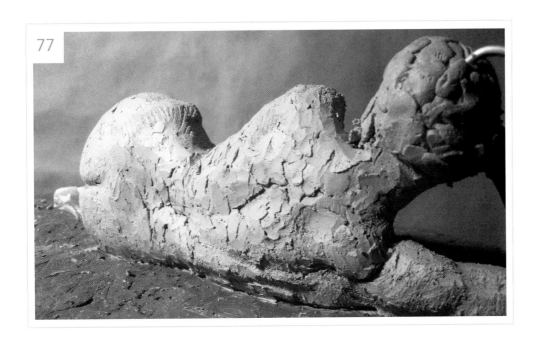

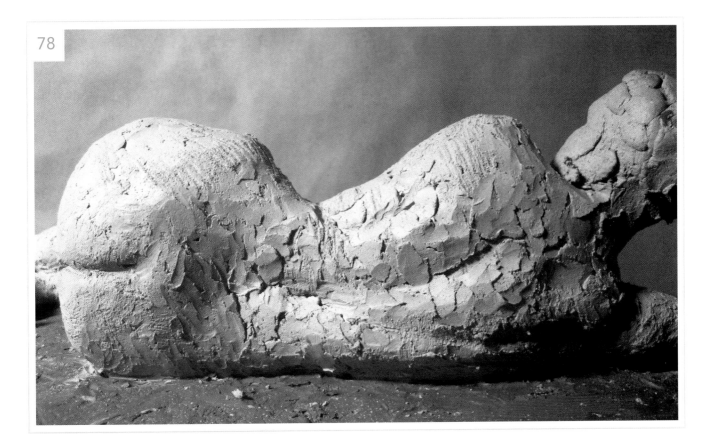

77 & 78. Build the volumes of the deltoid and trapezius at the top of the shoulder. Build up the center of the back on each side of the spine. At this point, the main shapes and forms of the back have been developed. Do some more tapping, raking, and blending before beginning the next stage: finishing. (See the first image on page 63 for reference.)

79. Begin the finishing stage by softening the edges of the large planes of the bottom leg as you shape the leg with wire tool.

80 & 81. Create the seam behind the knee between the thigh and calf muscles on the bottom leg. Put the edge of the riffler in the seam and roll the tool up, pressing against the clay. Then, roll down to curve the top of the calf muscle and create a slight separation of the two forms behind the knee.

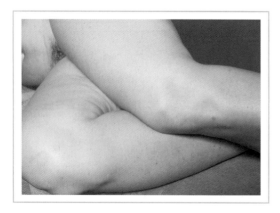

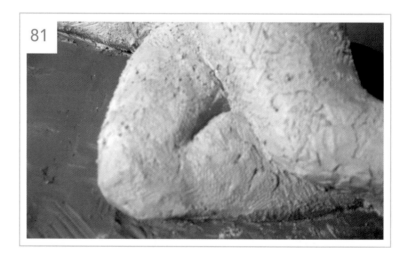

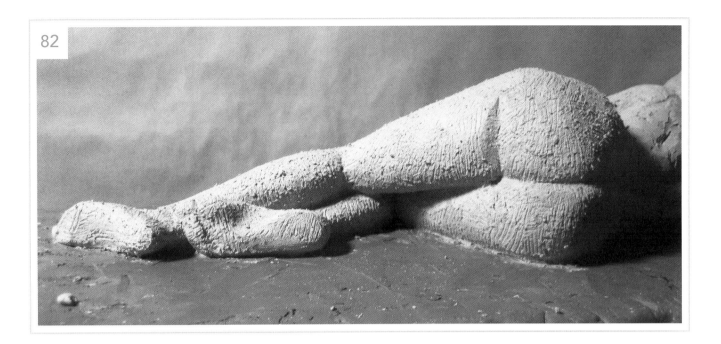

82. Using the wire loop tool, begin to rake the surface of the gluteal masses. Start at the seam and create a slight plane on the side of the muscle that's touching the seam. Shape the rest of the form. The muscles abut below the seam; consequently, there is space between the buttock cheeks as they roll inward at the seam The narrow plane on each buttock cheek, at the seam, gives dimension to the form. Note the shape of the contour, around the gluteal muscles, starting at the high point of the hip.

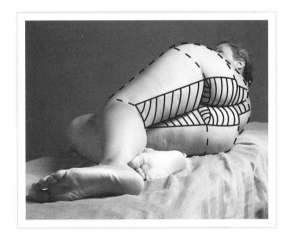

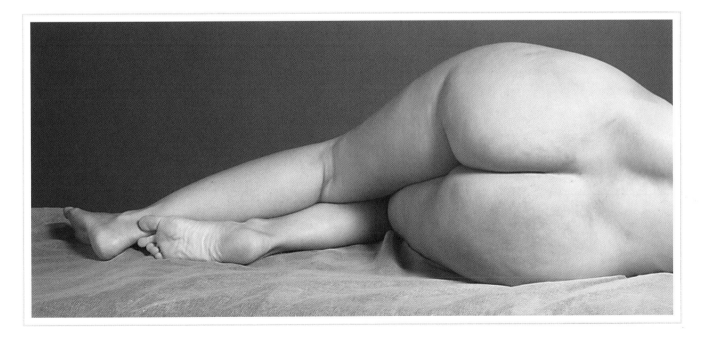

83 & 84. Add clay to build volume in the muscles of the lower back on each side of the spine. Use guidelines that you sketch into place. Muscles stretch and bunch together depending on the movement or action of the body. Instead of trying to define a particular muscle, outline a muscle group. The muscles create patterns and designs on the body that are best seen in shadows on the form. The shadows are in the transition areas, or low points, of the body and help "pop the forms." Draw the guidelines to match the patterns of the high forms and low transitions. The line on your sculpture should represent the low points and follow the shadows on the model. Then, when you add clay within the guidelines, the transitions will already be in place. Note the varied depth and curve of the spinal column from neck to sacrum.

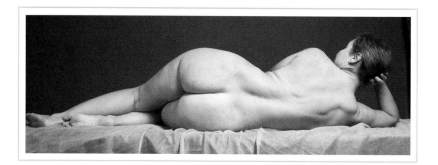

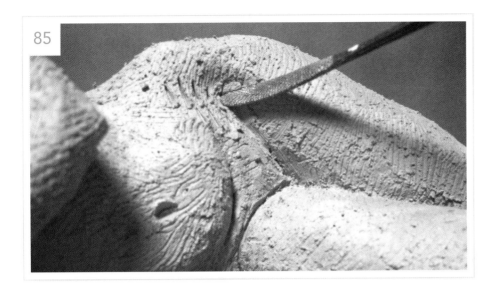

85. Add small pieces of clay onto the narrow plane of the inner thigh, starting at the hip, to make it a bit fleshier.

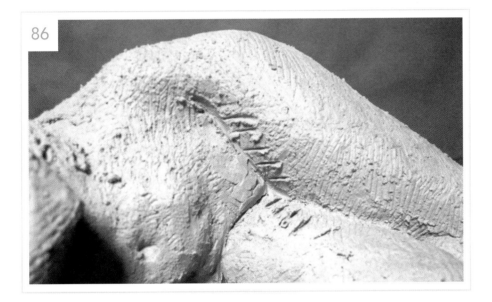

86. Continue adding clay down to the bottom leg and on the inner thigh, near the pubis. In the photo here, this area is indicated with incised lines on the clay.

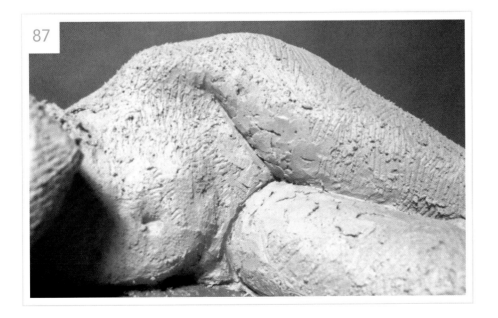

87. These small clay pieces are just enough to give the desired fullness to the thigh. Tap the area with the wood block, and then rake and blend with the wire tool. (See the second image on page 66 for reference.)

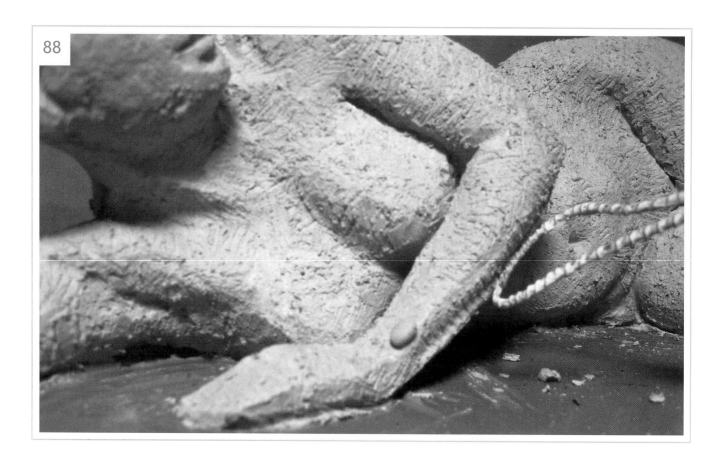

88

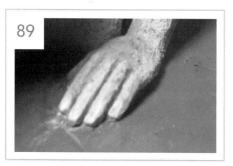

89

88 & 89. Place the edge of the wire loop in the side of forearm, and dig a narrow channel from the elbow to the wrist to create a transition between the bone and muscles of the forearm. Put a ball of clay, for the wrist bone, at the outside edge of the top plane of the wrist.

Develop the fingers and shape the hand with the riffler by pressing against the clay in between the fingers. Shape them one at a time.

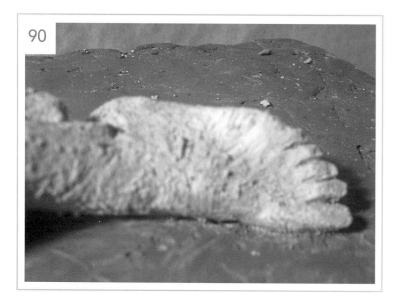

90

90. Shape each toe using the pressing motion of the riffler. Rake across the foot to soften the planes; then blend the clay of the leg to the foot.

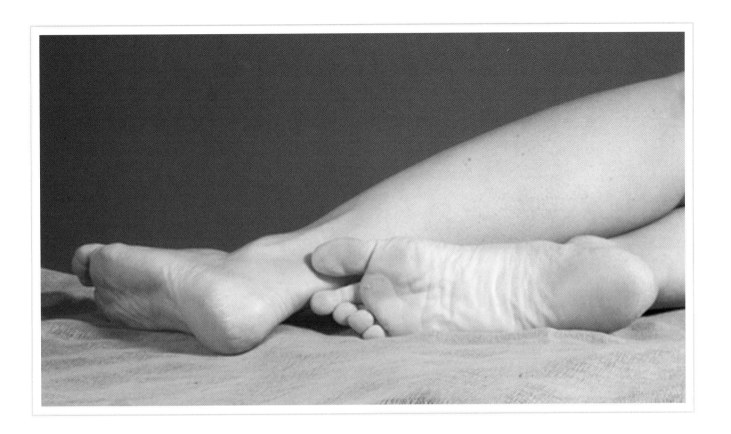

91 & 92. Rake the bottom planes of the foot and shape it with the wire tool. Shape the pads of the toes and the spaces between the toes with the embossing and stylus tool.

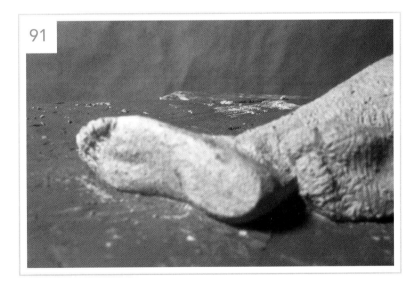

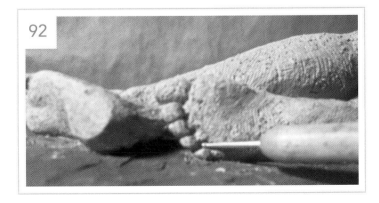

93. Build mass up in the hand that supports the head and then in the individual fingers behind the head. The top broad plane of the hand attaches to the top broad plane of the wrist.

You can also see from this angle that the muscles of the back and shoulder are beginning to pop. Add clay to the muscles and define them by going deeper with the wire tool around each one. (See the last image on page 62 for reference.)

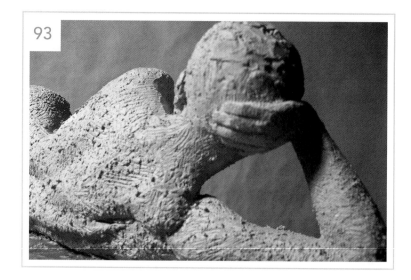

94. The skin rolls together and touches below the surface. It is never flat across a fold. Create the slight fold in the deltoid by cutting a line in clay. Then, place the edge of the riffler into the cut and roll the tool from side to side. The riffler will create a slight bevel on each side of the cut.

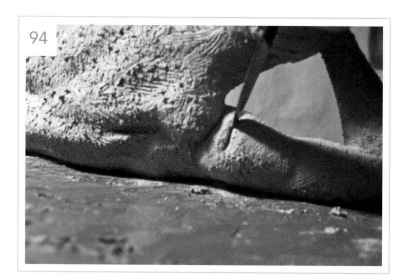

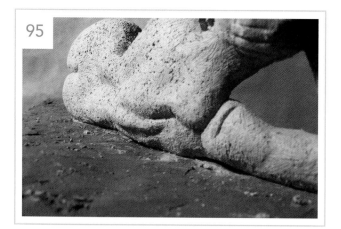

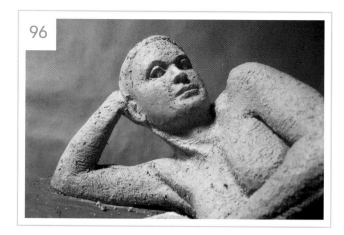

95 & 96. The surface, muscles, and body shape are becoming more refined. Model the arm, breast, and sternocleidomastoideus muscle with the rake tool. Finish modeling the facial features. Place a small piece of clay in each eye socket just below the eyelid for the eyeball. The clay eyeball should not protrude beyond the lid.

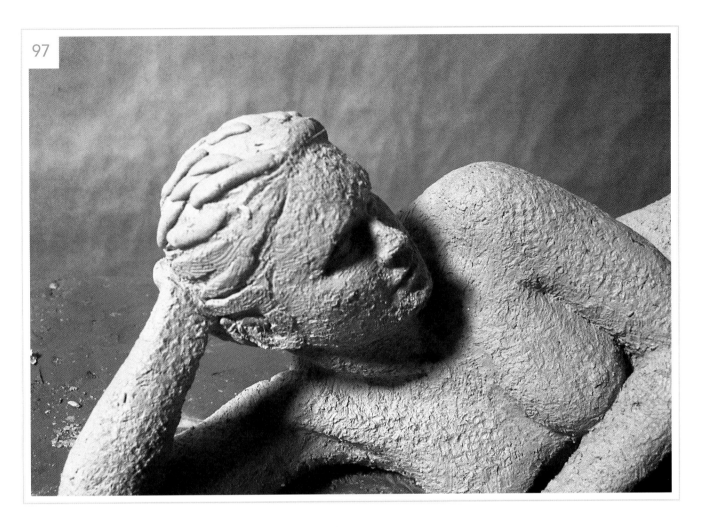

97. Model the hair mass with the stick and wood block. It's not necessary to model every strand of hair. Build groupings of hair mass with clay cylinders. Attach them, one at a time, to the head at the hairline in the front and stretch them to the back of the head. Make planes on the sides and top of each hair group to give the hair sculptural integrity, or form. The clay hair mass should take on the same design or pattern as the model's hair.

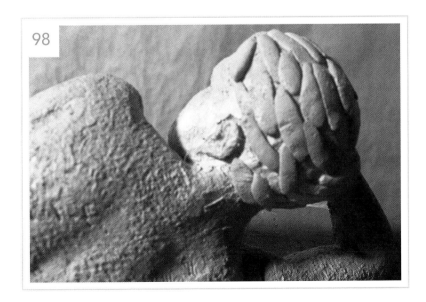

98. Model the back of the head and hair mass as well as the front.

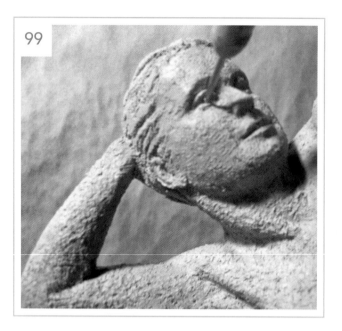

99. Finish modeling the face. Make eyeballs using embossing and stylus tool. Gently press the ball tip of the tool into the center of the eyeball to make a round depression for the iris. Don't make a tiny pupil hole; this will give the appearance of beady eyes. You can add a small strip of clay for the lower lid or just model it with the clay that's already there.

100. Begin to refine the entire surface of the sculpture with a subtle texture. Bunch up a wad of burlap in your hand, spray it with water, and tap it over the surface of the sculpture. The open-weave pattern of the burlap blends with the rake tool marks to create a rich surface texture. The final surface can range from smooth to rough. Texture is like a signature: It adds distinction. Create one that works best for you.

101. For the last detail, work on the folds of the rib cage, just below the arm, with the riffler, re-creating any needed dimension that the texturing process may have flattened out.

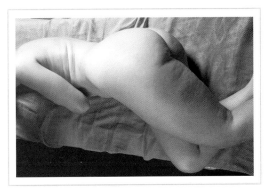

At this point, the piece is now finished, and you can take a moment to observe the relationships of the form. Looking down at the model from slightly varying angles gives a different perspective of the shapes and curve of her body. Note the shape of the hip, top thigh, buttocks, folds, back, and stomach.

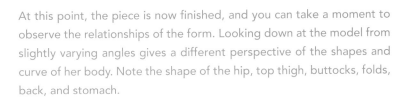

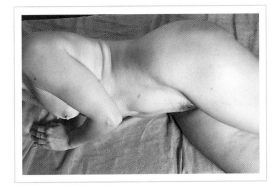

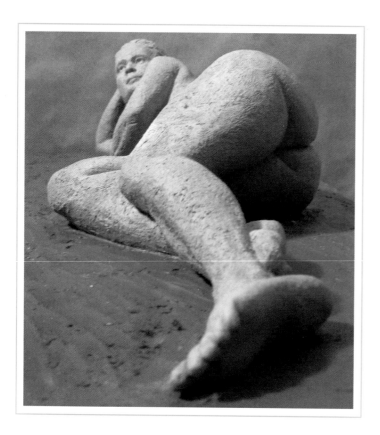

Viewing the finished sculpture from different angles will give you an opportunity to reflect on the stages of development and enjoy the results of your work. Look for harmony, rhythm, balance, and volume in your form from every point of view. There is always room for adjustments.

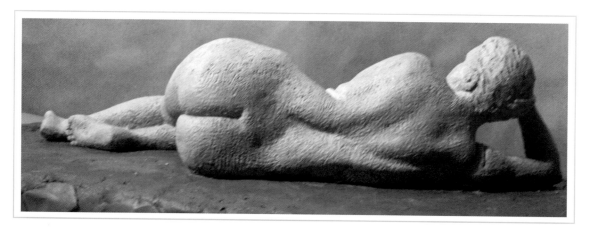

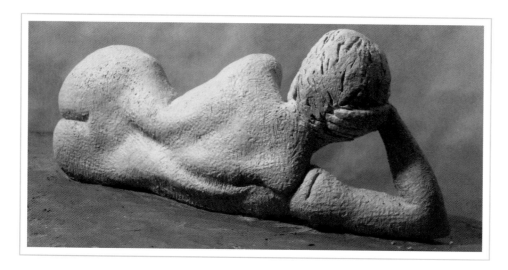

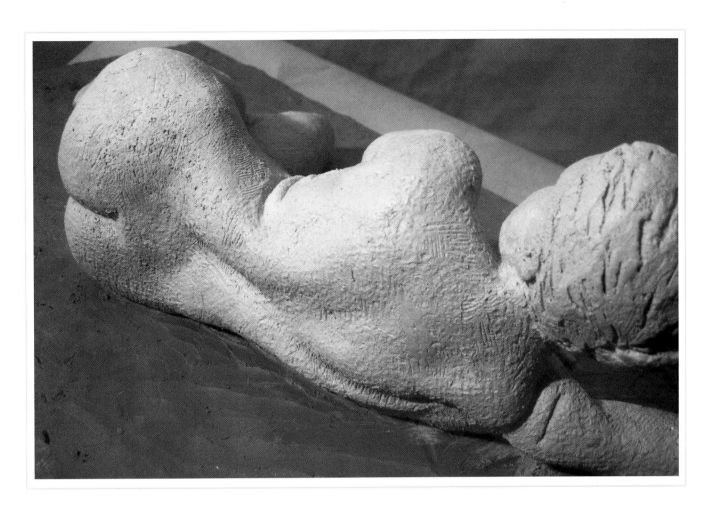

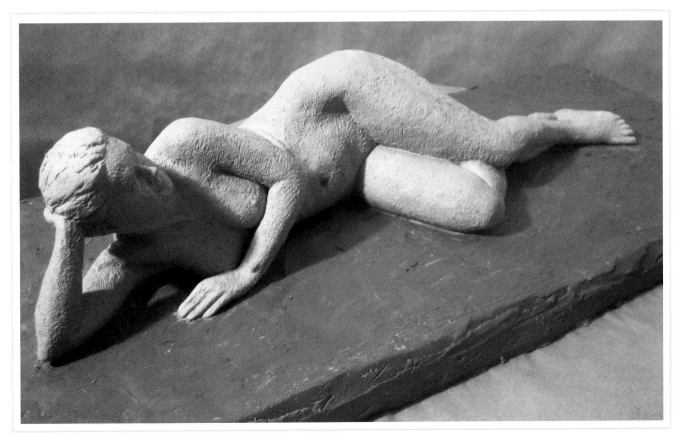

Looking at isolated areas or close-ups of the sculpture after viewing the entire piece from many viewpoints helps you to see the rhythm and balance of the smaller sections and how they relate to the whole.

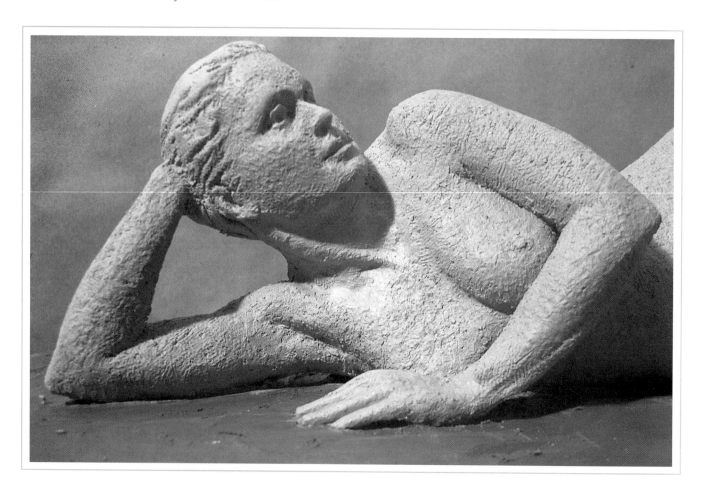

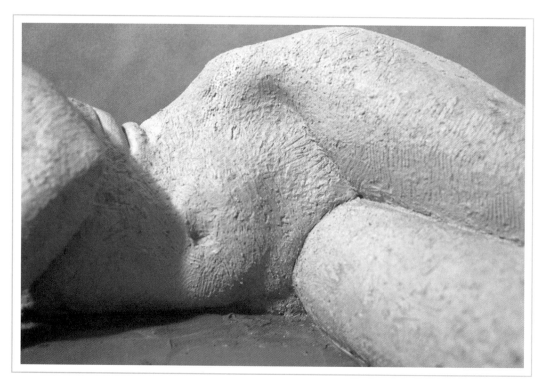

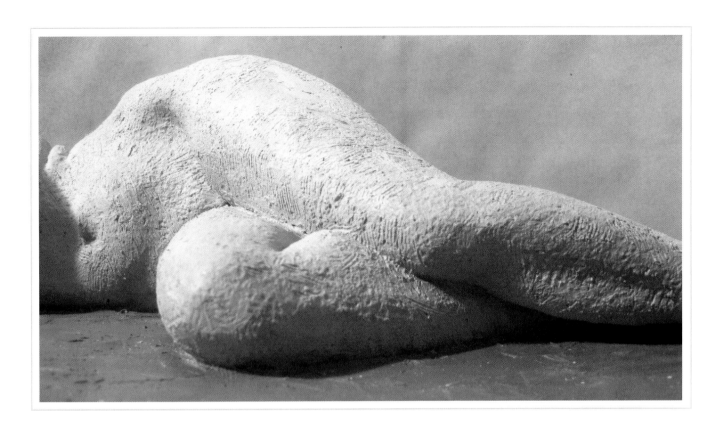

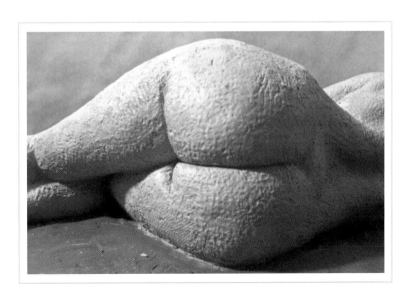

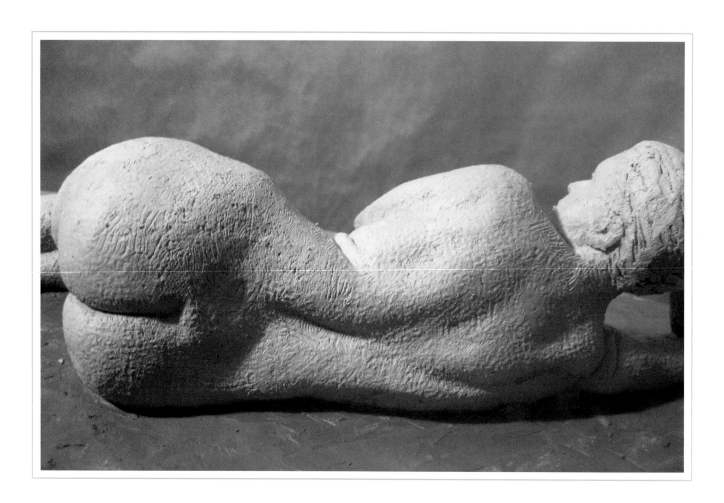

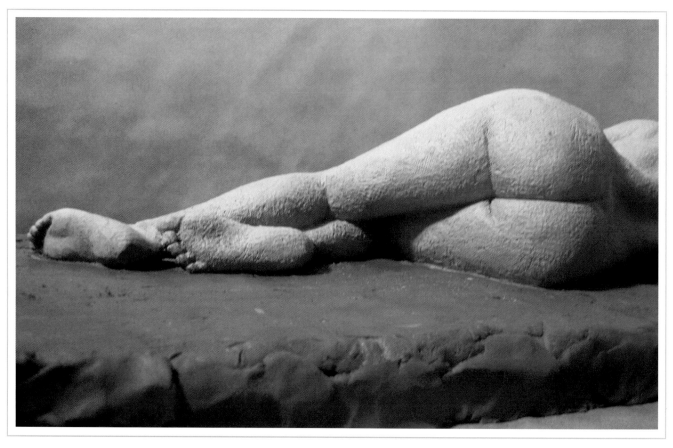

THE SCULPTING PROCESS

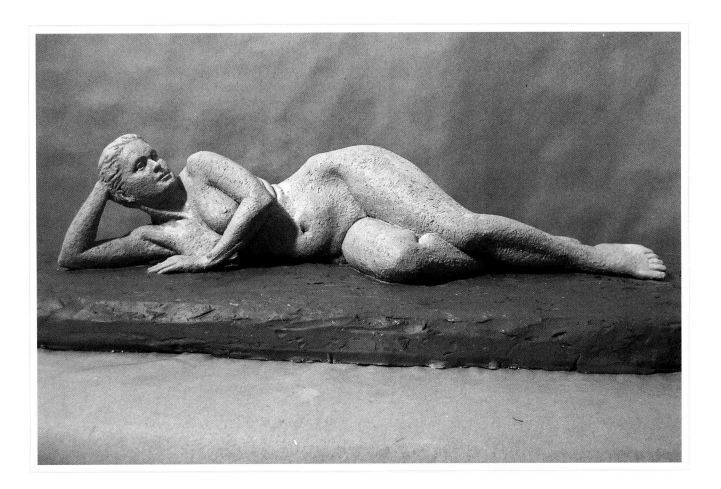

What is a figure sculpture? It is basically a three-dimensional interpretation of a model in pose. The clay representation should capture the gesture/mood and form of the pose and be an expression of what the pose means to you. Your sculptures should begin to take on a more professional look. You can achieve this by paying attention to the surface treatment and texture techniques explored in this chapter. With practice, you will be able to create sculptures very quickly by skipping and combining some of the steps along the way. For example, you can leave out the clay ball for the center core muscles when you begin and use one block of clay to represent the rib cage, pelvis, and core. This single block of clay would be the size of the two blocks and ball. Twist the clay block into position and go from there.

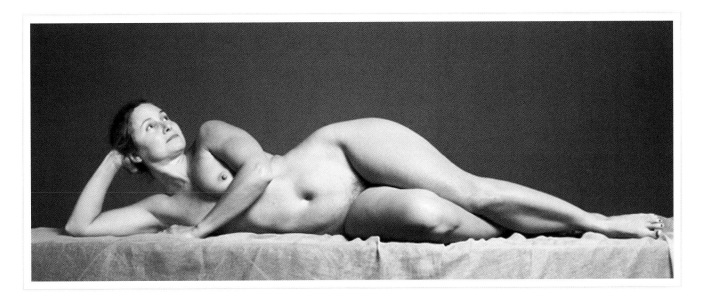

CONSIDERATION OF THE MAJOR PLANES AND DESIGN ELEMENTS OF THE FORM

The reclining figure has many more design elements than the torso, simply because the arms and legs are now part of the expression. In particular, there are many more triangles created by the body parts and, therefore, more open spaces between some of these parts (for example, the triangular space created by the arm holding the head). I have as much fun discovering the design, planes, and patterns of the figure when drawing these lined diagrams as I do when I sculpt the figure. I recommend you try this exercise and come up with your own patterns and designs. Use straight and curved connecting lines, and start anyplace on the figure. You'll be fascinated by the infinite amount of angles and how relative the parts are to one another and the whole. For a real eye-opener, trace these diagrams, without the underlying figures, to see some of the simple design elements of the pose.

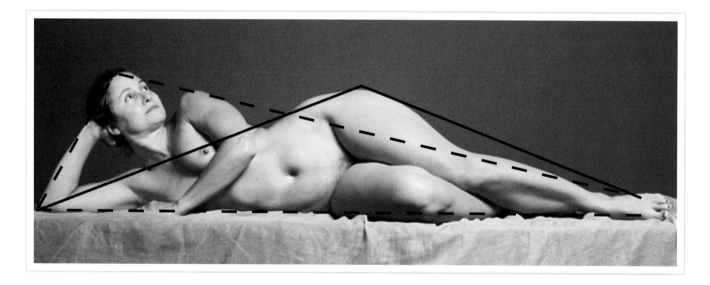

The lines here connect the high points to both the lowest and farthest points from them in the pose. The result is the formation of two triangles, one from the head to the elbow and the foot and the other from the great trochanter to the elbow and the foot (the solid line). It's fascinating to see how the parts of the body line up and fit into geometric patterns. Note that the dotted line from the head to the foot inter- sects the shoulder and knee. The solid line from the great trochanter to the lowest elbow intersects the lower shoulder, the nipple of the breast, the higher arm and the ilium (the crest of the hip). Use vertical, horizontal, and diagonal lines in this way, like a grid, to find the spatial relationships of the parts. This information will help when you start positioning the clay masses representing these parts.

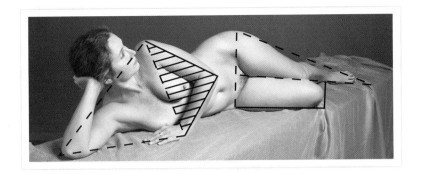

The position of the arms and hands creates the upper body design. The legs are the lower body design. The midsection of the body links these two design elements to make one dramatic design statement.

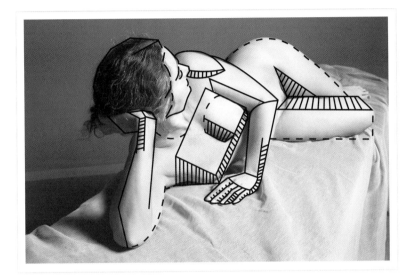

Combining curved and straight lines creates contrast and interest. From this view, you can see how the bottom leg projects from the front plane of the pelvis. The arms, head, and chest create an open box shape, and the smaller planes of the various parts are outlined.

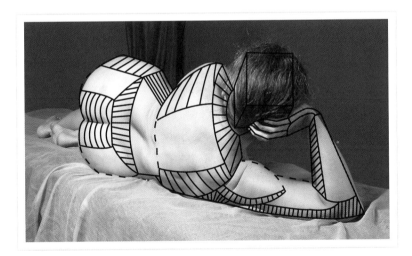

The smaller planes of the back are drawn to show the dimensional aspects of the trapezius and the curvature of the sides of the rib cage. Lines show the top and side planes of the gluteus maximus muscles, hips, shoulder, and arm.

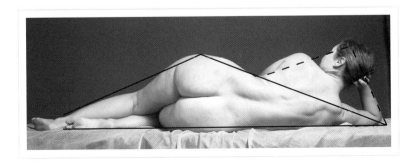

Just as with the front view, you can see that the body design can be distilled down to two main triangles. The solid lines show both the height at the hip and the length of the pose. The dotted lines show the triangular composition of the head, arm, and back.

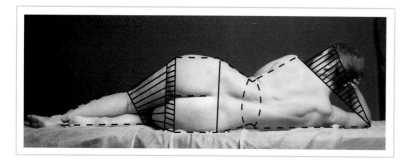

This series of solid and dotted lines shows the various shapes and relationships of the large sections of the back.

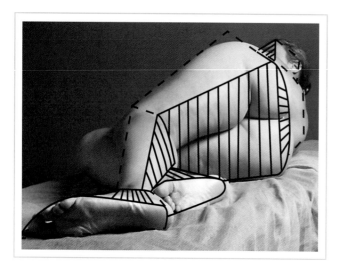

This breakdown shows the large, simple planes of the legs, gluteal muscles, and feet.

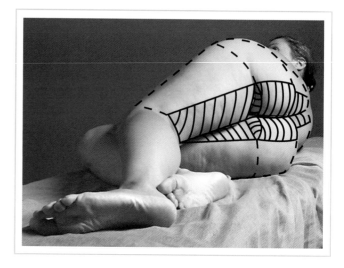

Additionally, from this angle, you can understand the planes of the back of the thighs, the small bottom planes of the gluteal muscles, and the center curvature of the lower back.

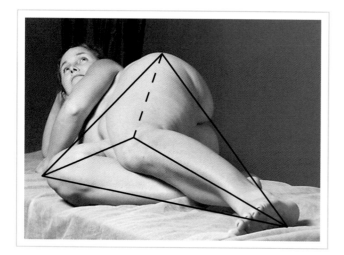

A pyramid effect is created by the three large triangles drawn around the legs.

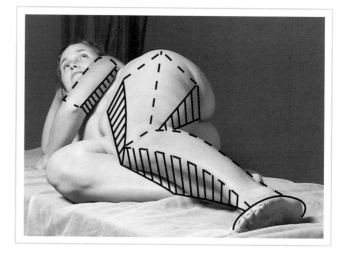

Two top planes are indicated on the top upper leg wedge, one on either side of the center dotted line that is the plane break in that space. The front and back planes of the leg (the adjacent shaded areas) are relatively parallel to each other. The curved dotted line in the center of the shin, indicating the tibia from the knee to the ankle, is the plane break for the two planes of the lower leg.

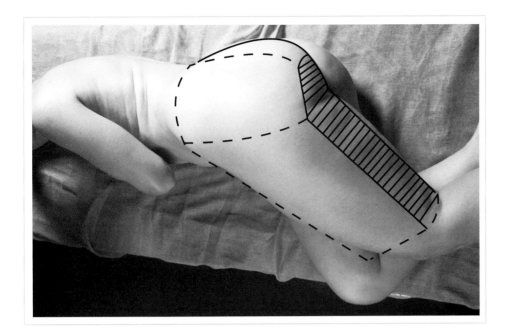

Here you see the planes of the rectangular shape of the upper thigh viewed from above.

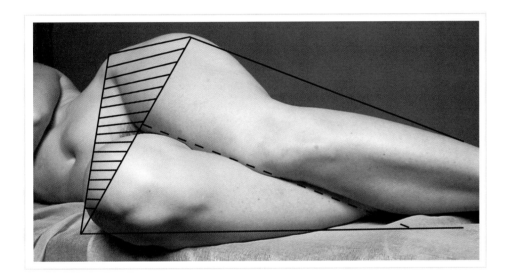

Large triangles show the dimensional aspects of the two legs when perceived as one form.

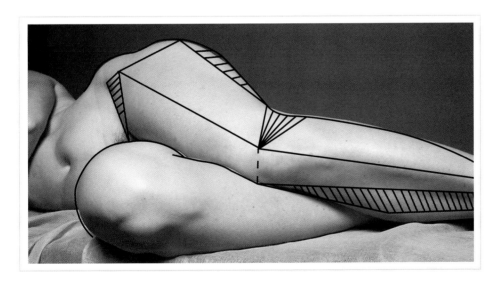

Here, planes of the legs are combined with flowing contour lines.

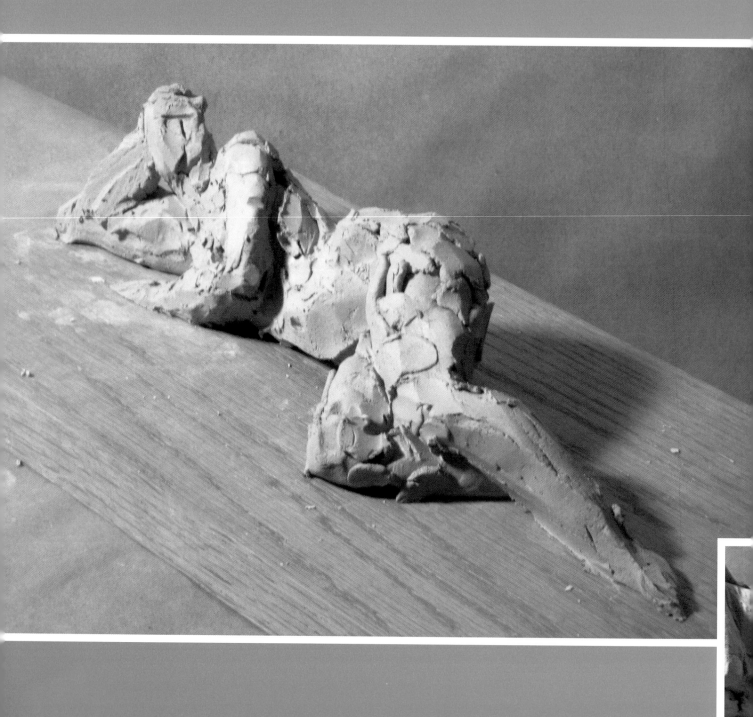

AN INTRODUCTION

TO FIGURE

ABSTRACTION

5

THE CLAY SKETCH

Before jumping right into a figure abstraction, let's explore what is called a *clay sketch*. I always make quick clay sketches of a pose before beginning my abstraction. Each sketch becomes more simplified and eventually the abstraction of the pose reveals itself through this simplification process. This is a great exercise that puts the focus on the large shapes, movement, angles, and gesture of the pose. Keep the head, hands, and feet small when doing a sketch. It helps to express the unity, flow, and design of the clay expression without calling attention to an individual part. These clay sketches are great to save and keep around the studio. They can be fired and inspire future sculpture projects.

CAPTURING THE GESTURE

Note that this clay sketch is based on the same reclining pose that was used in the previous chapter. The sketch is designed to help you understand the importance of the movement, gesture, and attitude of a pose, without getting bogged down with the details. After all, the essence resides in the wholeness of the pose and not in any single element. By quickly blending all the parts into a single unified sculptural expression, the sketch captures the gesture immediately and has a life of its own. This life energy is vital to the creation of all sculptures—and figure abstractions in particular. The figure abstraction must capture the gesture right away in order to express the essence of the pose; it does not hide beneath layers of detail.

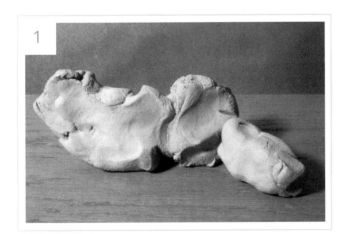

1. Work on a wood or laminate board. Maintain the relative proportions of the body, but feel free to exaggerate the movement of the pose in your first sketch. Start with two loosely formed pieces of clay for the rib cage and pelvis masses. Push them together and stretch the clay pieces into the movement of the pose. Draw a V for the pubic area at the bottom of the pelvis. Attach a blocky cylinder of clay for the thigh of the bottom leg at the V.

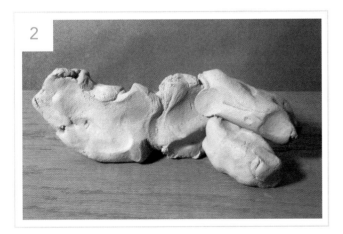

2. Attach the top upper leg, using a piece of clay of the same size as the bottom thigh.

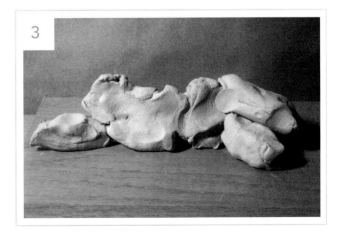

3. Add a chunk of clay under the shoulder area for upper arm that rests on the board.

4. Add a piece of clay for the neck and a small block for the head.

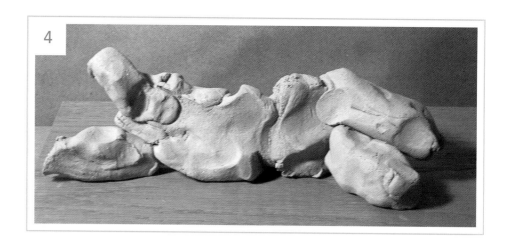

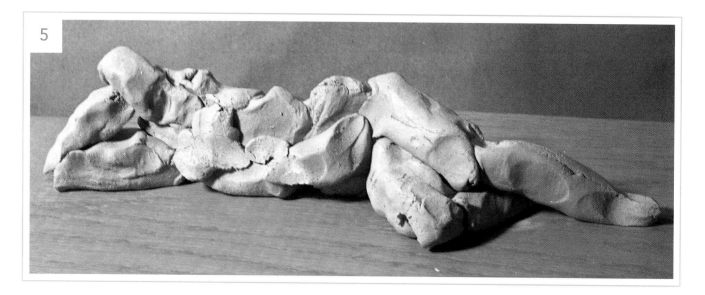

5. Add a chunk of clay from head to the elbow, making almost a solid clay triangle to support the head. Attach clay cylinders for the lower legs, and pinch them to upper legs at the knees to attach. Curve up the stretched-out leg just below the knee to indicate the high contour of the calf muscle. Pinch the clay at the bottom of the legs to create the feet. Drop in some clay for the stomach and stretch it from the pubic V to the rib cage.

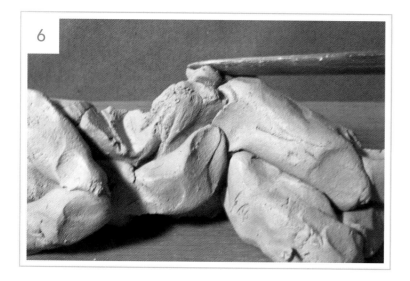

6. Attach a cylinder of clay for the other upper arm to the top shoulder and an elongated triangular piece for the front forearm, and pinch them together at the elbow. Cut a V-shape piece of clay out from the waist area between the rib cage and pelvis with the wood stick tool. Then, add small pellets of clay to the wood stick tool and apply to the hip.

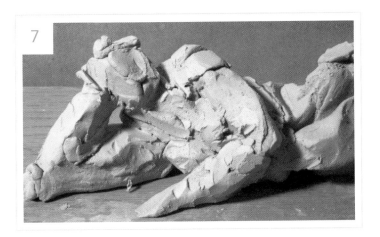

7. Continue to build up the top shoulder, to shape the front forearm, and to create a plane at the top of the front hand. Begin loosely shaping the head and the arm that supports it.

8. Cut a plane on the top thigh at the knee, using the wood stick tool to create a sloping direction to the leg.

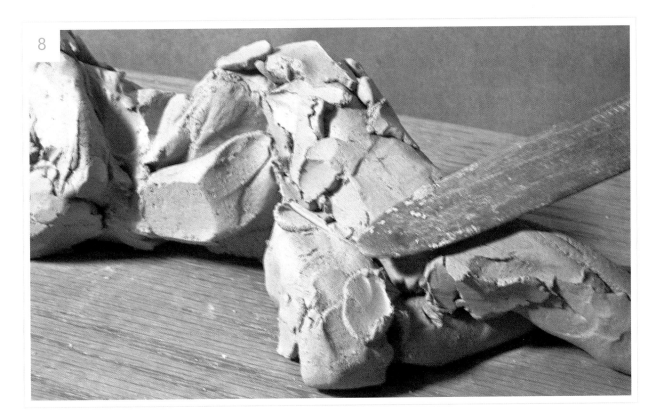

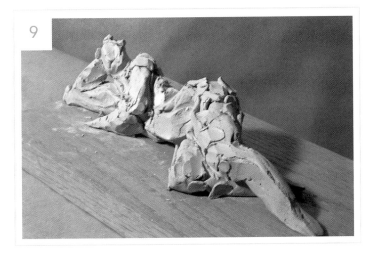

9. Cut a plane on the front surface of the shin on the extended leg. Add clay pellets to the thigh, hip, and lower leg of the extended leg with the modeling stick.

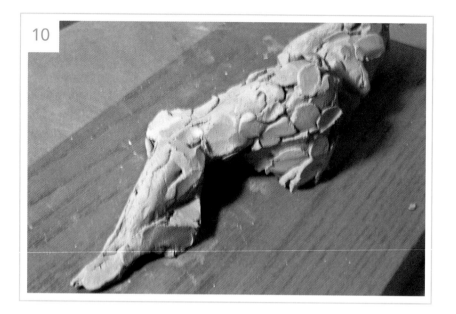

10. Build up the forms of the gluteus muscles, calf muscle, and feet.

11. Draw a curved guideline on the back from the right shoulder to the hip. Add a strip of clay to the guideline to link these two points, giving the back a sweeping movement. Make a plane in the back of the head and neck.

12. Add clay to the stomach, more visible breast, and both thighs.

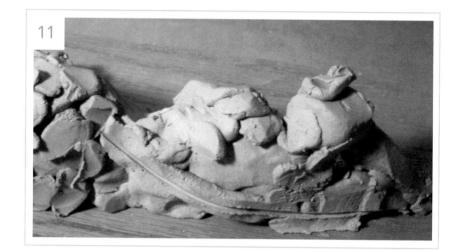

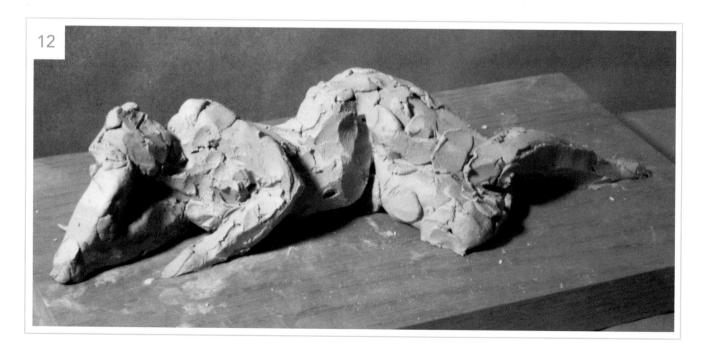

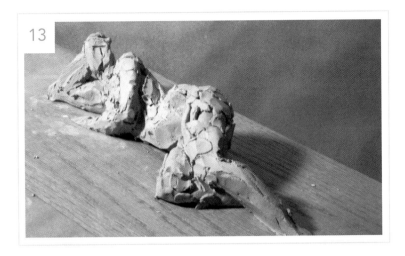

13. Create planes and shape the front and top sides of the hip. Add clay to increase volume on the front plane of the top thigh. Bend the head back, and turn it toward the top shoulder for more expression.

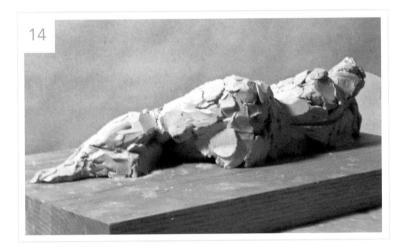

14. Loosely model the forms of the shoulders, hips, gluteus muscles, and lower legs. Add clay to the bottom of the gluteus muscles, and cut a plane on top of the calf muscle.

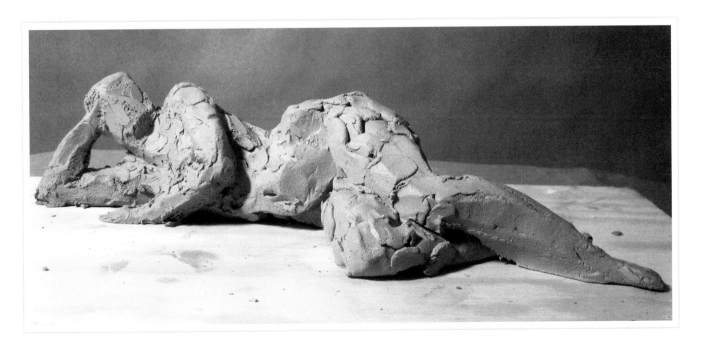

When the sketch is finished it should be a simplified version of the pose in its purest sense, capturing the gesture without the fuss.

6

THE FINISHED SCULPTURE

The figure lessons in this book are designed to teach you how to think abstractly so that you can see reality. Abstracting the figure allows the artist to make personal aesthetic choices and can open up a world of infinite creative possibilities. I use the principles of simplicity, exaggeration, and gesture—combined with the contrasting elements of flat and round shapes, rough and smooth surfaces, large and small forms—all coming together and capturing the essence of the pose, created in my own artistic style and expression.

ABSTRACTING THE FIGURE

As with the clay sketch, the reference pose here is the same as the one found in chapter 4. But the reclining figure is more than it appears to be. It is potentially a landscape, with hills and valleys, winding rivers, and whispering streams. Or perhaps it's a mountain range with rugged, majestic peaks or a desert with gentle, sloping dunes. Maybe it's the ocean with shimmering, calm waters or a swell of raging waves. The figure is a supreme source of inspiration and is all you imagine it to be.

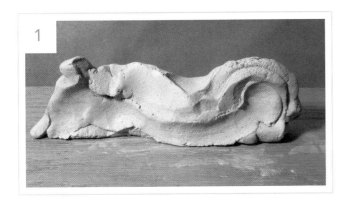

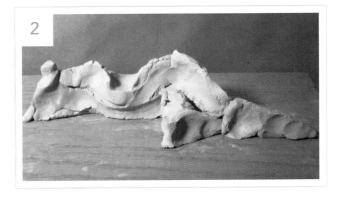

1 & 2. Stretch out a single piece of clay to represent the rib cage, pelvis, head, and bent arm that holds the head. Attach a triangular piece of clay to the pelvis for the bottom leg and a curved piece of clay to the hip for the top leg. Pinch up the clay at the hip to give the hip more height. Add a triangular piece of clay for the lower section of the extended leg. When you are done attaching the legs, press the clay down between the hip and the rib cage with your finger to create a narrow waistline.

3. Pinch a curved piece of clay to the top shoulder for the upper arm and another piece at the elbow for the forearm.

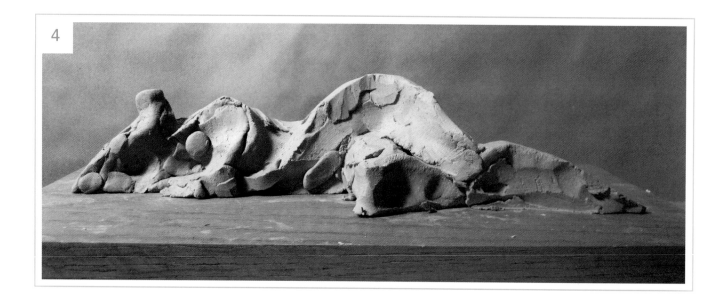

4. Build up the edge of the hip, and continue building the edge until it reaches the arm. Build up the edge of the curved front arm, and add a ball of clay for the breast area. On the arm that supports the head, develop the elbow and the concave space between the head and the arm.

5. Tap and shape the shoulder with the wood block tool. Shape the hip and gluteal area. Develop the fullness of the back mass, angle the shoulders, and create a steep angle for the hip and across the bottom of the pelvis mass and gluteus muscles.

6. Add small strips of clay around the edge of the curved arm to give it more contour.

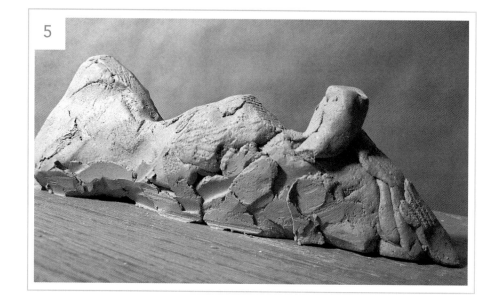

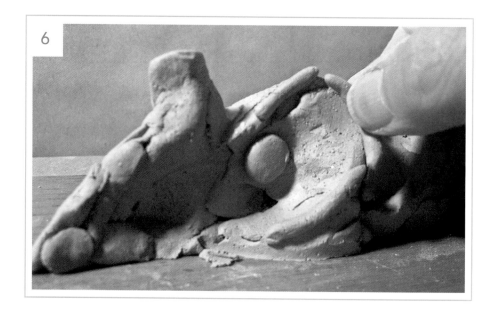

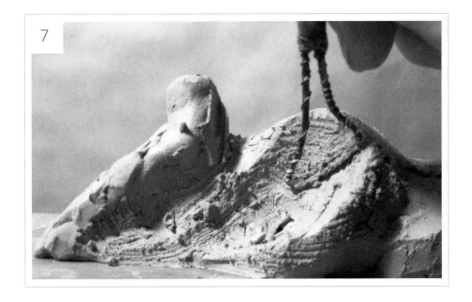

7. Use the wire loop tool to rake a concave surface on the curved arm and all around the edge. Continue shaping the edge, and connect it to the elbow of the other arm. Begin to link the swirling hills and valleys of the forms.

8. Use the riffler to press on the underside of the arm edge, and then press on the top side of the edge. This will give the clay a tight, sharp edge around the form.

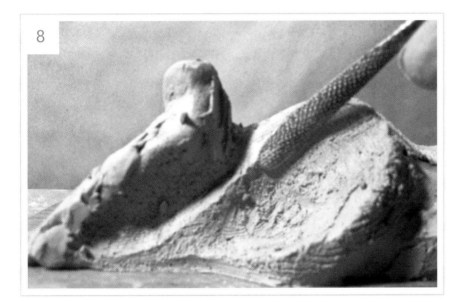

9. Ninety percent of my sculpture's design is set. Continue to build up the forms with small pieces of clay and add them to the surfaces and edges of the forms. The forms flow into one another by way of the edge. The shadows help us see the depth and planes of the forms. Eliminate hands, feet, and all the details of human anatomy except for a small head mass. Create a concave form for the bent leg next to the flat plane of the outstretched leg, also cutting a narrow plane from below the knees to the toe. If you leave this arrangement for now, you can always change it later. It's only clay!

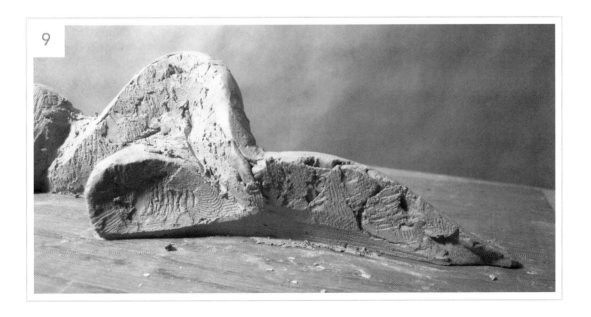

10. Add a few more small coils of clay to the hip and abdominal area to build up those forms. Also, in looking at the knees and hip from above, you can see that the edge of the hip is going to flow into the edge of the thigh of the top leg. The back of the hip and gluteus muscles will be built up and create broader contours that will continue behind the thigh to the back of the knee joint.

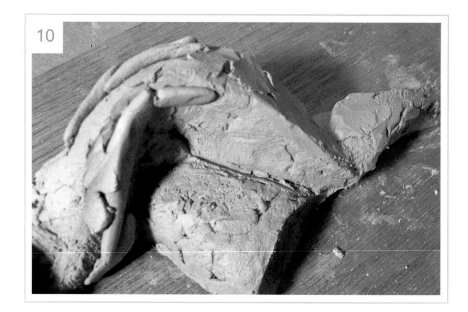

11. The edge of the thigh and hip are connecting and flowing to the arm. The backs of the thigh and gluteus muscles have been built up and now have more volume. Fill in the concave area of the bent leg to match the outstretched leg. Continue building up the stomach plane. Separate the arms, keeping one curved and one angled. The position of the arms creates a pattern or design, as do the legs. The midsection of the body links the design elements of the arms and legs to make one sculptural statement.

The face plane is in shadow and turned toward the hip. Create a continuous rhythmic flow throughout the sculpture, following the edge of the arm that starts under the chin to the outside and down to the elbow of the lower arm. This flow then travels under the ball of the breast and the curved arm to the side of the stomach. It continues up to the hip, around and down the thigh to the knee, and out to the toe.

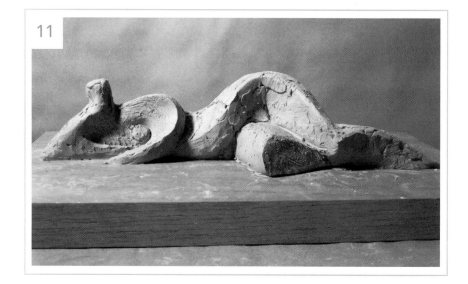

12. Rake a channel with the wire loop across the center of the back from the hip to the right shoulder to link the lower body to the upper.

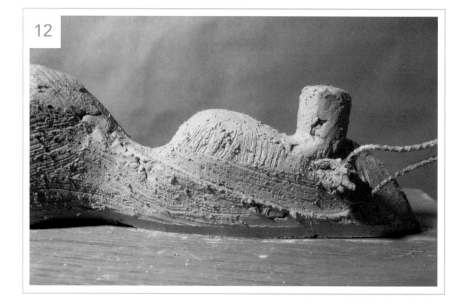

13. The plane of the top leg flows from the knee to the hip, continues around the stomach, and travels under the arm to become the chest plane. It's really one plane changing direction as it goes, like a river. Both the edges and the planes flow and link the forms together, making a harmonious expression.

When the piece is finished, both the back and front views show the arrangement of flats, rounds, and angles—the hills and valleys undulate as they travel through the landscape of the sculptural expression. As you go through the process to arrive at this finished stage, pursue it with passion—sculpt!

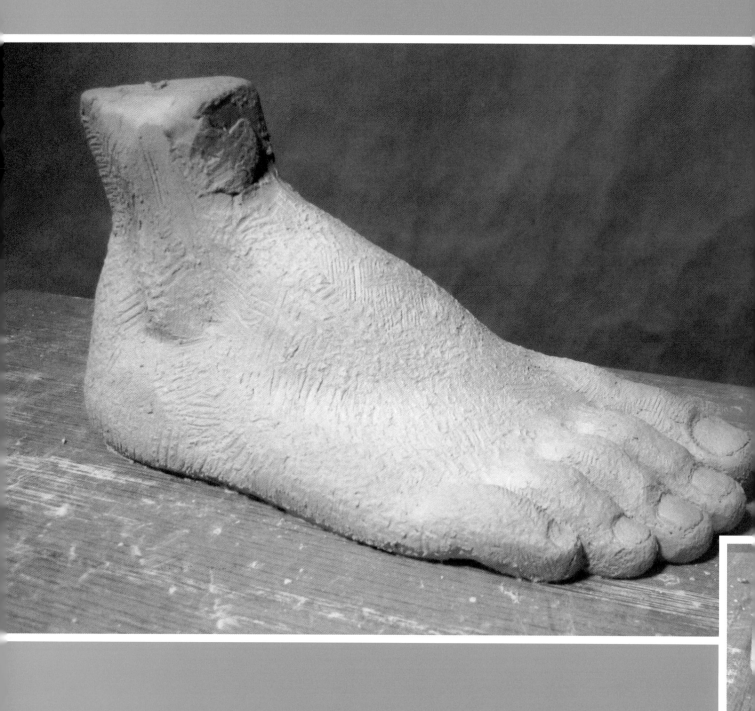

INDIVIDUAL PARTS

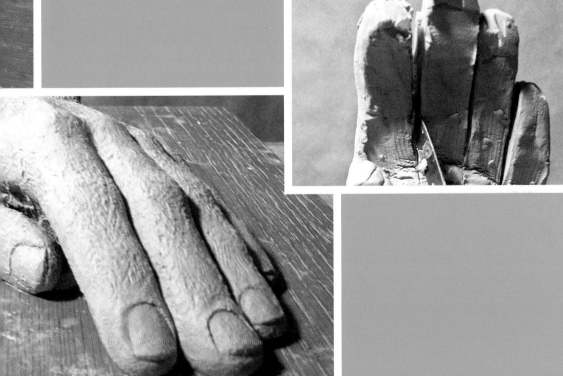

7

THE HAND

Hands are the most complex part of the body with regard to the

way they function. They are equally challenging to sculpt. As with

other parts of the body, everyone is first drawn to the details—in

this case, the creases of the knuckles and the veins on top of the

hand. I've heard of a few students who were so intimidated by

the hands that they sculpted gloves over them and renamed the

piece just to avoid modeling hands. Don't even go there!

STEP-BY-STEP CONSTRUCTION

When starting the hand, as with the figure, begin with simple shapes that best represent the form, and that will act as the foundation or stage one in the sculpting process. Then we'll move on to stages two and three, developing the form and finishing.

1. Roll a coil of clay, drop it on a laminate board, and stretch it into a rectangular block shape. Make the length twice the width.

2. Using the wood block tool, tap the top surface of the clay block on a 45-degree angle, from one end to the other.

3. Taper the mass of the four fingers from the wide area of the knuckles to the fingertips. Draw guidelines for the fingers, drawing the center line first and then drawing lines in the center of each remaining half. This is a left hand with fingers, so the thumb will be added to the right side later. The wrist section of the lower arm will attach to the front plane at the end of the hand. Note the slope of the hand from right to left. Draw a curved guideline for the knuckles in the center of the top plane, across the width of the hand. Note that the index (first) fingertip is farther from the wrist than the little finger (pinkie). Start the guideline at the knuckle of the index finger and curve it back to the knuckle of the little finger. The width of the hand is wider across the knuckles than at the fingertips when the hand is opened and the fingers are touching one another. The index and pinkie fingers curve in toward the middle finger.

This giant, ancient, marble carving of a hand in a pointing gesture is displayed in a courtyard museum in the Piazza del Campidoglio in the heart of Rome. Note the block shape of the fingers. Each section of the fingers has top, bottom, and side planes. The third, fourth, and fifth fingers curl and touch the palm below the thumb. The fingertips of those fingers are on a 45-degree angle, from the third finger near the thumb to the little finger near the base of the palm. Fingernails curve on the elliptical shape at the end of the fingers. The thumb is on the side of the hand.

4. Cut the top plane of the hand with the wood stick to lower the hand at the wrist area. Start the cut at the knuckles, and then slice toward the wrist, keeping the angle sloped from the index finger to pinkie. Do the same from the knuckles to the fingertips. The hand is wedge shaped. The knuckle of the index finger is the high point of the hand; the wrist and fingertips are the low points.

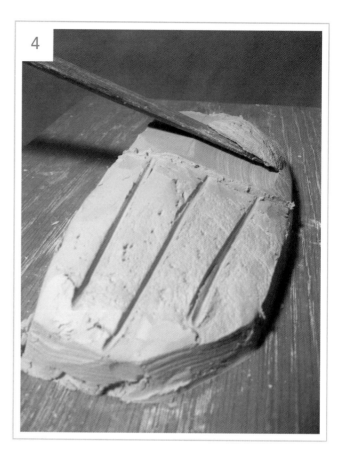

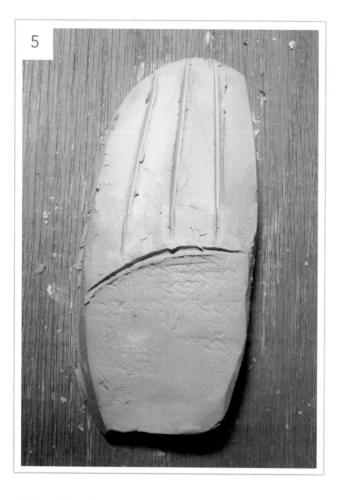

5. The view of the hand from above shows the curved line for the knuckles. The fingers taper to the tips, and the hand is wider across the knuckles than at the fingertips. The hand also tapers from the knuckle to the wrist. The fingers are different lengths and create a curved contour along the tips. Cut and shape the curve in the clay for the ends of the fingers. The curve should be parallel to the curved line of the knuckles. The final foundation shape of the hand should look like a hand wearing a mitten or sock.

6. Check the front view of the fingertip end. The knuckle of the index finger should be higher than the knuckle of the pinkie. The plane of the tops of the fingers slopes down and forward from the knuckles to the fingertips, and down and to the outside of the hand from the high knuckle to the low one.

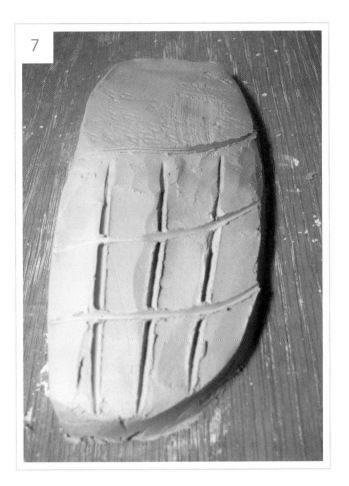

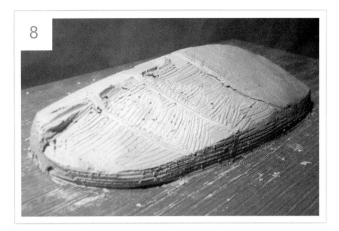

7 & 8. On the top plane, draw two curved guidelines lines for the second and third sets of knuckles across all the fingers (7). On all fingers except the first, create planes on each tier of knuckles, creating a slight step down from knuckle to knuckle from top to bottom (8). Leave the index finger as is for now.

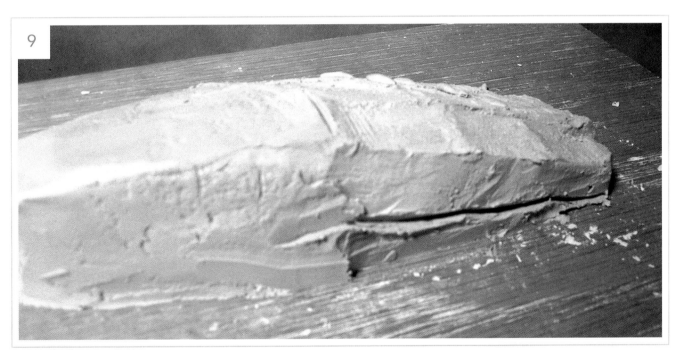

9. On the side of the hand where the thumb will be attached, draw a guideline along the underside of the index finger. Clay below this line will be removed to thin out the finger. Make three planes on the index finger, and begin forming the knuckles.

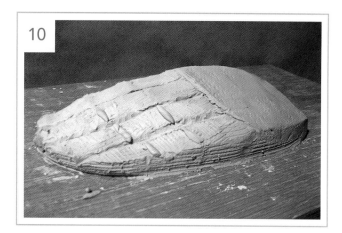

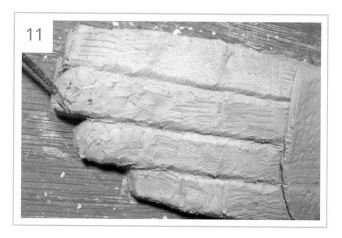

10. Add small strips of clay to each knuckle and begin shaping the fingers. Put the edge of the riffler in between the fingers, roll the tool, and press on the sides of the fingers. The sections of the fingers should be narrower than the knuckles.

11. Cut the fingers to their proper relative lengths, giving a rounded shape to the tips: The middle finger is the longest, ring finger is next, the index finger follows that, and the pinkie is the shortest. Hold your hand up, and note where each fingertip ends in relation to the place on the finger next to it. For example, on my hand the pinkie ends a bit higher than the third knuckle of the finger next to it.

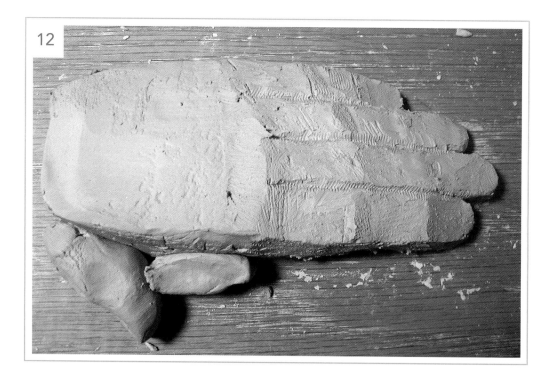

12. The thumb is a separate form that attaches to the side of the hand and begins at the wrist. Hold your left hand out in front of you with the top of the hand facing the ceiling. Relax your hand and notice that the thumb drops down and out to the side; it's not part of the hand mass. The knuckles and fingernails are located on the top plane of the fingers. The parallel bottom plane has the thicker muscle pads between each knuckle. The fingers have four sides (planes), so make them slightly rectangular at first. Place a cylinder of clay at the wrist for the first phalanx, or section, of the thumb at a 45-degree angle to the index finger. Also, begin to fill the space between the thumb and hand.

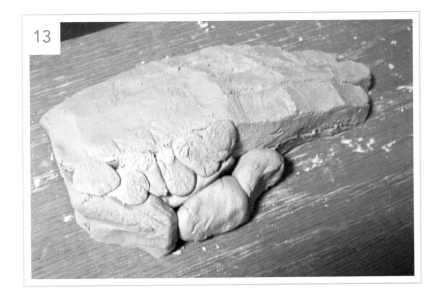

13. Add clay pieces for both the second and third phalanx of the thumb. Continue to fill the space between the top edge of the hand and the thumb with strips of clay. Tap the thumb and clay in this area to make a flat plane on the thumb and on the area between the thumb and hand.

14. There's a flat, sloping, triangular-shaped plane on the side of the hand between the thumb and index finger. This is where the small, puffy interosseous muscles are located. The top plane of the hand and this triangular side plane meet, creating a plane break along the hand between the wrist and the index finger. Smooth the clay together in this area. Note that the thumbnail plane faces to the side and the fingernail planes face upward.

15. Use the wood block tool to tap the side plane of the thumb and triangular plane shape of the interosseous muscle area, starting at the wrist and moving toward the fingertip.

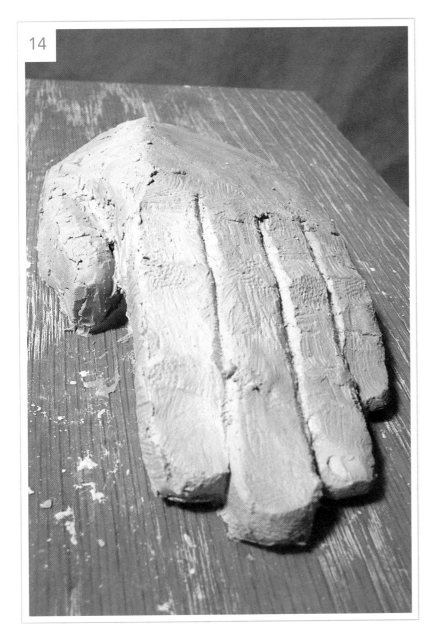

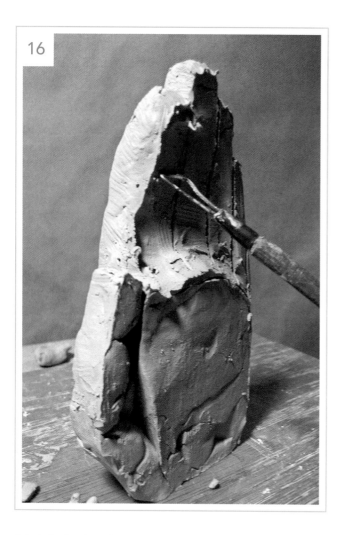

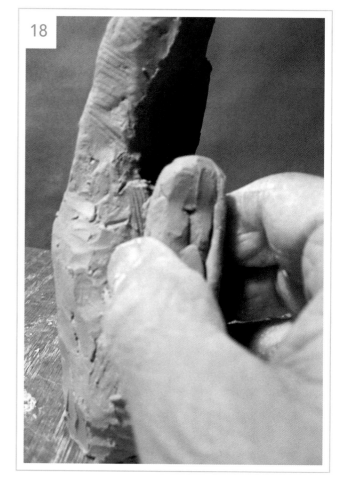

16. Lift the hand up on its wrist end. Rake the finger mass with the wire loop tool to thin it out. Rake down to the palm, where the fingers begin. Make a narrow plane on that small top edge of the palm.

17. Draw a semicircle in the center of the palm, with its open side facing the thumb, for the pocket of the palm. The palm is padded with muscles in the center and slightly thicker ones around the perimeter. Look at your palm, and close it slowly. Watch a pocket form in the center, just like a baseball glove.

18. Gently move the thumb until it's forward of the palm.

19. Cut the fingers free from one another with a plaster tool, which is a thin, metal spatula. (You can use any unserrated knife that's handy.) Rake and thin out the center of the palm, add pieces of clay to the padded muscles around the palm, and build up the narrow plane at the top of the palm, where the fingers meet the palm.

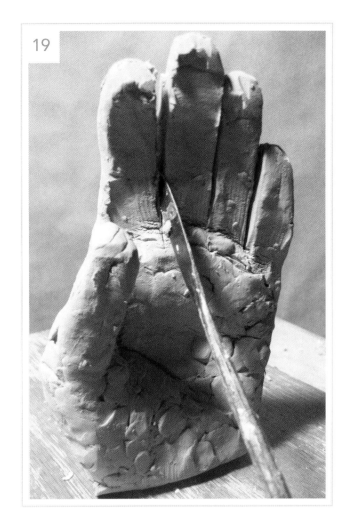

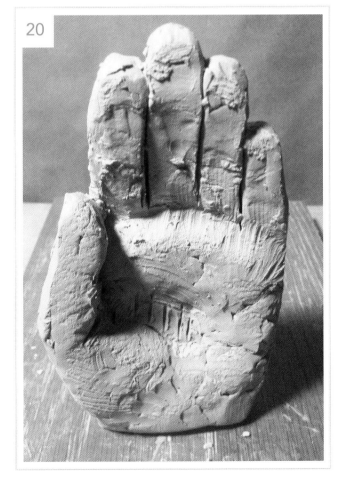

20. Tap the clay with the wood block, and rake out the shape of the thumb, fingers, and palm. There's no need to refine the palm, because the hand will ultimately rest palm down on the base.

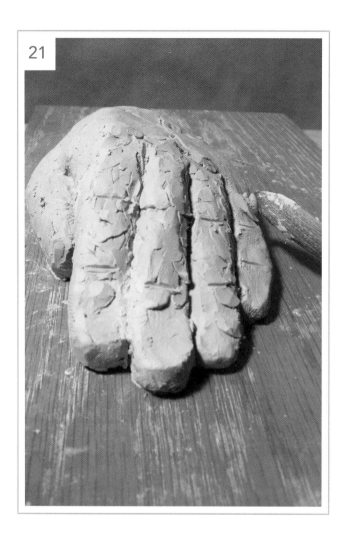

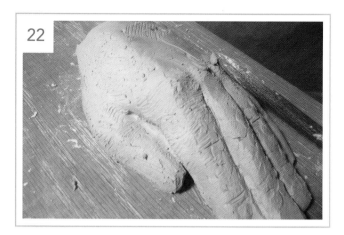

21. At this point, you can return the hand to its original orientation. For reference, stick your left hand out in front of you, palm facing the floor; relax your thumb, and let it drop. Now, rest your hand on the table, keeping it relaxed. This is the position of the hand we're sculpting. One at a time, add small pieces of clay to the tip of the wood stick tool, and apply them to the top planes of the fingers to create rounded surfaces. Slightly round out the top surface of the thumb, where the nail is to be positioned.

22. Put small pieces of clay on the end of the wood stick tool, and add them to the knuckles.

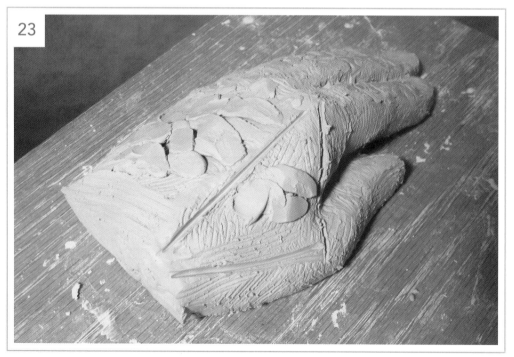

23. Mark the triangular shape of the plane located between the thumb and the back of the hand. Add clay to this plane to build volume in the interosseous muscles. Add clay to the top plane of the hand and begin to round the surface. Tap and rake.

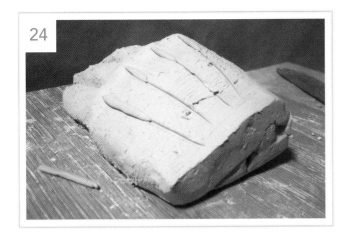

24. Add strips of clay to the top plane of the hand for the tendons of the fingers from the knuckles to the center of the wrist. Blend the sides of the clay strips into the hand.

25. Attach a rectangular block of clay to the hand for the wrist. Add small pieces of clay to build up the knuckles of the thumb. Blend with the rake tool.

26. Tap planes on the top and side surfaces of the wrist. The top plane of the wrist is wider than the side of the wrist, and it is part of the same surface as the top of the hand and tops of the fingers. Hold your hand out in front of you, keeping your wrist and hand straight. The top plane is flat from the middle of the forearm to the fingertips. Bend your wrist back, up, and with fingers down; note that the top plane is the same, but the direction changes when bending the hand and fingers at the joints. The same is true with the narrow side plane of the wrist; it is the same plane as the side of the index finger and the top plane (the nail plane) of the thumb.

The lines drawn on the hand indicate the plane breaks, where the planes meet, between the top and side planes of the wrist and thumb, as well as the triangular plane of the interosseous muscle area.

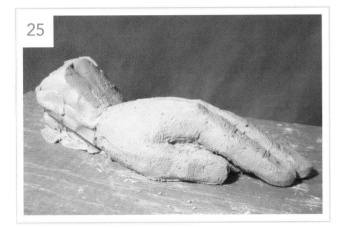

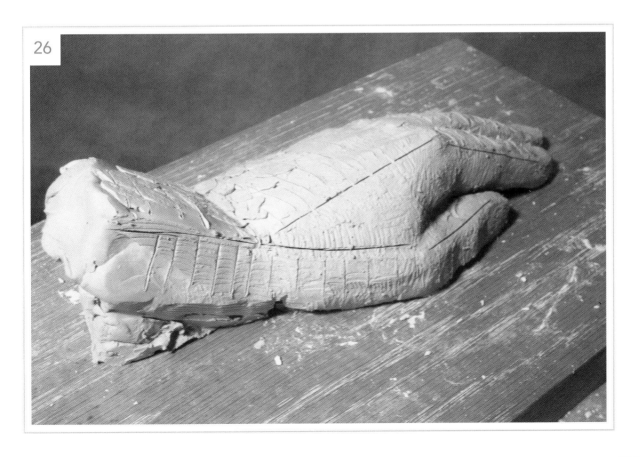

27. Curve the fingertips up at the ends. Curve the thumbnail phalanx out to the side. Shape the fingertips and knuckles, using the wire loop tool and the pressing action of the riffler to model and give shape to the forms. The guidelines here indicate the top and side plane breaks of the hands and fingers (where the planes meet).

28. Add some clay to build up the thick muscle form at the outside of the hand between the pinkie and wrist (the palmaris brevis). Tap and rake the shape of the palmaris muscle, and rake the area of the pinkie under its first knuckle to give a transition between the two forms. The guideline here indicates the plane break between the top and side planes along the hand, fingers, and wrist.

29. Add small strips of clay to the fingertips for the nails.

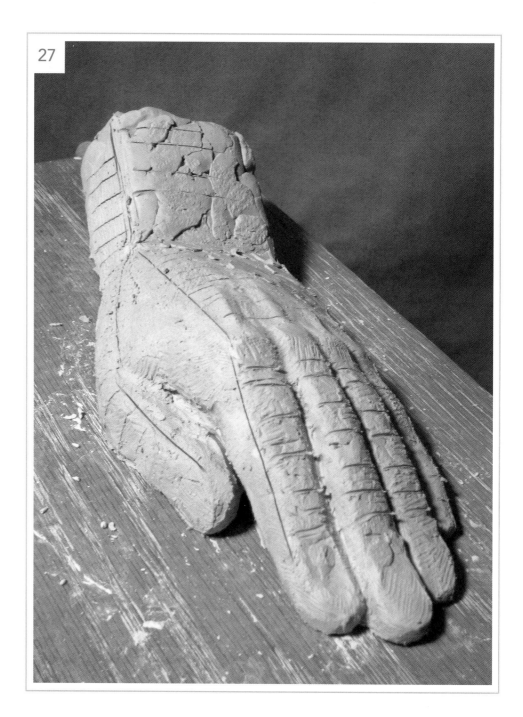

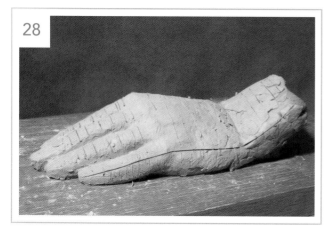

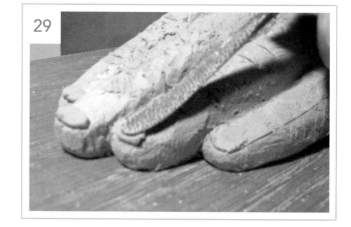

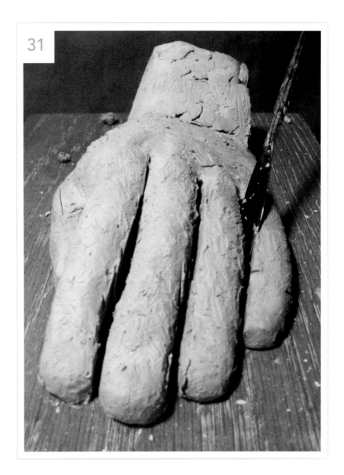

30. The ends of the fingers and thumb are elliptical. Round the side edges of the fingertips with a pressing motion of the riffler.

31. Use the plaster spatula tool to cut and separate the fingers at the seams. You can give individual movement to each finger when they have some separation. Bend and twist the fingers at the joints to add character. Roll each finger slightly to the outside, away from the thumb, so that the top planes of the fingers slope in the same direction as the top plane of the hand.

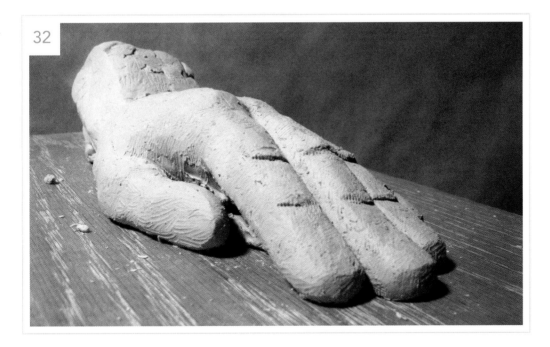

32. Continue to develop the knuckles and shape the tip of the thumb. The thumb is wide at the last knuckle and tapers to the tip. The last phalanx curves outward, as in a thumbs-up gesture. Round the area of the thumbnail.

33. Press the edge of the riffler into the knuckle joint of each finger to give the knuckles some depth.

34. Place the flat side of the riffler at the tip of the finger, under the nail. Press against the tip of the finger and roll the riffler from one side of the finger to the other, keeping it placed under the nail. The front edge of the nail and round tip of the finger will be shaped at the same time.

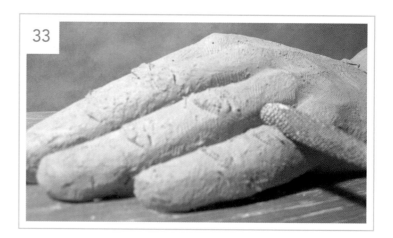

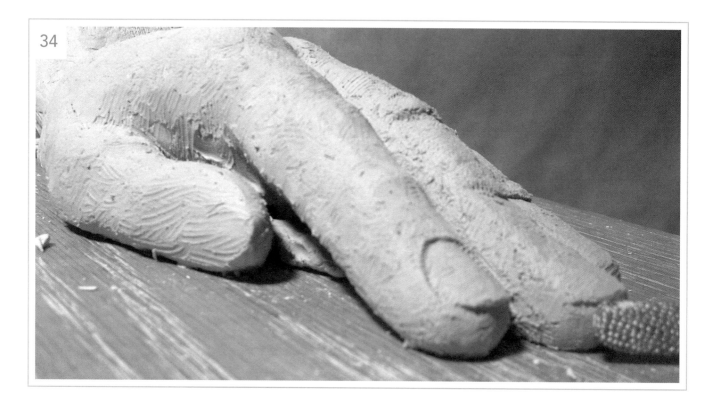

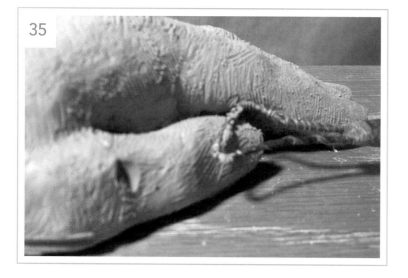

35. Rake and shape the top plane of the thumb. The sides of the thumb should be sloped where the nail is to be positioned. Create a slight bevel there with the raking action of the wire loop.

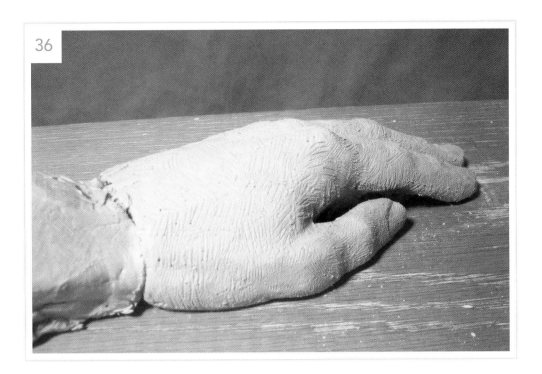

36. Blend the surface of the hand and fingers with a cross-hatching motion of the wire loop. Add more clay to build up the knuckle mass of the thumb. Rake and blend, knuckles to fingers. Vary the height of each finger.

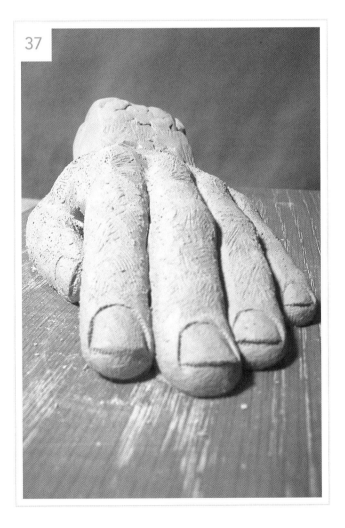

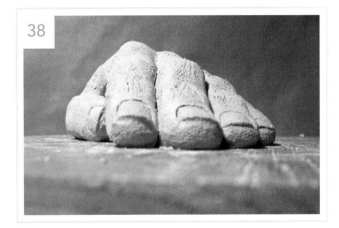

37. Note the varied heights of the fingers and the bend at the knuckles. Also note that the fingernails are taking shape.

38. Note the downward slope across all fingers from the index finger to the pinkie. In addition, the individual fingers roll to the side in the same direction as the top plane of the hand. The fingertips roll up and rest on the center of the pads. The fingernails rest on a curved surface. Sink the fingernails into the skin at the sides and back with a pressing motion of the riffler. Note the resting position and angle of the thumb.

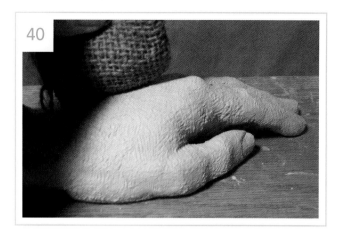

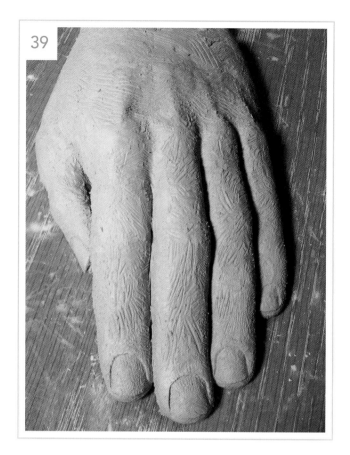

39. Make the little finger and index finger curve toward the middle finger. The middle and third fingertips can curve into each other, as well. See if yours do.

40. Roll up some burlap and lightly spray it with water. Tap the burlap gently against the clay to create a texture on the surface. The best technique is to press the burlap firmly but gently against the surface, roll it, and then lift: Press, roll, and lift.

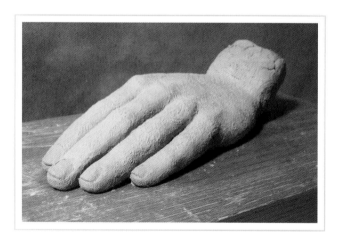

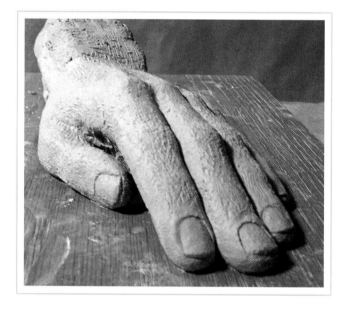

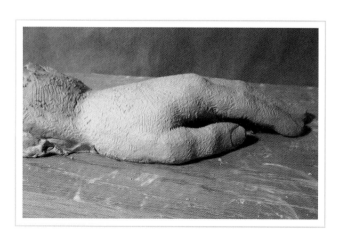

The step-by-step lessons were designed to provide a simple foundation and starting point for sculpting a hand. Keeping it basic will keep you focused when sculpting a more expressive hand. Knowing some fundamentals will go a long way. Practice sculpting larger-than-life-size hands, and put more detail in if you choose. This particular hand gesture is obviously relaxed and simplistic in its development and is a good example for study purposes.

THE FOREARM

The lower arm is the most complex of the four limbs. The two bones of the lower arm, the ulna and radius, enable the arm to move in two directions at the same time. The ulna moves up and down, and the radius rotates inward. The large muscle group of the forearm (in the upper half of the forearm) supplies the power to the narrower muscles at the wrist, which activates the movement of the hand.

To get a feel for the structure, rest your arm at your side, and bend your lower arm up until your palm is parallel to, and faces, the ceiling and the elbow faces the floor. Place the fingers of your other hand on the wrist of your bent arm, like you're taking a pulse. Slide your fingers along the flat surface, from your wrist up to the start of your upper arm, at the inner elbow joint. This surface is the long plane of the entire lower arm. It is wider at the elbow joint than it is at the wrist. Keep your fingers on the plane at the inner elbow joint, and rotate your arm 90 degrees, until your palm faces a wall. Don't move your elbow. Now slide your fingers along the plane back to your wrist. Notice how the plane is still flat but begins twisting about halfway down the arm as you get closer to your wrist.

Next, continue to rotate your arm another 90 degrees (for a total 180-degree rotation from the original starting point) until your palm is facing the floor. Do this without moving the elbow. Slide your fingers back and forth from the wrist to the inner elbow joint, along the twisting plane. The forearm muscles begin to change shape, becoming rounder as the arm rotates; however, the wrist remains relatively flat and rectangular before and during the rotation.

The wrist in the lower section of the forearm is a rectangular block. The top plane of the wrist block is broader than the side plane and is the same plane as the top of the hand. The plane changes direction as the wrist bends up and down. The bottom wrist plane is the same plane as the palm of the hand. The upper section of the forearm is somewhat triangular. The transition between the two areas happens somewhere in the middle of the forearm as it rotates.

When sculpting, determine the location of the bottom plane of the wrist in the pose, then locate the plane of the inner elbow of the forearm, and establish their positional relationship to each other. Create the planes of the clay wrist block with the wire loop tool, and tap them with the wood block. Build the rounded, triangular shape of the upper part of the forearm with small pieces of clay. Follow the twisting, flat plane from the wrist to the elbow, and look for the transition area between the two forms of the forearm. Build these forms with small pieces of clay and blend them together.

Here, the palm and inner elbow face the camera.

When the arm rotates 90 degrees from that starting position, the palm faces down toward the floor. The inner elbow still faces the camera.

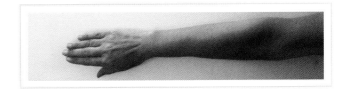

When the arm rotates another 90 degrees (180 degrees from its starting position), the broad, flat bottom plane of the wrist now faces the wall.

The arm is a triangular form that's wider at the elbow and narrower at the wrist. In the image at right, a line marks the center of this plane from one X at the wrist to another at the inner elbow. This bottom plane of the forearm at the wrist is same plane as the palm and changes direction when the hand moves up and down.

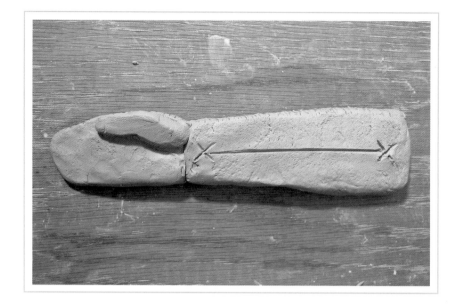

When the arm rotates 90 degrees, the elbow itself does not move. Muscles at the elbow that attach to the thumb side of the wrist, however, cross over and follow the new position of the wrist. The muscles at the elbow attached to the wrist on the pinkie side of the hand roll under to follow the rotated position of the wrist. The side plane of the arm and wrist rotates from mid-arm. The lined area indicates the twisting side plane of the arm, wrist, hand, and index finger.

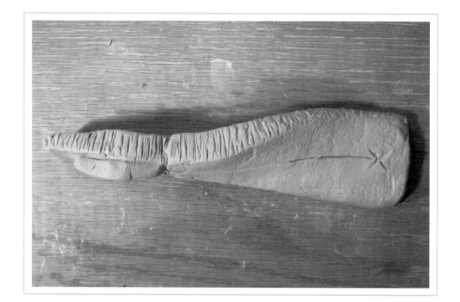

As you twist the clay arm another 90 degrees so that the palm and bottom plane of the wrist touch the base, the muscles stretch to accommodate the new wrist position. The radius bone completely crosses over the ulna. The side plane continues the twisting action.

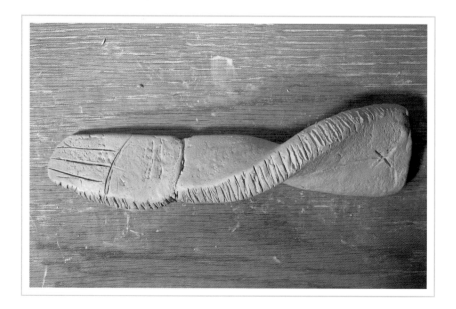

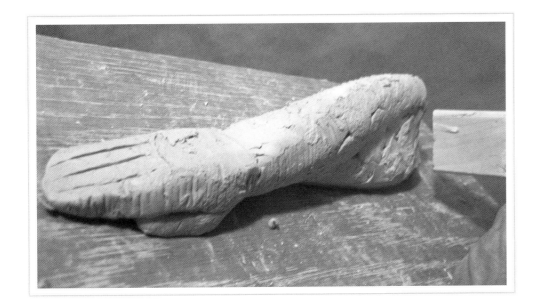

As when sculpting the full figure or the hand, once the beginning block structure is established, you can start adding pieces of clay to the planes of the arm and wrist to give volume to the forms. Tap the clay with the wood block and rake with the wire loop tool to blend the forms as the narrower wrist transitions to the wider elbow.

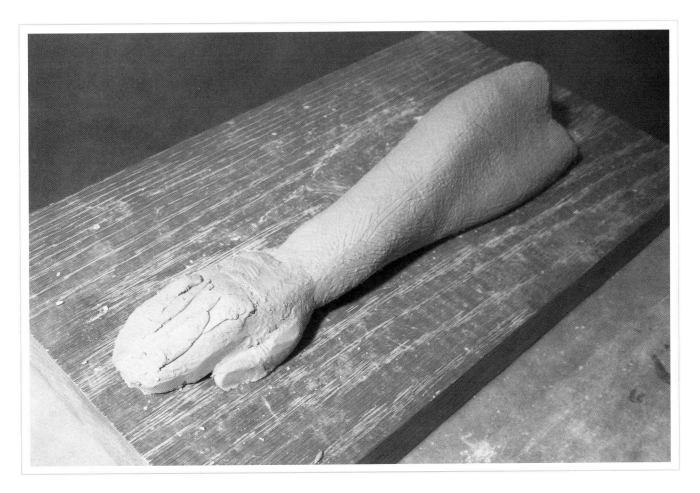

To finish, tap the form with rolled-up burlap to create a final surface texture.

8

THE FOOT

The foot is similar in its construction to the hand. Feet keep us from

tipping over, and the big toe stands alone, so to say, when it comes to

maintaining our balance. The thumb of the hand, as you know, enables

us to grip and hold things with ease, while the big toe grips the road

and helps us to walk with ease. Although not quite as capable of mak-

ing some of the flamboyant ascending hand gestures, the foot can take

flight. Beginning from a flat position on the floor, the foot can spring

into an elegantly arched shape, with toes pointing and stretching out,

as it leaves the ground behind.

STEP-BY-STEP CONSTRUCTION

When starting the foot keep a simple shape in mind. A triangle from the side view, the foot is wider in the front than in the back when looking down on the form. The front curves around across the front from big toe to little. Let's begin with the basic shape before developing individual toes.

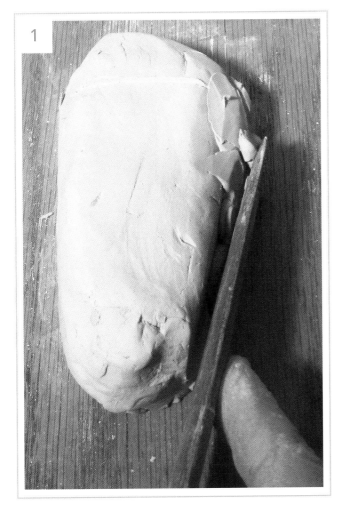

These two amazing, giant marble feet are displayed in the same museum courtyard in the Piazza del Campidoglio as the hand on page 135. Note the block shape of the toes and the elliptical shape at the end of them under the toe-nails. The toe pads are rich in volume, not flat, and curve upward at the ends. Note the high metatarsal bones (leading up to the start of the leg) and flat plane between the metatarsals and the toes. The sole on the side of the foot before the pinkie toe is thick from the bottom to the top plane of the foot.

1. Roll a piece of clay into a thick cylinder, and let it drop onto your work board. Roll it out as you would roll dough for a loaf of bread. Pat the top with your hand to flatten the surface. Since this is a right foot, cut a clay slab off on the left side for the instep, from heel to first phalange (the bone of the big toe). From that boney spot, change direction 30 degrees to the right and continue to cut off clay at the big toe. The big toe angles toward the little toe.

Also add pieces of clay to the outer edge of the foot, building up the area of the pinkie toe.

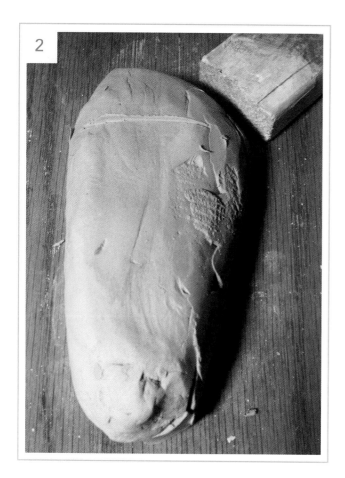

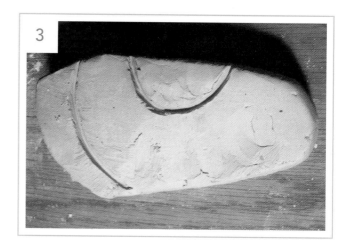

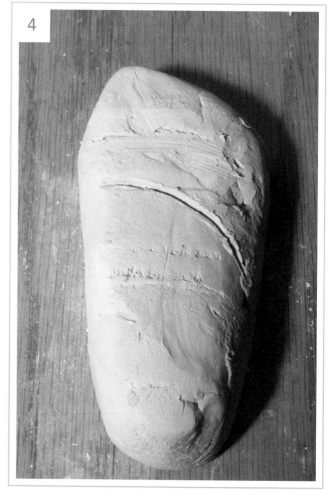

2. Curve the front of the foot at the end of the toes from the big toe back to the little toe. Cut off clay on the outside edge of the foot, from the toes back to the heel, tapering the foot as you get to the heel. The widest part of the foot is across the front, from the first bone of the big toe to the first bone of the pinkie toe. The heel is approximately half as wide as the front of the foot. Use your own foot as a reference. Measure the length, the width of the heel, and the front of the foot to understand the proportions and shape of the foot.

3. Turn the clay upside down and, using the front tip of the wood stick tool, draw a curved guideline for the toes and a semicircle for the arch of the instep on the bottom of the foot.

4. Turn the clay right side up again, and draw a curved guideline just below the metatarsals. This line is parallel to the curvature of the toes at the front of the foot.

5. Use the long edge of the stick tool to slice a plane from the guideline downward toward the four toes (exclusive of the big toe). Slant the plane to the outside of the foot.

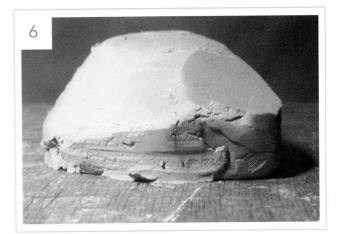

6. Cut a plane on top of the big toe parallel to the board. In this eye-level front view of toes, note the sloped angle of the top plane of the toes from the plane break where the planes meet, and also the angle of the top plane of the big toe. Also observe how the narrow front plane of the foot diminishes from the big toe on the right to the little toe on the left.

7. Draw a curved guideline from the first joint of the big toe to the first joint of the little toe. Draw four parallel lines for the toes. The lines start at the curved guideline and angle, or flare slightly, to the outside of the foot. In this view from above, note the sloped plane of the toes and the top plane of the big toe.

8. Make planes, like steps, from the top set of toe knuckles to last set at the toenail. Use the riffler to press down on the top section of each toe, following the curving direction of the toes from the big toe to little toe. At this point, also add a strip of clay to the tips of the toes to make them longer. Remember: No mistakes, only adjustments.

9. Add small pellets of clay to the tips of the toes and the big toe to give them a rounded shape at the ends.

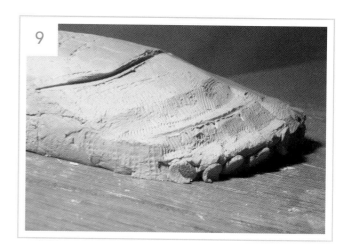

10. Add a thick cylinder of clay to the top back section of the foot for the ankle section of the lower leg and a thinner cylinder of clay to create the talus (the high bone of the foot).

11 & 12. Build up the rest of the high bones, making them lower as you get to the outside of the foot. Note that the foot is triangular in shape in the side view. The bony sections of the top of the foot make a long, steep slope from the leg to the big toe.

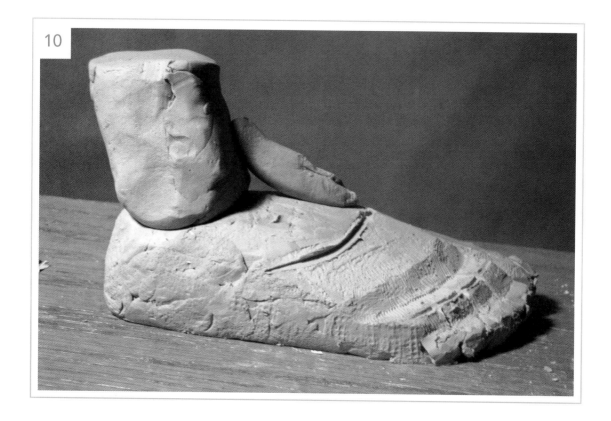

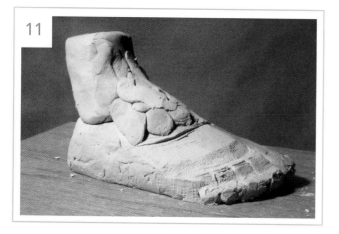

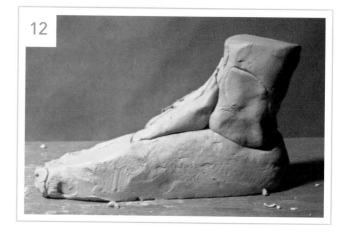

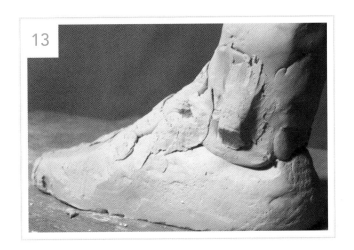

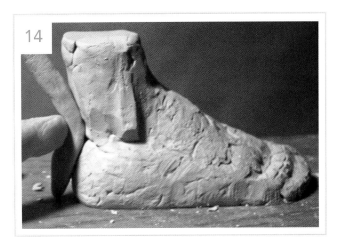

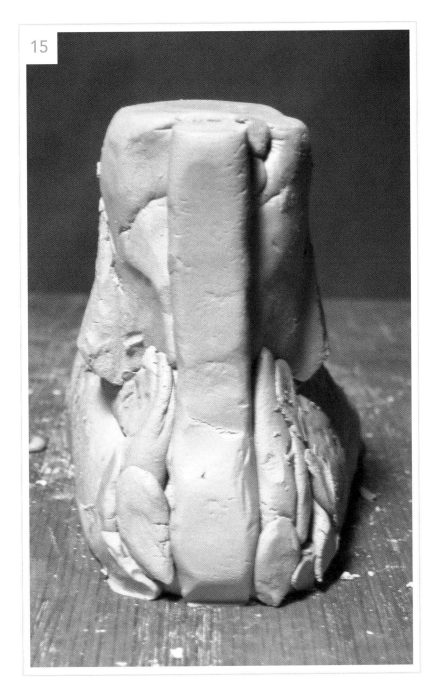

13. Fill in top area and begin to build a triangular shape for the ankle on the instep side of the foot above the heel and slightly forward of the center of the leg.

14. Roll a cylinder of clay and attach it vertically in the center back of the lower leg for the Achilles tendon and the calcanium (the back of the heel). Press the clay strip in with your thumb at the top of the heel to form the transition between the two forms. Build a blocky triangular shape for the ankle on the outside of the foot, taking into account that the outside ankle is slightly lower and farther back on the leg than the inside ankle.

15. Add clay to build up the sides of the heel. Note the width of the clay strip for the Achilles tendon in this back view.

16, 17 & 18. Rake texture into the form to unify the elements of the heel using the wire loop tool. Note that the heel is pear shaped or triangular and swells out at the bottom. The outside ankle is lower and farther back than the inside ankle. In the view of the heel on the outer side of the foot (17), note the shape and contour of the heel arching from the tendon in the back. In the back view from the big-toe side (18), note the contour and shape of the heel and the plane structure of the ankle on the instep side of the foot. Also note the flat plane of the back of the Achilles tendon and the plane of the leg on the side of the tendon, wedging forward to the ankle and down to the side of the heel.

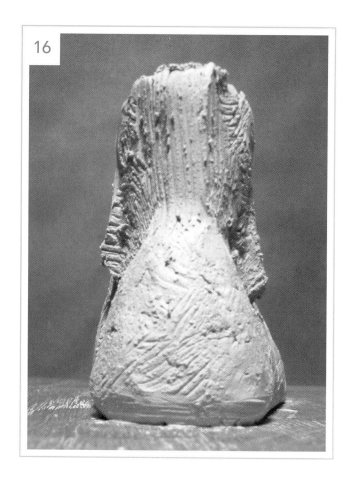

19. Place the clay foot on its heel to begin removing clay for the instep (the arch of the foot). Place the riffler on the side of the foot at the open end of the semicircle guideline made in step 3. Cut and scoop clay out for the arch. Don't cut more than half an inch up into the side plane of the foot.

20. Scoop out a ½-inch channel between the toes and front pads of the foot. Follow the curved guideline of the toes made in step 3.

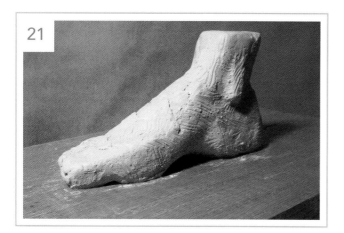

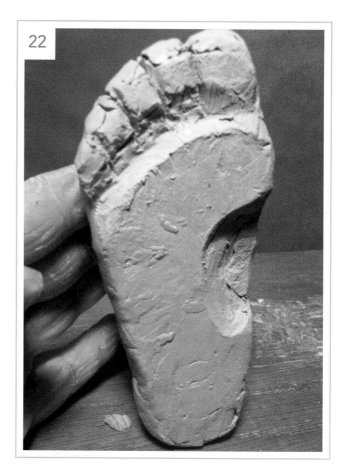

21 & 22. Draw lines for the toes, and develop the pad at the end of each toe. Place the edge of the riffler in between the toes, and press and roll the tool to the sides of each toe. Then reposition the foot with the sole on the board. In the view of the foot from the instep side, note the arch between the heel and the sole pad on the ball of the foot. This is a transition area between two muscle groups. Another transition occurs between the ball of the foot and the pad of the big toe.

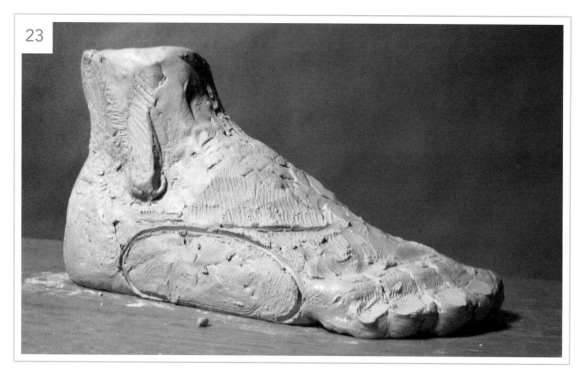

23. Draw a guideline for the sole pad on the little-toe side of the foot. Begin raking and blending the surface of the foot with the wire loop tool.

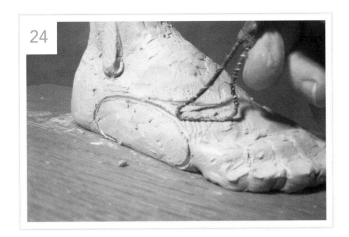

24 & 25. Insert the end of the stick tool into a wad of clay and scoop some clay onto it. Add the clay on the stick to the sole pad to build the volume of the form. Rake the surface of the foot and planes of the ankle and side of the foot.

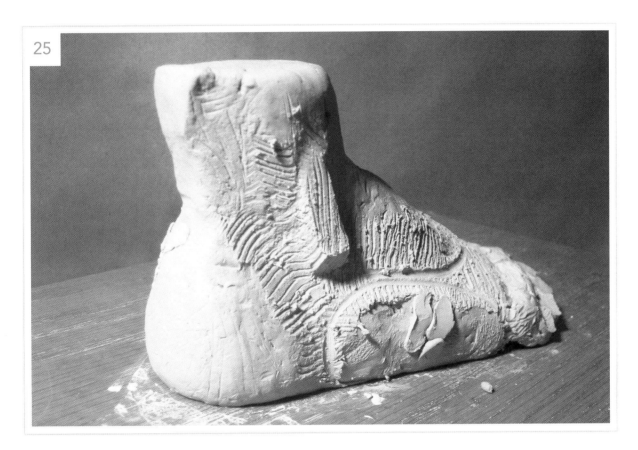

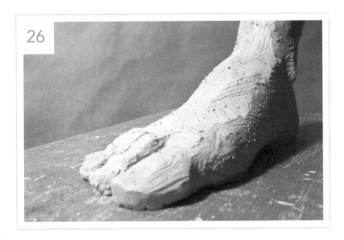

26. Begin raking the shape of the toes with the wire loop tool. The big toe is narrow between the sole pad and the pad of the toe. It is also wide at the start of the nail and tapers to the tip of the toe. It curves upward from the pad to the edge of the toenail. Develop the plane structure of the side, front, and top of the big toe.

Add clay to each knuckle of each toe to create height. Add clay to the tips, shaping and increasing the volume of the toes. Note that the toes are blocky, rectangular shapes.

27. Create planes on the sides of the big-toe nail. Draw guidelines to position the nail. Place the front edge of the riffler between the toenail and toe, and press the clay of the toe around the curve of the toenail. This will shape and separate the nail from the toe.

Curve the front edge of the toenail, and then press down on the toe surface at the sides of the nail. Create a beveled plane around the toenail to give it the appearance of being set into the toe.

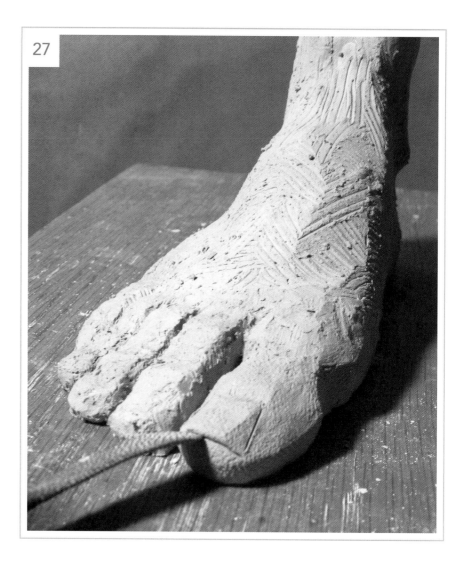

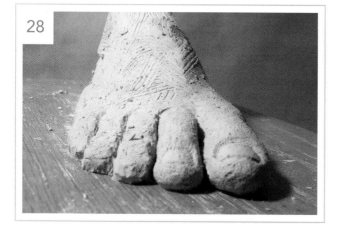

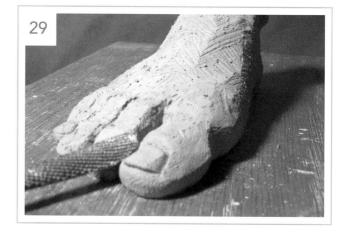

28 & 29. Continue to finish the side planes of the big-toe nail. Note that the nail is set into the top plane of the toe and follows the elliptical shape at the end of the toe. In addition, the other toes should take on a slightly rounded shape as they evolve.

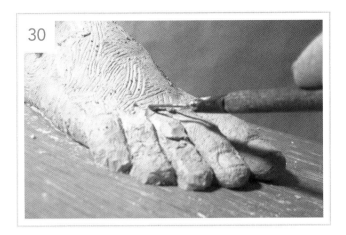

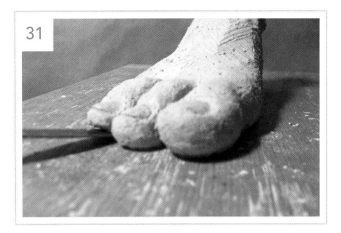

30. Continue to shape each toe. Rake down with the wire loop tool from the high bones on the top of the foot to the first section of each toe. Then put more pressure on the tool and make a slight transition, or valley, just before raking across the top plane of each toe. This will give the toe a little bend where it begins to emerge from the foot.

31. Lift and slightly curl each toe upward at the end with the riffler.

32. Continue to add small clay pieces to each toe with the stick tool, shaping and giving them more volume.

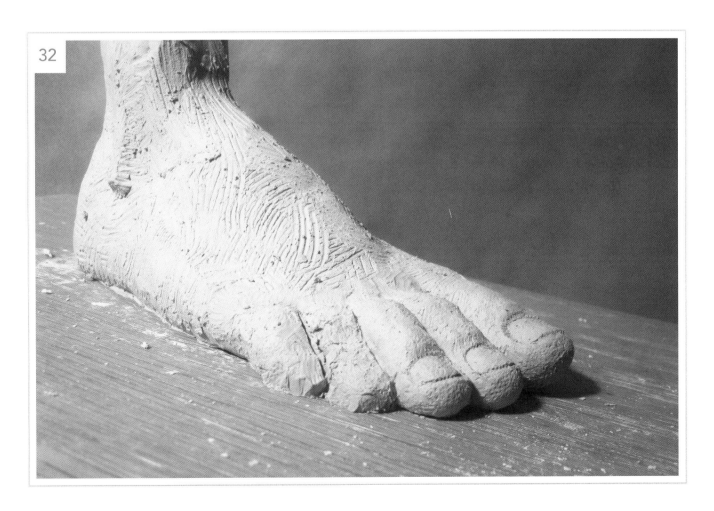

33. Add small strips of clay onto the toe just above the nails to give the toes more height in this area.

34. Turn the foot on its big-toe side. Follow the guideline and continue to scoop out clay for the arch of the foot using the wire loop tool.

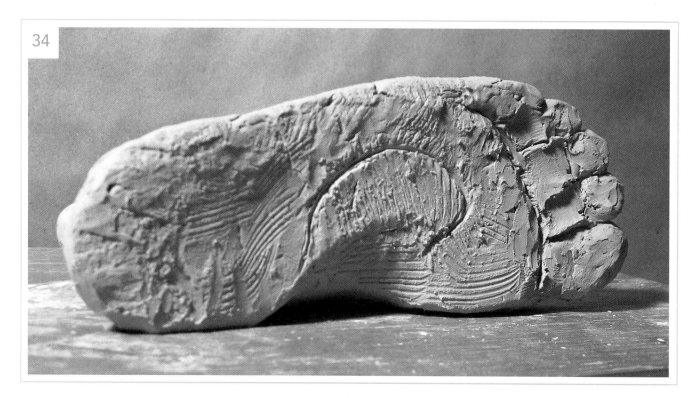

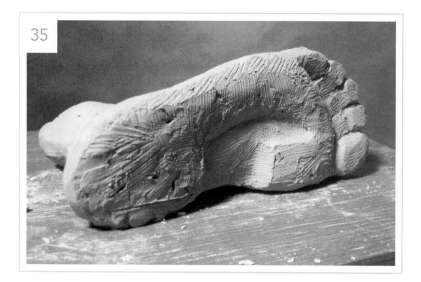

35. Create a plane structure for the sole pad of the big toe where it projects from the arch.

Create planes and the shape of the sole at the heel and outer edge of the foot.

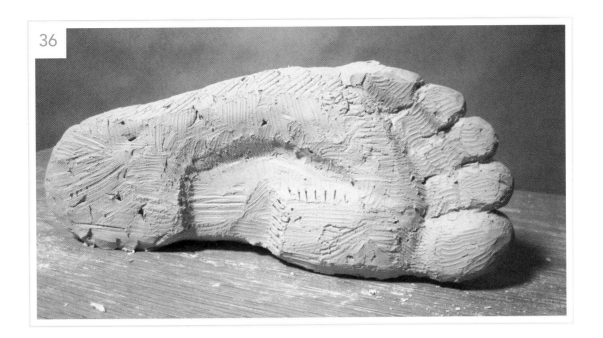

36. Shape the middle sections and pads of the toes. Note the narrow plane that travels around the heel and sole to the sole pad of the big toe.

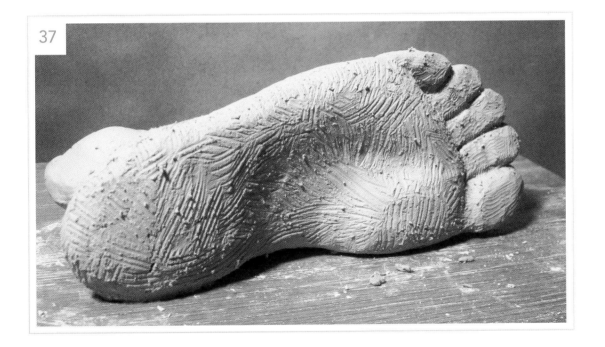

37. Rake and soften the planes of the sole to create the shape and rhythmic flow of its forms. Follow the contour along the outer edge of the foot. Start at the big toe, travel around to the little toe, continue across the outer edge around the heel, into the arch, and around the sole pad of the big toe.

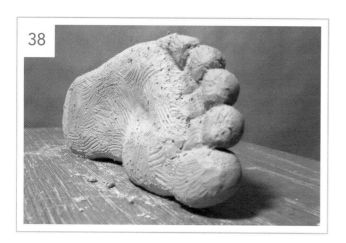

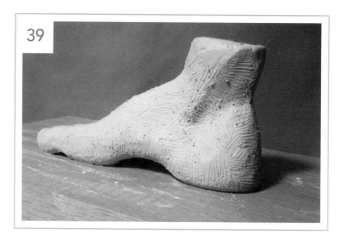

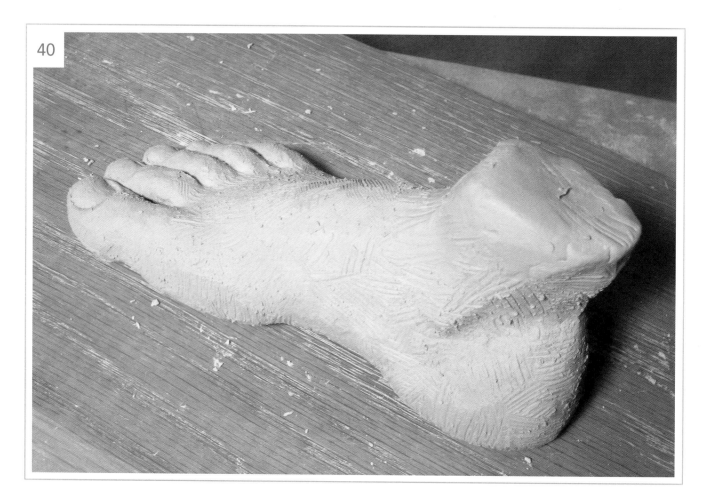

38, 39 & 40. Before continuing, assess the relationships of the form. Follow the flow of the surface over the toe pads into the channel over the sole pad of the big toe into the arch and up to the heel.

Also observe the shape of the heel from the Achilles tendon to the arch, high bones of the foot, sole pad, and pad of the big toe. And note the long flat bones (phalanges) of the toes and the placement of the ankle.

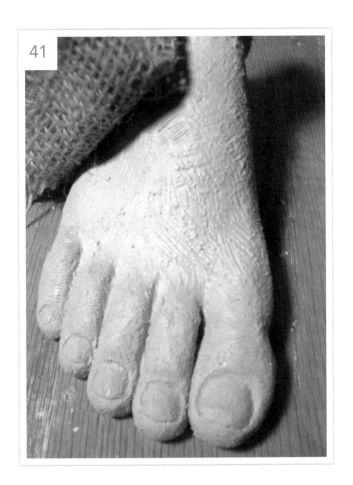

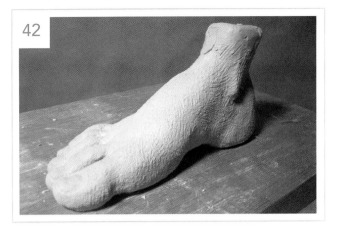

41, 42 & 43. Bunch up a wad of burlap, spray it with water, and press it to the clay surface to create a soft textural pattern.

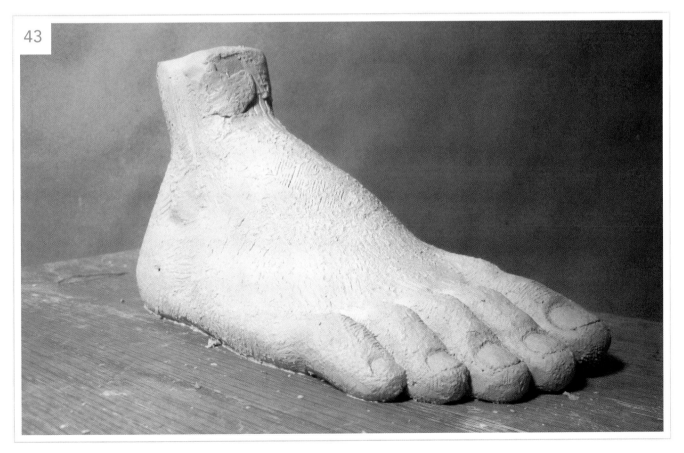

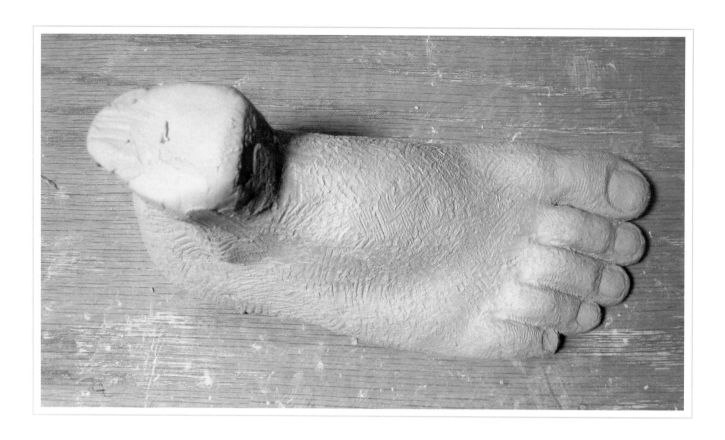

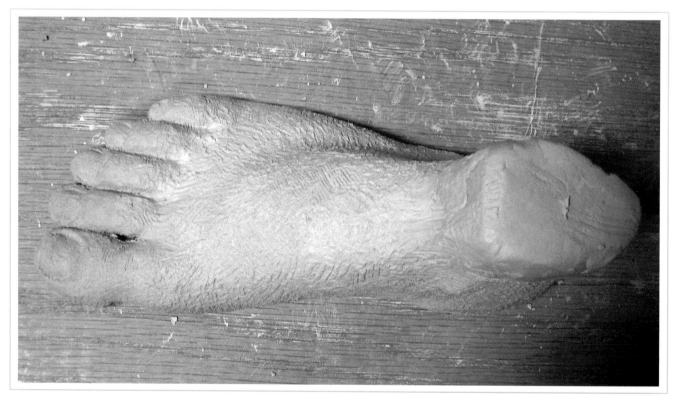

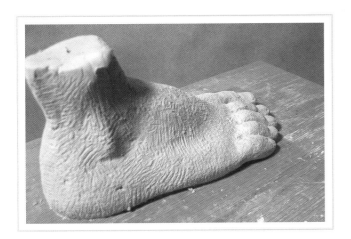

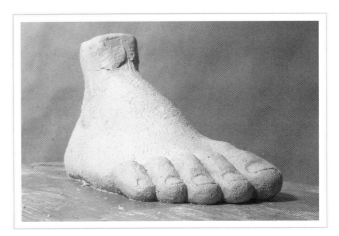

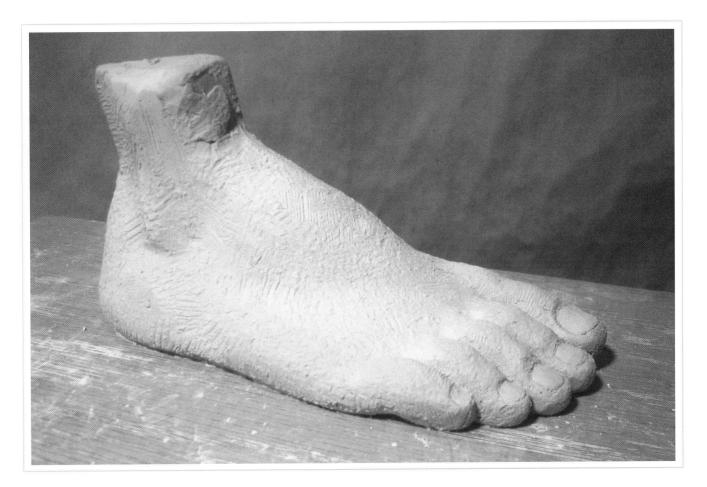

Finished foot from above and various side views.

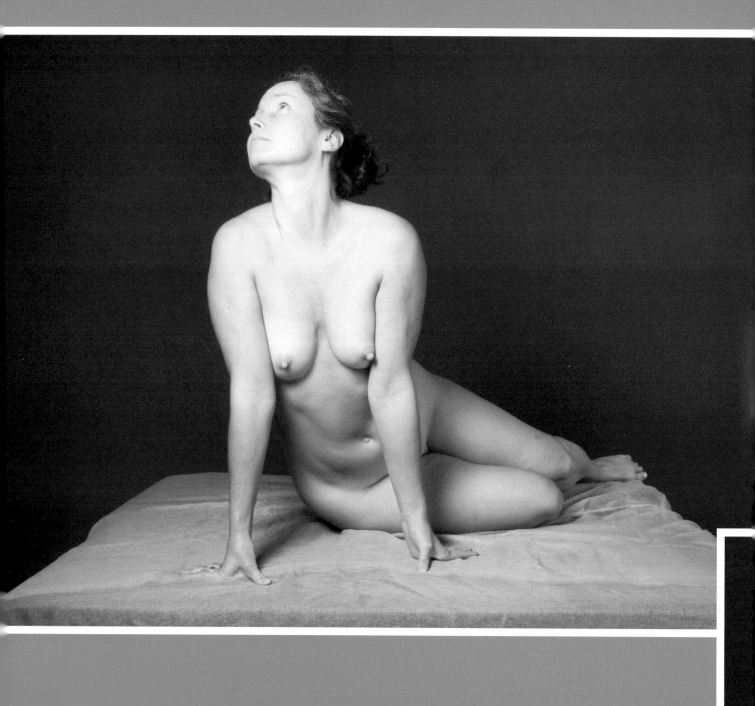

PART FIVE

REFERENCE

POSES

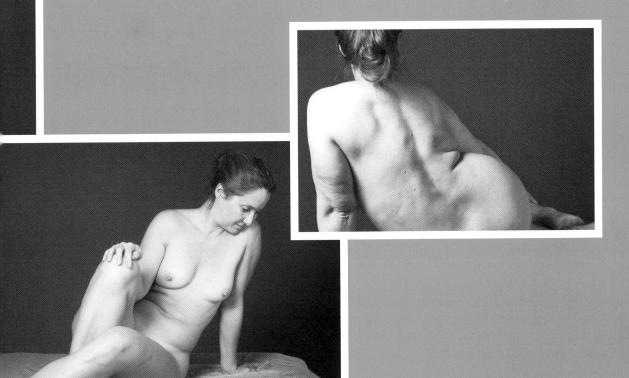

ARM ON HEAD

This reference pose section is designed to simulate how we observe the model in the studio, in the round. The sculptural poses are set up in sequential order so that you get to see the entire pose from all views. There are also a few dramatic single-view poses and a few details comparing views from eye level and looking down from above with close-ups. The two models are different in body type, which will help broaden your vision and expression. Having this variety of poses on hand makes it easy and affordable for students to be able to sculpt at home. This is especially important for those who cannot readily get to a sculpture class or who just cannot find female models. The reference poses are not exclusive for sculptural expressions; these individual photos are also intended to inspire drawings and paintings. All artists studying the figure will benefit from this chapter. Pursue it with passion!

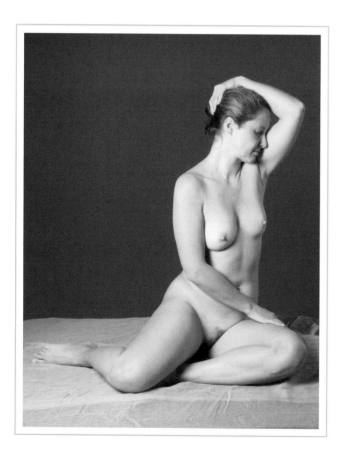
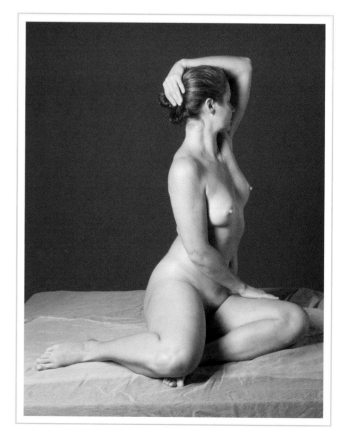

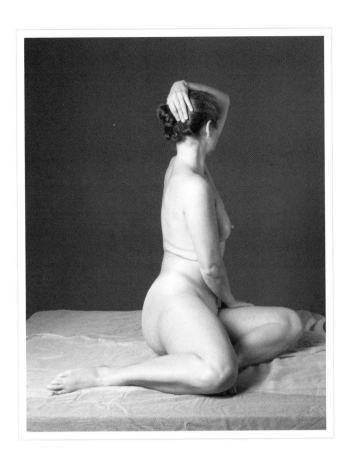

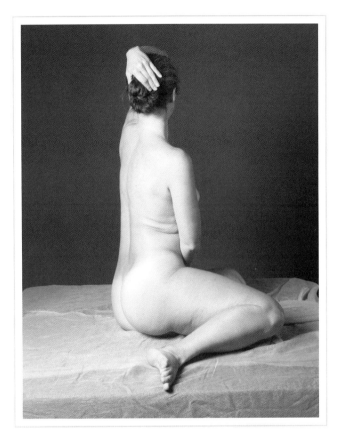

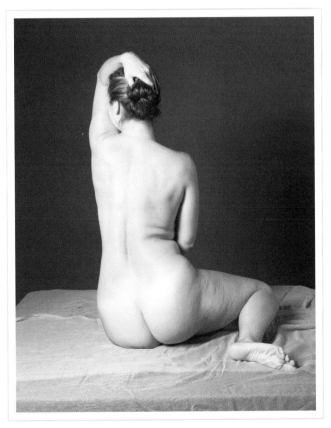

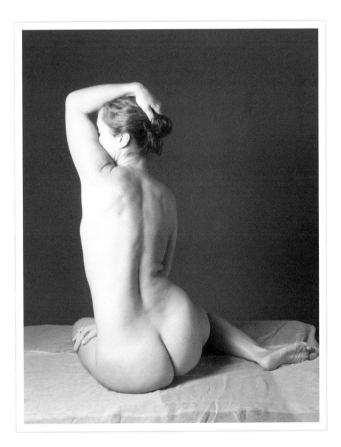

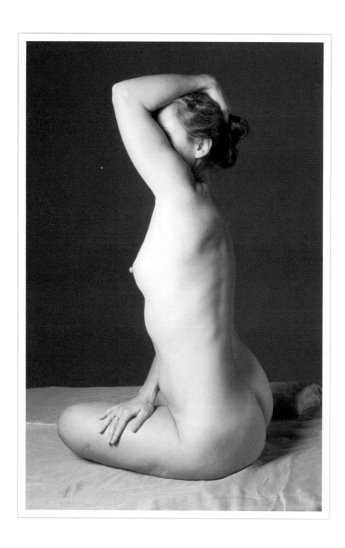

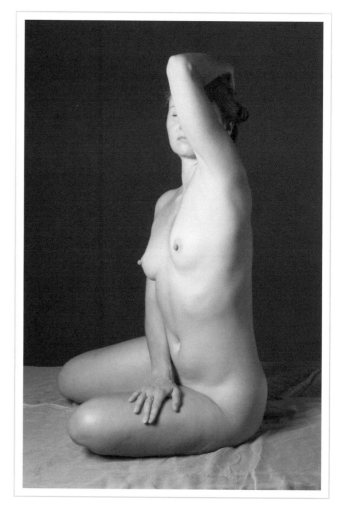

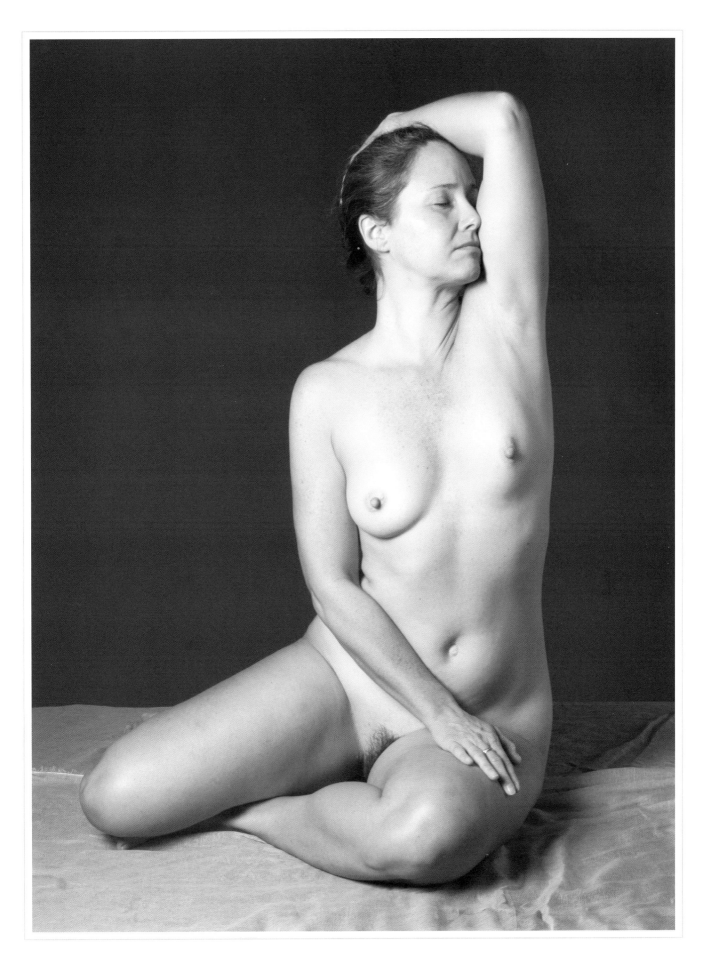

HAND ON KNEE

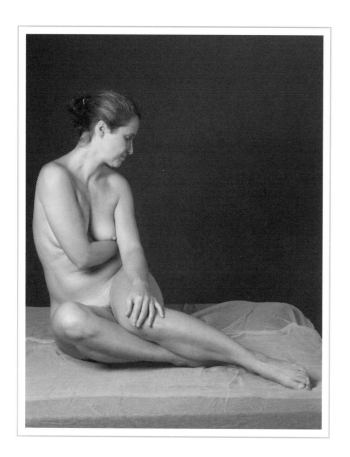

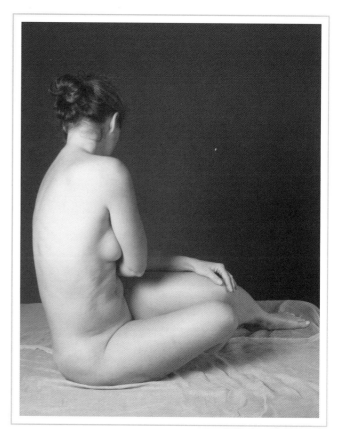

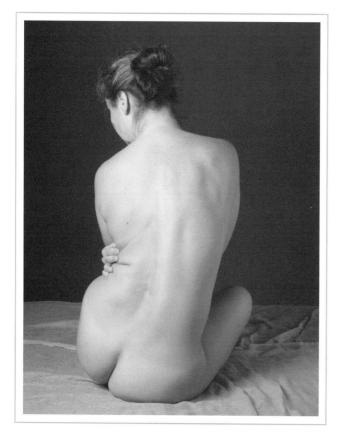

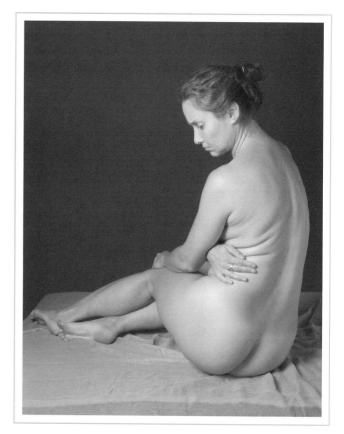

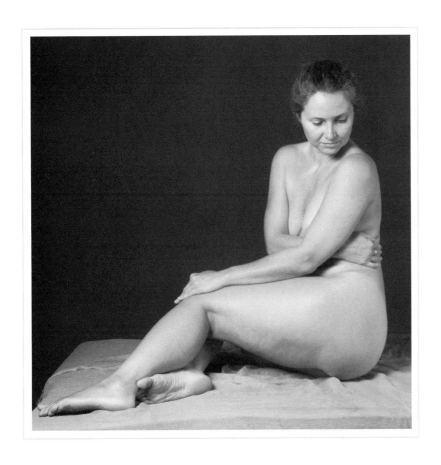

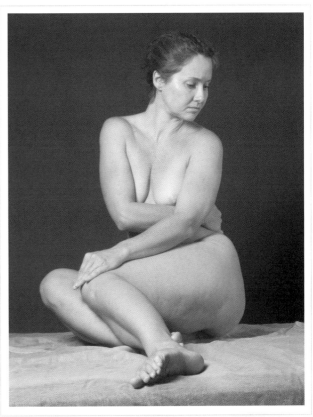

HAND ON SHOULDER

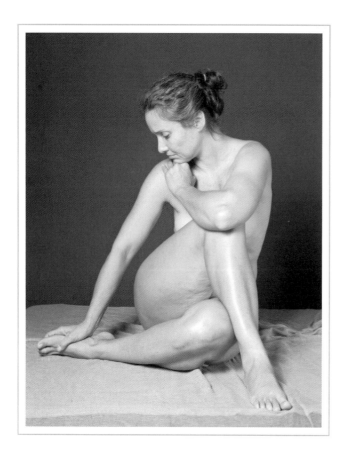

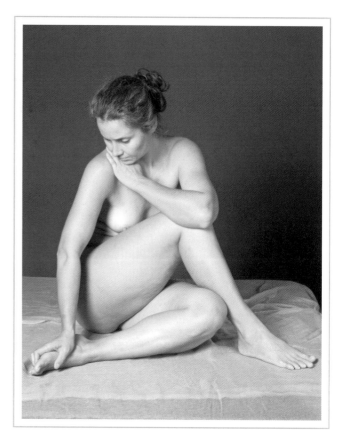

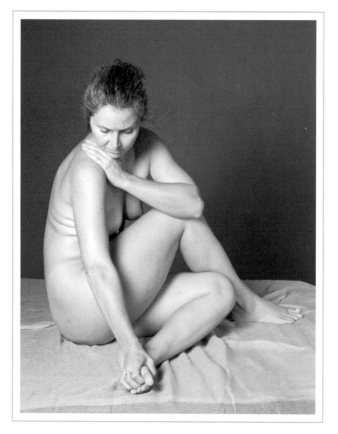

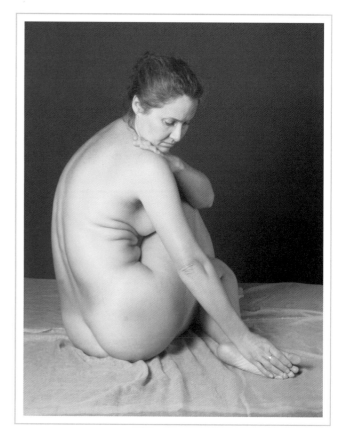

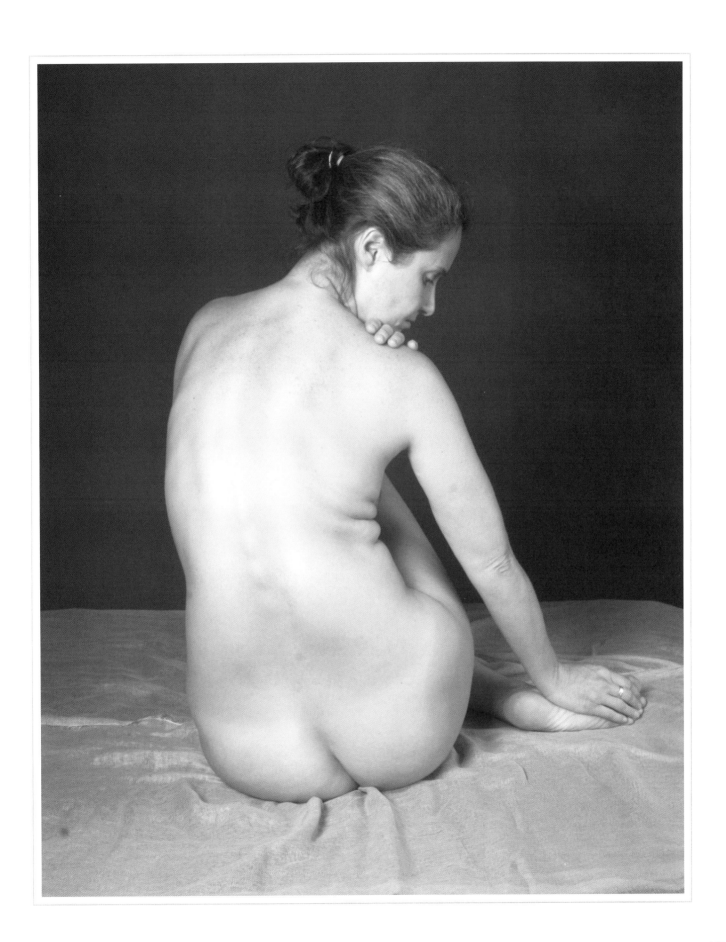

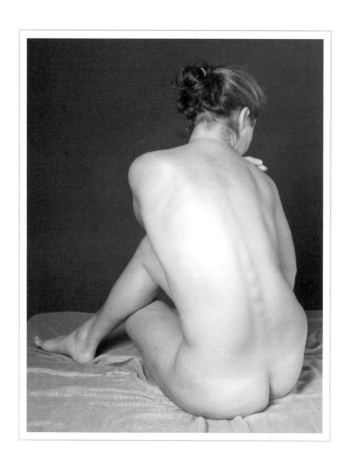

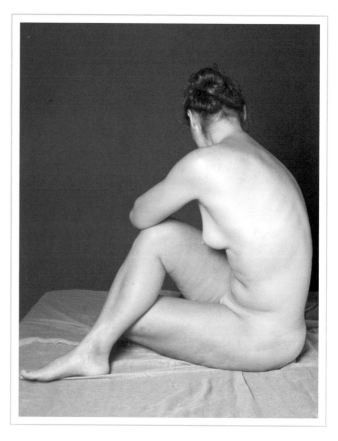

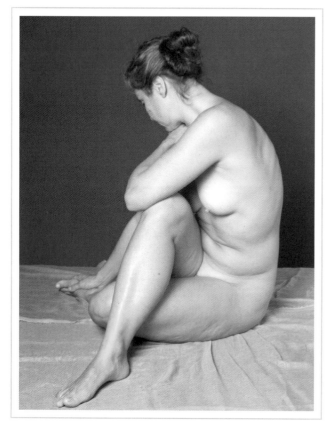

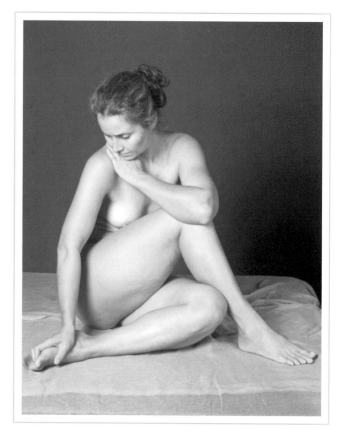

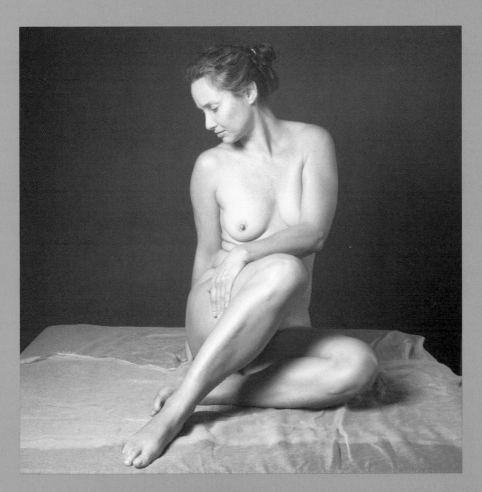

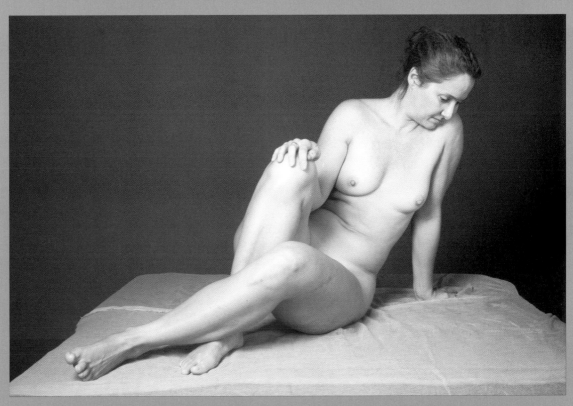

LOOKING UP

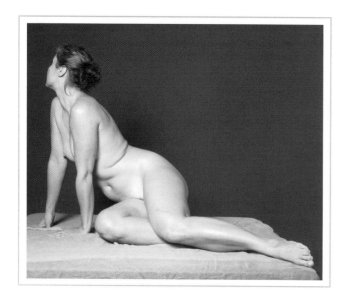

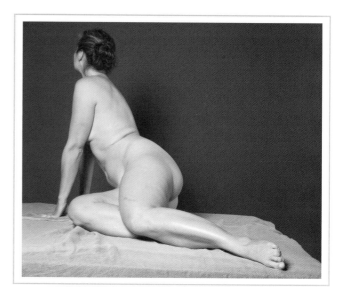

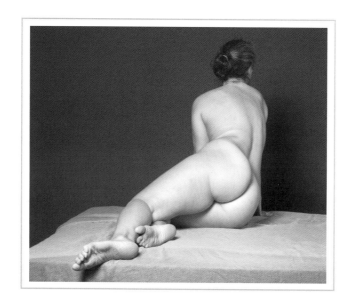

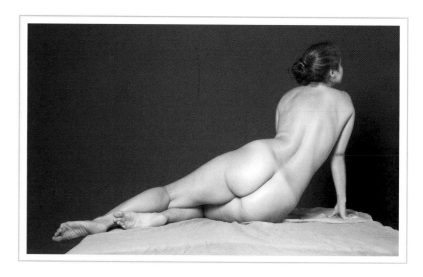

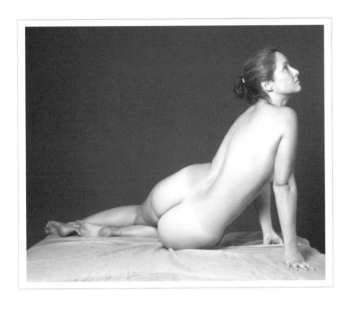

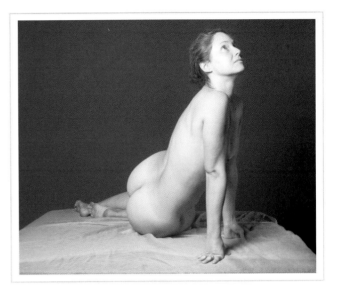

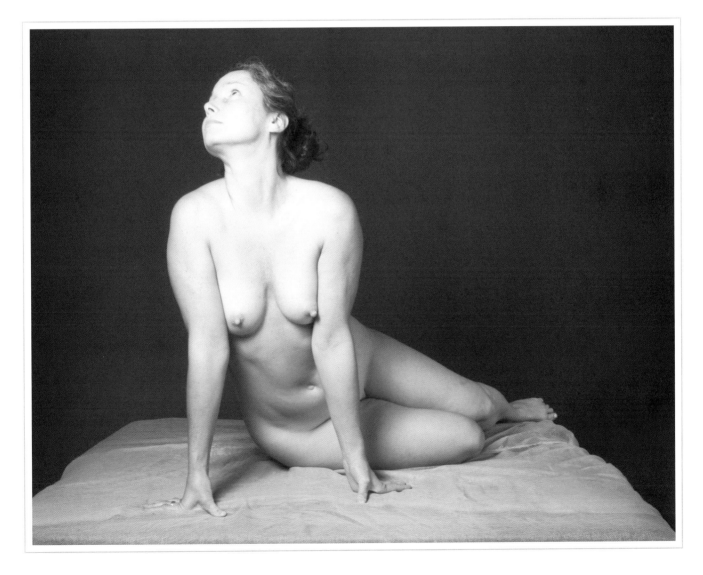

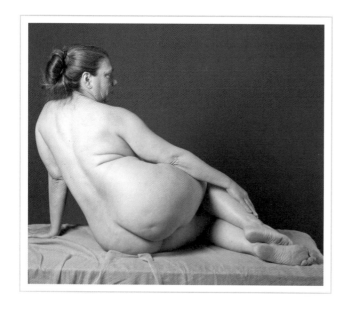

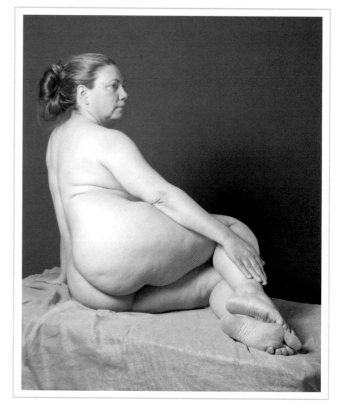

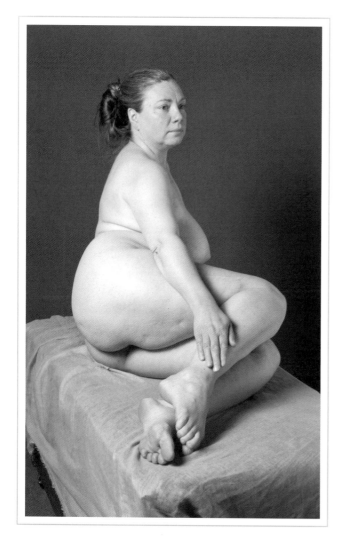

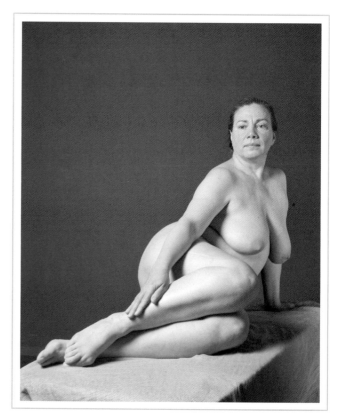

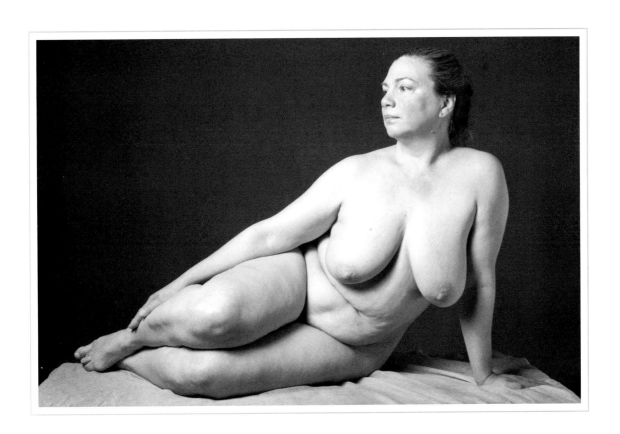

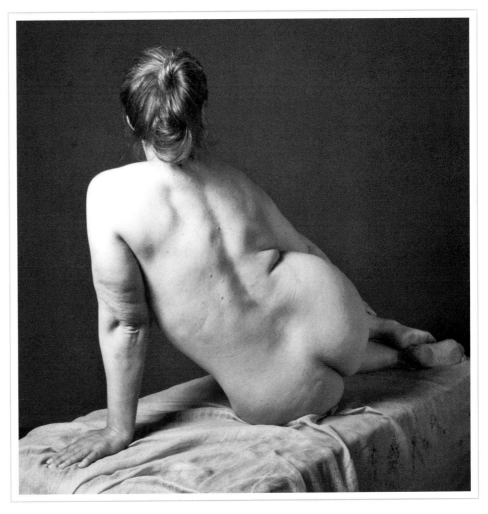

CHIN IN HAND

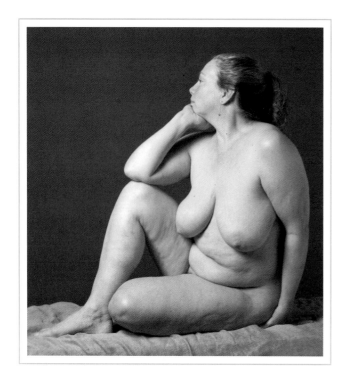

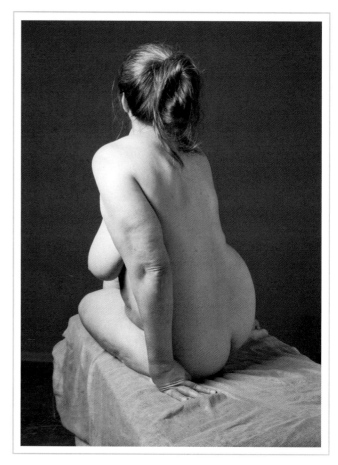

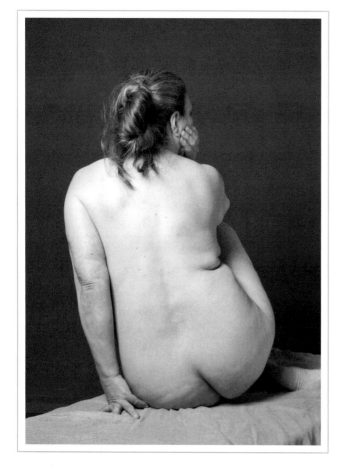

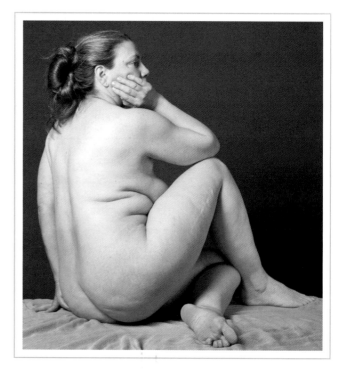

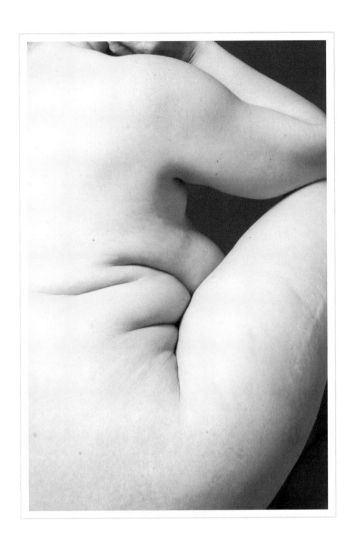

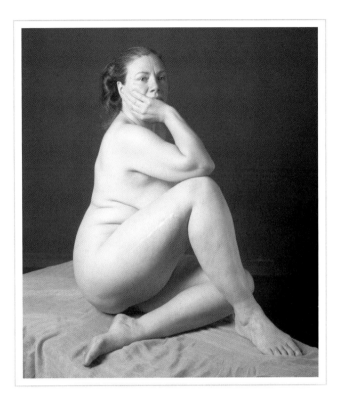

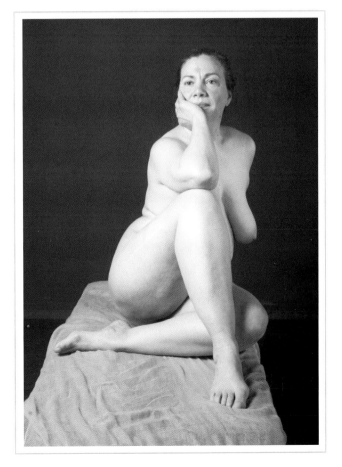

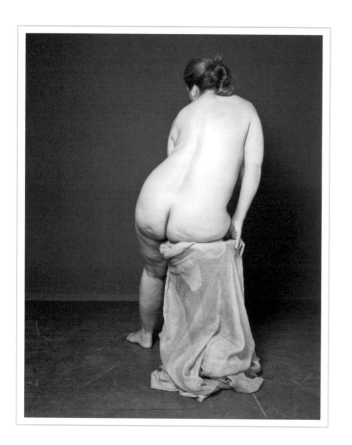

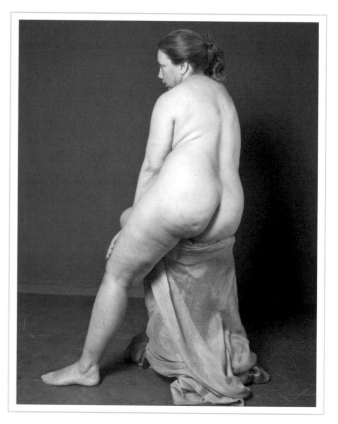

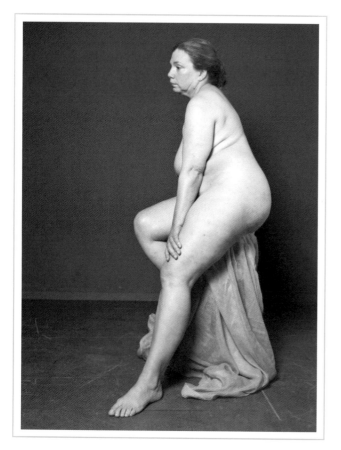

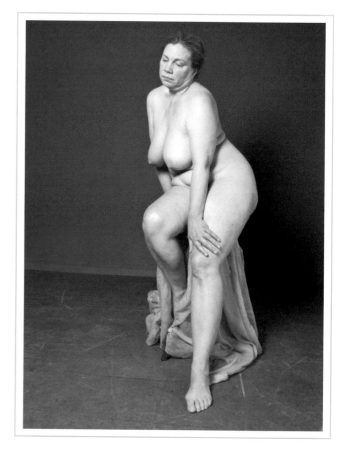

► **Arm Variation**

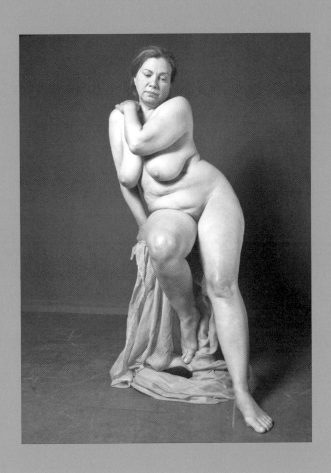

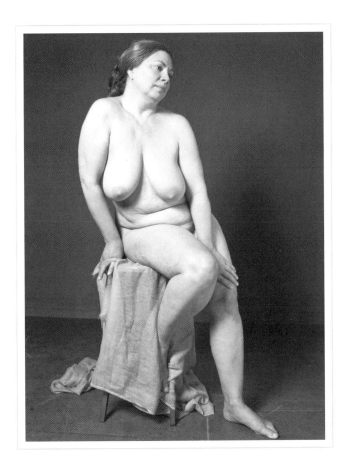

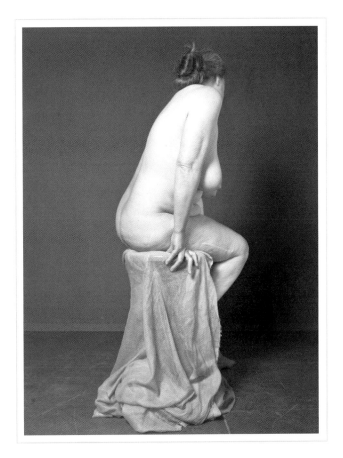

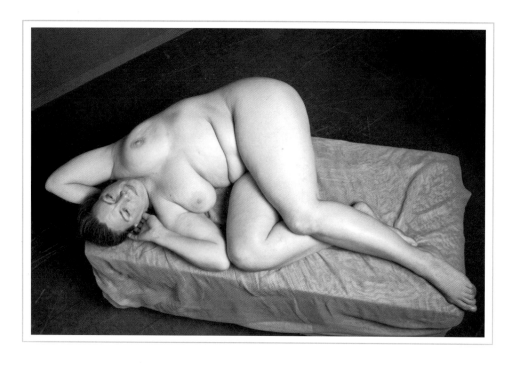

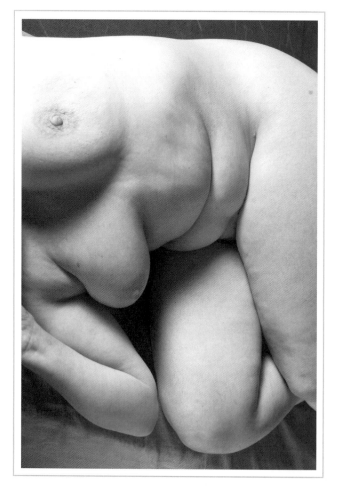

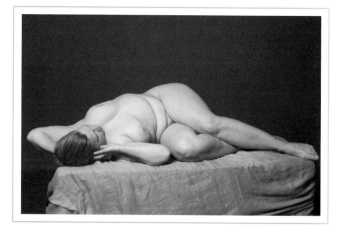

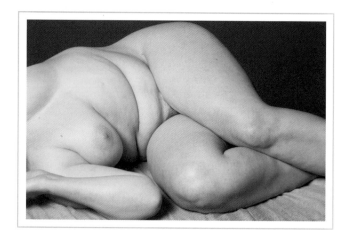

RESOURCES

In addition to those listed here, more resources can be found at www.sculpture.org.

Ranieri Sculpture Casting
2701 47th Ave.
Long Island City, NY 11101-3409
Dominic Ranieri
ph: 718-752-0167
Provides custom mold making and casting in all mediums, custom bases, mountings, restoration, and enlargement work.

Argos Foundry
Route 312
Brewster, NY 10509
ph: 914-278-2454
Bronze casting.

The Clay Place
60 East Ave
Norwalk, CT 06851
Dale Shaw
ph: 203-847-6464
Provides clay services, pottery, and classes.

The Compleat Sculptor
90 Vandam Street
New York, NY 10013-1007
ph: 212-243-6074 or 800-972-8578
www.sculpt.com
Tools and sculpture supplies online.

Greenwich Art Society
299 Greenwich Avenue
Greenwich, CT 06830
ph: 203-629-1533
www.greenwichartsociety.org
Sculpture and art classes.

New Canaan Sculpture Group
New Canaan, Connecticut
ph: 203-966-9181

National Academy Museum and School of Fine Art
5 East 89th Street
New York, NY 10128
ph: 212-996-1908
www.nationalacademy.org

Armory Art Center
1700 Parker Ave.
West Palm Beach, FL 33401
ph: 561-832-1776
www.armoryart.org
Sculpture workshops.

Scottsdale Artists' School
3720 North Marshal Way
Scottsdale, AZ 85251
ph: 800-333-5707
www.scottsdaleartschool.org
Sculpture workshops.

Il Chiostro
241 West 97th Street, Ste. #13N
New York, NY 10025
ph: 800-990-3506
www.ilchiostro.com
Sculpture workshops in Italy.

INDEX

A
armatures, 19

B
balance, 108, 110
bend, 13, 60
 of blocks, checking, 32
 of model, observing, 21
blending, 97, 147
body, masses of, 13
building process, 31
burlap, 18

C
calipers, 18
clay
 "delumping," 34
 firing temperatures of, 19
 spraying of, 41
 water-based, 18
clay block system, 13–17
clay sketch, 120–125
 capturing gesture with, 121–125
composition, creating unified, 61
cutting wire, 18

E
embossing tool, 18
 used for eyeballs, 106

F
facial features, defining, 88
figure
 abstracting, 121, 127–131
 broadening vision of, 58
 checking foundation in relation to, 33
 design elements of reclining, 114
 full, 60
 as inspiration, 9
 reclining, 68–108, 127
finish, 26
 components of, 30
 working through, 54
flat modeling stick, 18
foot, 152–169
 step-by-step construction of, 153–167
forearm, 149–151
form(s), 26
 blending of, 56
 checking relationships of, 92
 completed, 53
 components of, 30
 design elements of, 58–59, 113
 of human figure, 9
 looking for rhythms, patterns, and
 contours of, 58
 observing relationship of, 107
 "popping," 100
 of pose, capturing, 113
 transition between, 54
foundation, 26

checking, in relation to figure, 33
completed, 48
components of, 30
related to amount of work left, 48
for sculpting hand, 148

G
grog, 18
guidelines, drawing, 32, 34, 39, 50, 75,
 78, 88, 90, 100, 137, 154, 155, 160,
 162

H
hands, 134–148
 step-by-step construction of, 135–148

L
lean, 13, 60
 of blocks, checking, 32
 of model, observing, 21

M
materials, 18, 19
Milani riffler, 18
model
 gathering visual information from, 70
 observing, 20–23, 60
 paying attention to proportions of, 27

P
painter's brush, 18
planes, 13, 60
 of arms and legs, 81
 of blocks, checking, 32
 consideration of major, 58–59, 114–
 117
 directional changes between, 35
 of rib cage and pelvis, interpreting, 21
 of shoulder blades, 39
 tapping, 37
plaster spatula tool, 18
plinth, 68
pose
 assessing, 27
 basic standing, 21
 capturing gesture of, 40, 113
 capturing movement of, 12
 creating reclining, 17
 creating seated, 16
 determining BLT and three Ps of, 13
 expressing essence of, 121
 making decisions about movement
 of, 22
 movement of, 27
 reclining, 61–67
 taking final look at, 56
 visualizing, as architectural design, 67
position, 13, 60
 of blocks, checking, 32
 of rib cage and pelvis, interpreting, 21
proportion, 13, 60

of blocks, checking, 32
of rib cage and pelvis, interpreting, 21

R
reference poses
 arm on head, 172–175
 arm on leg, 184–185
 arm variation, 189
 chin in hand, 186–187
 chin to shoulder, 181
 eye level vs. from above, 190
 hand on knee, 176–177
 hand on shoulder, 178–180
 looking up, 182–183
 on a stool, 188
rhythm, 108, 110

S
sculpture
 architectural elements inherent in
 figure, 20
 checking and rechecking, from all
 angles, 68
 development stages of, 26
 differentiation of, from drawing and
 painting, 27
 elements becoming foundation of, 12
 finished, 126–131
 giving life to, 56
 managing development of clay, 70
 in progress, maintaining and storing,
 41
 viewing, from different angles, 108
 what to look for in finished, 108
shadows, 100
stylus tool, 18
 used for eyeballs, 106

T
texture, 54, 158, 167
 applying surface, 18
 burlap, 55. *See also* burlap
 creating final surface, 30
 developing fine surface, 56
 techniques, 113
tools, 18, 19
torso, 26–59
 characteristics common to, 12
 fundamentals of clay, 12–23
 standing, 30–59
tripod sculpture stand, 19
turn, 13, 60
 of blocks, checking, 32
 of model, observing, 21

W
water-misting bottle, 18
wire brush, 18
wire loop tool, 18
wood block tool, 18